Books are to

£ 9.50D

D0241869

The Old Contemptibles

THE OLD CONTEMPTIBLES

A Photographic History of the
British Expeditionary Force
August to December 1914

KEITH SIMPSON

London
GEORGE ALLEN & UNWIN
Boston Sydney

First published in 1981

GEORGE ALLEN & UNWIN LTD
40 Museum Street, London WC1A 1LU

© Keith Simpson, 1981

British Library Cataloguing in Publication Data

Simpson, Keith
 The Old Contemptibles.
 1. European War, 1914–1918 – Campaigns –
Western
 I. Title
 940.4'21 D546

 ISBN 0-04-940062-2

Set in 10 on 12 point Baskerville by Bedford Typesetters Ltd
and printed and bound in Great Britain by
William Clowes (Beccles) Limited, Beccles and London

Contents

List of Illustrations *page* ix

Acknowledgements xv

Introduction 1

1. Over by Christmas 3

2. Rival Plans and Armies 16

3. The Encounter Battles 35

4. The Battle of Ypres 81

5. Aftermath 112

Epilogue 129

Note on the Illustrations 130

Notes 137

Bibliography 139

Index 140

Illustrations

PHOTOGRAPHS

1. British infantry during the Curragh incident, March 1914 *page* 3
2. General Sir Horace Smith-Dorrien 5
3. Reservists of the Grenadier Guards re-enlisting on 5 August 1914 5
4. First Battalion Grenadier Guards leaving Chelsea Barracks 7
5. Field Marshal Sir John French leaving HMS *Sentinel* 8
6. 11th Hussars in sight of Le Havre on 16 August 1914 9
7. British Army officers viewing 'la belle France' from their ship 9
8. Soldiers of the BEF being 'courteous' to French ladies at Boulogne 10
9. The Scottish Rifles are welcomed at Le Havre 11
10. British soldiers parading soon after landing in France 12
11. Tea break for the 11th Hussars halted at Rouen station 13
12. British cavalry with a Boy Scout pass through a French town 14
13. 'Stand Easy' for British troops in northern France 14
14. Royal Welch Fusiliers resting by the roadside in Belgium 15
15. German infantry advance in pre-war manoeuvres 18
16. French infantry pose for the camera 20
17. French Hussars canter through a town 20
18. King Edward VII and senior British Army officers at Aldershot 23
19. Equipment of the British soldier in 1914 24
20. Webbing assembled on the soldier 24
21. British troops campaigning near Quetta, India, 1911 26
22. British infantry battalion marching through Curragh 28
23. British Army manoeuvres 1913 29
24. British infantry move across country 30
25. Royal Horse Artillery in Ireland in 1913 30
26. Cavalry machine gunners in action 30
27. British cavalry adopting an infantry role on Salisbury Plain 31
28. Officers of the Irish Guards at Wellington Barracks, August 1914 32
29. A typical British soldier in August 1914 34
30. The first Air Review on 22 May 1913 34
31. German transport entering Brussels on 20 August 1914 35
32. Scottish pipers advance north into Belgium 38

33.	British troops advance on Mons	*page* 39
34.	Troopers of the 9th Lancers reach Mons in August 1914	39
35.	Patrol of the 18th Hussars talking to Belgian civilians	39
36.	Royal Fusiliers resting in the Grand' Place, Mons	39
37.	An officer and troopers of the 4th Dragoons near the Mons canal	39
38.	Barricading a house in Mons	40
39.	Soldiers barricading a road between Mons and Jemappes	41
40.	Erecting barricades between Mons and Quesney	41
41.	Soldiers of the Lincolnshire Regiment digging trenches outside Mons	42
42.	British infantry firing at the Germans	43
43.	Two British infantrymen at an advanced post	43
44.	The bridging of the canal from Mons to Jemappes	44
45.	Staff of the 9th Brigade sheltering during action at Frammeries	45
46.	Taube spotting	46
47.	British cavalry screening the BEF during the retreat from Mons	46
48.	British cavalry retiring from Mons	47
49.	Officers' consultation before the battle of Le Cateau	49
50.	British troops on the retreat from Mons	51
51.	British Lancers with a French liaison officer	52
52.	French refugees streaming south past British soldiers	52
53.	British firing squad shoot a Belgian spy	53
54.	Field kitchens and infantry on the retreat from Mons	54
55.	Lieut-Gen. Sir Douglas Haig consults fellow officers	54
56.	Major-Gen. Monro and Colonel Malcom watch the retreat	55
57.	Royal Flying Corps pilots and observers being briefed	56
58.	Lieut. Arkwright, 11th Hussars, at ablutions	57
59.	French troops advance to the Marne, 6 September 1914	59
60.	The Scottish Rifles advance to the Aisne	59
61.	Soldiers of the Scottish Rifles watch British 18-pdrs in action	59
62.	Horse-drawn transport of the Middlesex Regiment under fire	60
63.	A British padre and Bavarian prisoners captured on the Marne	61
64.	The pursuit to the Aisne	61
65.	Scottish Rifles crossing a pontoon bridge over the Marne	62
66.	French and British cavalry during the advance to the Aisne	63
67.	Soldiers of the York and Lancs Regiment en route to the Aisne	64
68.	A field ambulance halted on the line of march	65
69.	British wounded being evacuated from Braine	65

70. Headquarters of the York and Lancs on the Aisne *page* 66
71. British 60-pdrs 'on trek' 67
72. British 60-pdrs in position behind cover on the Aisne 68
73. Company dug-outs of the York and Lancs on the Aisne 68
74. British soldiers in impoverished shelters on the Aisne 69
75. Brigadier-General Shaw and staff of the 9th Brigade 70
76. Captain Maitland of the Essex Regiment with machine gun 70
77. Royal Marine Reservists filling their water bottles 73
78. British Royal Marines and mascot in an armoured car 74
79. French cavalry march past the Scottish Rifles 74
80. Train halt in France 75
81. Scots Guards and Gordon Highlanders on board the ss
 Lake Michigan 76
82. Scots Guards and Gordons disembarking at Zeebrugge 77
83. Scots Guards en route by train from Zeebrugge to Ghent 77
84. Wounded British marines being evacuated by bus from
 Antwerp 78
85. British marines and Belgian soldiers withdraw from Antwerp 78
86. Trench digging in a field outside Ghent on 9 October 1914 79
87. Scots Guards prepared for the German attack on Ghent 79
88. Waiting for the Germans 79
89. Officers consulting in Ghent on 11 October 1914 80
90. Scots Guards withdrawing from Roulers to Ypres 80
91. A windmill in Flanders about to be used as a military post 82
92. Military transport in the town square of Thielt 82
93. British troops move through a Belgian village in Flanders 83
94. A Belgian aeroplane flying over a British camp 84
95. Belgian infantry and their machine gun resting by the
 roadside 85
96. Royal Flying Corps ground crew undergoing small arms drill 85
97. French heavy cavalry passing British cavalry near Zelobes 85
98. Indian troops march to the front near Ypres, October 1914 86
99. British and French troops outside a café in Flanders 86
100. British artillery and infantry pass French Hussars near Ypres 87
101. British cavalry ride through the Grand' Place in Ypres 88
102. British infantry moving up to the front in Flanders 88
103. A British naval armoured car on the Menin Road 89
104. Scots Guards move towards Gheluvelt 90
105. The body of Drummer Steer, Scots Guards 90
106. German infantry on the line of march in Flanders 90
107. French Fusilier Marines of Admiral Ronarc'h's Brigade 91
108. French cyclist troops lining a ditch in Flanders 91
109. Officers leaving Hollebeke Chateau during the battle of
 Messines 93

110.	Digging trenches near Zandvoorde	*page* 93
111.	British infantry prepare to meet a German attack	94
112.	German infantry advancing at Ypres	95
113.	German dead after an attack during the battle of Armentières	95
114.	German troops deploy in Flanders	96
115.	A patrol of the Gordons on the edge of a field near Ypres	97
116.	Soldiers of the 129th Baluchies outside Wytschaete	97
117.	Issue of hot cocoa to Scots Guards on the Menin Road	98
118.	French wounded outside Ypres	98
119.	A French '75' dug-in near Ypres	99
120.	A German prisoner being brought back from the line	100
121.	View from a front-line trench of the Scottish Rifles	100
122.	French Hussars passing French infantry near Ypres	101
123.	Royal Warwickshire Regiment being transported through Dickebusch	102
124.	British infantry in a trench outside Ypres	102
125.	Soldiers of the York and Lancs Regiment in a trench at Bois Grenier	102
126.	A primitive trench near Armentières	104
127.	Royal Horse Artillery in action at Wytschaete	105
128.	A British Household Cavalry trooper eating his rations	105
129.	Brigadier-General Charles FitzClarence VC	106
130.	Major-General Thompson Capper	106
131.	A primitive communication trench full of British soldiers	107
132.	Grenadier Guards resting by the Menin Road	107
133.	Ferme de Biez, Armentières, HQ of the York and Lancs Regiment	108
134.	Officers inside Battalion Headquarters of the York and Lancs Regiment	109
135.	Headquarters cooks of the York and Lancs Regiment	109
136.	1st Battalion The Queen's Royal Regiment after mobilisation	110
137.	The same Battalion much depleted after the fighting at Ypres	110
138.	'Old Contemptibles' taken prisoner by the Germans	111
139.	Soldiers of the 7th Division discuss the war news	111
140.	Survivors of the London Scottish after the battle of Messines	113
141.	A British soldier operating a pump in a water-logged trench	113
142.	Sergeant Coggan of the York and Lancs Regiment	113
143.	Sandbag barricades erected across the Lille-Armentières railway	114
144.	Sleeping accommodation in the Houplines sector	114
145.	Goatskin jackets worn by soldiers of the York and Lancs Regiment	115

146. Stretcher bearers of the Argyll and Sutherland Highlanders *page* 115
147. Informal armistice at the Rue de Bois in December 1914 116
148. Making 'gunfire' tea in the Houplines sector 116
149. Men of the Scottish Rifles digging for potatoes 117
150. View across no-man's land on 5 December 1914 117
151. A British 18-pdr field gun in the Armentières sector 118
152. A British sentry guarding a motor transport petrol dump 119
153. Soldiers of the Scottish Rifles learning how to handle a
 machine gun 119
154. A Royal Engineers telephone cable wagon in Flanders 120
155. British soldiers use a large greenhouse as a billet 120
156. A local estaminet, HQ of the 1st Cavalry Brigade 121
157. Soldiers of a Territorial Force Royal Engineers unit sort out
 mail 121
158. 2nd Cavalry Division pack of hounds at Vieux Berquin 122
159. British troops embark for France after home leave 123
160. The Border Regiment marching off to the trenches 123
161. A horse-drawn ambulance in Bailleul 124
162. Christmas Day truce 1914 – Rue de Bois, Armentières 125
163. Another view during the Christmas Day truce 125
164. British and German soldiers meet in no-man's land 126
165. German officers pose with British officers in no-man's land 126
166. British and German soldiers fraternising at Ploegsteert 126
167. A typical front-line trench in December 1914 127
168. 2nd Battalion Scots Guards in the trenches near Fleurbaix 128
169. The 1914 Star 129
170. The 'stirrup-charge' of the Scots Greys and Highlanders at
 St Quentin 131
171. British valour near Compiègne 132
172. Lieut. Money and officers of the Scottish Rifles 133
173. Sergeant C. Pilkington, Artists Rifles 134
174. Paul Maze, 2nd Cavalry Division 134
175. Lieut. J. A. Reid, York and Lancs Regiment 135
176. Soldiers of the King's Liverpool Regiment at Ypres 136

MAPS

1. Rival war plans *page* 17
2. The concentration of the armies, August 1914 36
3. Battle of Mons, 23–24 August 1914 37
4. Retreat from Mons 48
5. Battle of the Marne and advance to the Aisne 58
6. Flanders, October 1914 72
7. Battle of Ypres, 29–31 October 1914 92

Acknowledgements

I should like to thank a number of people and institutions who have helped me in preparing the photographs and text for this book. Mr James Lucas, Deputy Head of the Department of Photographs at the Imperial War Museum, let me consult the catalogue he compiled on the photographs held by the Museum relating to the BEF between 1914 and 1915. It is always a pleasure to do research in the photographic library of the Imperial War Museum because the staff are both knowledgeable and helpful. Miss Rose Coombs, Special Collections Officer at the Imperial War Museum, provided me with some useful information about the Old Contemptibles Association. Lieutenant-Colonel A. W. Stansfeld, Regimental Secretary of the York and Lancaster Regiment, kindly let me examine the photograph album of Lieutenant Reid and gave me permission to reproduce some of the photographs. Major-General R. C. Money provided me with some valuable information about his activities as an amateur photographer in 1914. Mr John Hunt, Librarian of the Royal Military Academy Sandhurst, and his staff were very tolerant in allowing me to borrow a considerable number of books over a long period of time from what must be one of the finest Ministry of Defence libraries in the country.

Grateful acknowledgement is made to the following for permission to quote material in copyright: The Colonel of the Royal Welch Fusiliers for excerpts from *The War the Infantry Knew 1914–1919* (1938); Faber & Faber for excerpts from John Lucy, *There's a Devil in the Drum* (1938) and Frank Richards, *Old Soldiers Never Die* (1933); George Allen & Unwin for an excerpt from Rudolf Binding, *A Fatalist at War* (1929); J. M. Dent for excerpts from C. B. Purdom, ed. *Everyman at War* (1930); Curtis Brown for an excerpt from Arthur Osburn, *Unwilling Passenger* (1933); Routledge & Kegan Paul for excerpts from F. A. Boswell, *With a Reservist in France* (n.d.); A. D. Peters for excerpts from John Terraine, ed. *General Jack's Diary* (1964); Eyre & Spottiswoode for excerpts from Lieutenant-Colonel A. F. Mockler-Ferryman, ed. *The Oxfordshire and Buckinghamshire Light Infantry Chronicle 1914–1915* (n.d.); Cassell for excerpts from John Charteris, *At GHQ* (1931); Macmillan, London and Basingstoke, for excerpts from J. M. Craster, ed. *'Fifteen Rounds a Minute'* (1976); Peter Davies for excerpts from Walter Bloem, *The Advance from Mons* (1930).

Grateful acknowledgement is also made to the following for permission to reproduce photographs in copyright:

Amalgamated Press: 10, 13, 39, 40, 41, 42, 129, 131, 171, 176.
George Newnes: 19, 20.
Historical Research Unit: 7, 16, 17.
Illustrated London News Picture Library: 4, 8, 53, 57, 74, 85, 170.
Imperial War Museum: 2, 3, 5, 6, 9, 11, 12, 14, 15, 21, 27, 28, 29, 30, 31, 32, 34, 35, 36, 37, 38, 43, 44, 46, 47, 48, 49, 50, 51, 52, 54, 55, 56, 58, 59, 60, 62, 64, 65, 66, 68, 71, 72, 76, 77, 78, 79, 81, 82, 83, 84, 86, 87, 88, 89, 90, 91, 92, 93, 94, 95, 96, 98, 99, 100, 101, 102, 103, 104, 105, 106, 107, 108, 109, 110, 111, 112, 113, 114, 115, 116, 117, 118, 119, 120,

121, 122, 123, 124, 126, 127, 128, 132, 138, 139, 140, 141, 144, 146, 147, 148, 149, 150, 151, 152, 153, 154, 155, 156, 157, 158, 159, 160, 161, 164, 165, 166, 167, 168, 172, 173, 174.

National Army Museum: 1, 22, 23, 24, 25, 26, 80, 169.

The Queen's Regiment: 136, 137.

William Blackwood & Sons: 33, 45, 63, 69, 75, 97.

York and Lancaster Regiment: 67, 70, 73, 125, 133, 134, 135, 142, 143, 145, 162, 163, 175.

Whilst every effort has been made to acknowledge copyright of material used in this book it has not been possible in every case to trace the copyright holder.

Finally, I should like to thank Mr Des Smith of the Department of Military Technology, R.M.A. Sandhurst, and Captain Anthony Raymer, Coldstream Guards, for their technical assistance.

R.M.A. Sandhurst, June 1980 KEITH SIMPSON

Introduction

Every year on Armistice Sunday there are dwindling groups of old soldiers in their eighties and nineties who gather amidst the fallen leaves in front of war memorials throughout the United Kingdom and Ireland. They are the men who served in the First World War, or the Great War as they call it, a conflict as far away from today's generation as the Crimean War was to them in their youth. Some of these old soldiers were Regulars, others Territorials, many Kitchener Army volunteers or conscripts. Occasionally, amongst the array of medals on their chests, one will spot the 'Mons Star,' the name given to the 1914 Star. If the medal ribbon has a bar or rosette, then one can be sure that the wearer was in France and Belgium under fire at some time between 5 August and 22 November 1914. As likely as not, he was a member of the old Regular Army, perhaps even an 'old sweat' who served in the original five divisions of the British Expeditionary Force, the BEF, who were sent to France before 19 August 1914. The survivors who wear the 1914 Star are known as 'Old Contemptibles', a name which seems familiar even to younger generations. But why remember the 'Old Contemptibles'?

Millions of men served in the British Army during the First World War, the majority of them volunteers who joined the New Armies in 1914 and 1915. The battles they fought are associated with the Somme in 1916 and at Passchendaele and Ypres in 1917. Why remember the soldiers who fought in the first few months of the war?

Precisely because the majority of them were Regular soldiers or Reservists, with a limited number of Territorial and Indian Army soldiers, and some specialist volunteers. These original members of the BEF fought alongside the French and Belgians at the battle of Mons, at the battle of Le Cateau, through the retreat, the advance to the Marne and the Aisne, and finally at the battle of Ypres in October and November 1914. The majority of the original BEF, particularly the infantry, were killed or wounded in these battles, so that by Christmas 1914, the BEF, despite having been continuously reinforced by Regular Army units brought home from overseas, and by the Territorials, was a different Army with a different ethos. The survivors of the Regular Army of 1914 were reorganised and reinforced with drafts of new men. There were few units of the BEF after 1915 which had more than a handful of pre-war Regular soldiers. In fact, many of the surviving Regulars were transferred to the New Armies in order to give them a small nucleus of trained and experienced soldiers.

The spirit of the original BEF of 1914 is epitomised by their acceptance of the nickname 'Old Contemptibles'. It is alleged that, on 19 August 1914, Kaiser Wilhelm II issued an order to General von Kluck, commander of the First Army, which read: 'It is my Royal and Imperial Command that you concentrate your energies for the immediate present upon one single purpose, and that is, that you address all your skill and all the valour of my soldiers to exterminate the treacherous English and walk over General French's

contemptible little Army.' In translation from the German the word 'contemptible' was used instead of the more accurate 'contemptibly little'. But the soldiers of the BEF on being informed of this order, mainly through the popular press, were quite happy to be known as 'the contemptibles'.

The object of this book is to provide a pictorial history of the 'Old Contemptibles' and of that opening period of the First World War before the fighting on the Western Front became formalised into the trench warfare which is the prevailing image of the war. Until November 1914 the fighting was highly mobile. The pictorial record of it is, unfortunately, patchy for a number of different reasons (described in the Note on the Illustrations at the end of the book) which include official censorship, the banning of cameras and the preference of newspapers for war artists as opposed to photographers.

However, it is possible to compile a photographic history of the BEF in 1914 from photographic archives and regimental museums as well as magazines, newspapers and private collections; and this illustrates vividly the life and death of the old pre-war Regular Army, from the excitement of mobilisation in August to the grim aftermath of the battle of Ypres in November 1914. Complementing these photographs and giving them the depth of personal experience are the accounts and observations of some of the officers and other ranks who served in the BEF, taken from their published diaries and memoirs.

I
Over by Christmas

'Home before the leaves fall.'
Kaiser Wilhelm II's promise
to his troops in August 1914

In the month following the assassination of the Archduke Franz Ferdinand of Austria and his Consort at Sarajevo on 28 June 1914 which precipitated the First World War, the attention of the British public was on Ireland rather than on Europe. To the British it appeared that civil war in Ireland was far more likely that year than a war in Europe. The crisis in Ireland went back many years, but had been intensified by the Liberal government's decision to give Ireland Home Rule. By June 1914 both the Protestant Ulster

1. British infantry entraining in Ireland during the Curragh incident, March 1914.

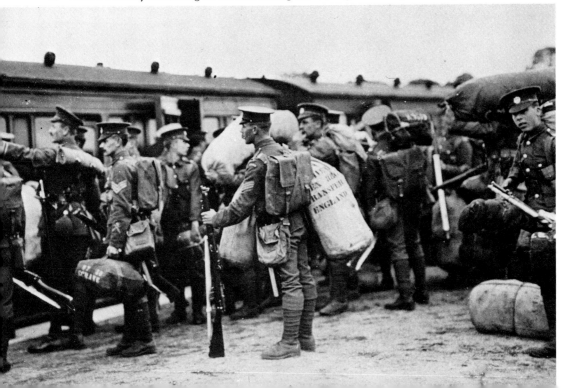

Volunteers and elements of the Irish Nationalists were prepared to resort to arms when the Home Rule Bill was passed, and it was probably only the outbreak of a European war which prevented the British Army from being involved in a civil war in Ireland.

On 28 July, however, Austria-Hungary declared war on Serbia. The British government took precautionary measures on 29 July including the recall of officers and men on leave and the manning of all coastal defences. On the same day the Belgians placed their Army on a reinforced peace footing, and the Russians mobilised their southern Armies facing Austria-Hungary. On 30 July the Russians began general mobilisation, and on 1 August, both Germany and France began to mobilise. None of the European powers could allow themselves to be overtaken in mobilising and once mobilisation began then plans that had been laid before the war were automatically activated. The British government reluctantly began to make preparations to mobilise, but it was not until 3 August when Germany declared war on France, and then on 4 August when Germany invaded Belgium, that direct British involvement became inevitable, for it was the German violation of Belgian neutrality that decided the British government to declare war and order the mobilisation of the Army.

Mobilisation occurred at a very inconvenient moment, for 3 August had been a Bank Holiday, and it was high summer and many Territorial units were in the process of moving to their summer camps when orders arrived cancelling the training. More importantly, the British Government was uncertain as to its strategic policy. Although plans had been made for the sending of the Expeditionary Force to reinforce the French left flank, it remained uncertain until 6 August whether the British government would agree to the implementation of those plans. On 5 and 6 August the British Prime Minister chaired two meetings attended by senior ministers and senior Army and Navy officers to decide on strategy. Lord Kitchener, who was in London on leave from Egypt, also attended, and on the 6th was appointed Secretary of State for War. Alternative schemes to send the Expeditionary Force to Antwerp were considered, but eventually discarded in favour of the detailed plans prepared before the war to send the Expeditionary Force to France. It was decided to embark four divisions – the 1st, 2nd, 3rd and 5th – and the Cavalry Division, plus one brigade, almost immediately. For the moment, the 6th Division was to remain in Ireland and the 4th Division in Britain. It was also decided to bring home British Regular troops from overseas and to transport two Indian Divisions to Egypt. At the same time the Territorial Force began to take over the duties of Home Defence from the Regular Army.

Command of the British Expeditionary Force had been given to Field Marshal Sir John French. 'Johnnie' French was sixty-two years old, a short, quick-tempered cavalry officer who had distinguished himself in South Africa. But French lacked staff training and probably reached high command too late in life. Personally a brave man, he was a soldier's soldier and had a good rapport with the rank and file. His Chief of Staff, Lieutenant-General Sir Archibald Murray, was a dedicated staff officer, but lacked physical stamina. The sub-Chief of Staff, Major-General Henry Wilson, was an effervescent and unconventional officer, a passionate francophile, a political intriguer and a strong influence on French. Major-General 'Wully' Robertson, the Quartermaster-General of the BEF, was an ex-ranker who had persevered against great odds to be commissioned

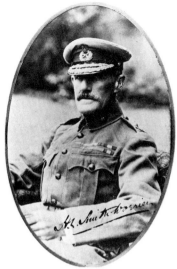

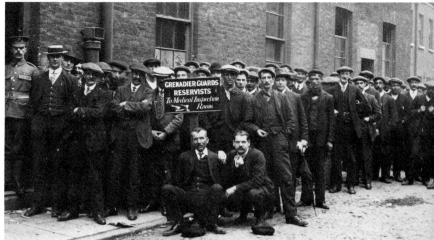

3. Reservists of the Grenadier Guards re-enlisting at Wellington Barracks on 5 August 1914. Nearly fifty per cent of the BEF was made up of reservists such as these men who had to leave their civilian occupation and answer the call to arms.

2. General Sir Horace Smith-Dorrien, GOC II Corps BEF.

and to reach the High Command of the Army. He was dour and sometimes inarticulate but, nevertheless, an excellent administrator. The commander of I Corps was Lieutenant-General Sir Douglas Haig, a very professional officer but orthodox in his military thinking, who had served as Chief of Staff to French in South Africa. The II Corps was originally commanded by Lieutenant-General Sir James Grierson, but when he died of a heart attack on 17 August he was replaced by General Sir Horace Smith-Dorrien who was not liked by French and who was prone to violent and uncontrollable outbursts of rage. Although the senior commanders of the BEF were therefore personally known to each other through years of service and social intercourse, and could be expected to work as a team, they also maintained personal animosities and jealousies towards each other which at times threatened to disrupt the operational direction of the BEF in the field. But all this was unknown to most officers and men, and to the public at large they were, as one newspaper described them, 'a happy band of brothers'.

The actual process of mobilisation was carried out efficiently and speedily. Reservists were called-up by telegram, arrived at depots where they were fitted out and underwent the same routine as the Regulars – medical inspections, inoculations, documentation, and the issue of weapons, equipment and clothing:

> The first draft of reservists from the Depot had arrived early in the morning, and further drafts kept arriving throughout the day. As they arrived they were told off to companies. Quite a few of them were South African War veterans, and on the whole they were a very useful lot of men. When they first arrived they looked a pretty sketchy lot, in their new uniforms all creased from being stored for years in the mobilisation store; in new boots – putty-coloured and as hard as nails; with their equipment hanging on them anyhow; and with long hair and in many cases beards![1]

In many units the war establishment was made up by forty per cent and in some cases sixty per cent of Reservists:

> On the evening of the third day of mobilisation, i.e., the 7th August, the whole Battalion, at full war strength, paraded at 5 pm, complete with mobilised transport. It was a marvellous sight, and a truly wonderful piece of organisation accomplished in three days. Imagine it – between 500 and 600 reservists collected from all over the country (though chiefly, of course, from the county of Northamptonshire), clothed, fully equipped, transported to Blackdown Camp, with clothing and equipment properly fitted, the transport brought up to war strength with new vehicles, harness and horses (most of which last-named had to be practically rebroken to do their work in a military style); in addition, the peace-time establishment of the Battalion reclothed and served out with their mobilisation kit. And all this had been carried out in three days.[2]

Although the Reservists had attended an annual inspection, actual mobilisation came as a shock, and for those softened by civil life it was a considerable physical effort to carry 60 lb of kit and break in an ill-fitting pair of ammunition boots from the stores. There was also a certain sense of unreality about mobilising for war for many Regular soldiers. Company Sergeant-Major Boreham of the 2nd Battalion Royal Welch Fusiliers remembered the pre-war planning:

> When first we got the pay-books and identity-discs, about two years before the War, we smiled at the idea of ever having to use them. Behind the Commanding Officer's table in the Orderly Room was the mobilisation chart – another smile. What an awful bore it was to listen to the King's Rules and Regulations relating to Active Service being read out each quarter! And when we had to make out family allotment forms the smile changed to a broad grin.[3]

The majority of Regular soldiers and Reservists were quite happy to go off to war and were not particularly concerned whether they fought the French or the Germans. Private F. A. Bolwell of the 1st Battalion Loyal North Lancashire Regiment remembered that:

> Being a Reservist, I was naturally called to the colours at the outbreak of war between England and Germany on August 4th 1914, so I downed tools; and although a married man with two children, I was only too pleased to be able to leave a more or less monotonous existence for something more exciting and adventurous. Being an old soldier, war was of course more or less ingrained into my nature, and during those few days before the final declaration I was at fever heat and longing to be away.[4]

For Corporal John Lucy of the 2nd Battalion Royal Irish Rifles:

> Events outside the army hardly concerned us at all. International Affairs were beyond the professional soldier. We were ignorant and uninterested until, at the end of the summer, the war-clouds gathered over Europe. Then there was no reasoning. Our job was to fight. We were well trained and willing to fight any foreigner, and we were delighted at the prospect of war and glory.[5]

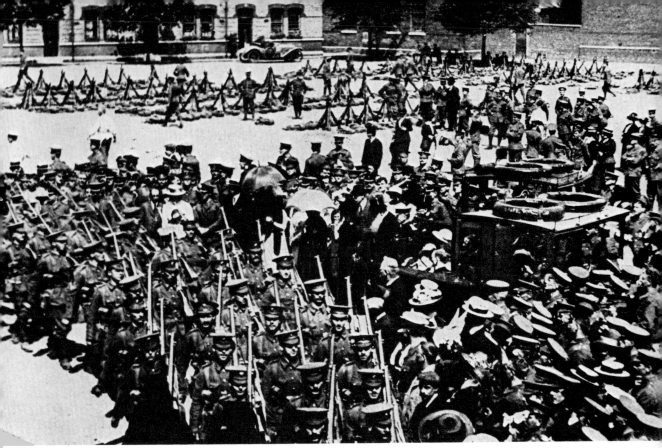

4. The First Battalion Grenadier Guards leave Chelsea Barracks watched by members of the Royal Family on 12 August 1914.

The younger officers were wild with enthusiasm and their only fear was that they might be left behind at the depot. Some of the older officers and non-commissioned officers were less enthusiastic because they remembered the less attractive side to active service from the South African War – dirt, lice and dysentery. Captain J. Jack 1st Battalion Cameronians (Scottish Rifles) was one such officer:

> All ranks are in high fettle at the prospect of active service. But hating bloodshed as I do, and having had a hard if not dangerous fifteen months in the South African War, together with many racing, hunting and polo accidents, I personally loathe the outlook. A queer soldier![6]

Many ambitious officers feared that if they were left behind on the Home Establishment they would miss the war which everyone seemed to agree would be over by Christmas. The need to find sufficient numbers of trained staff officers for the BEF and the rush to go on active service saw the closure of the Staff College and the emptying of the War Office, which left the Army Council with few experienced officers once the BEF had left for France.

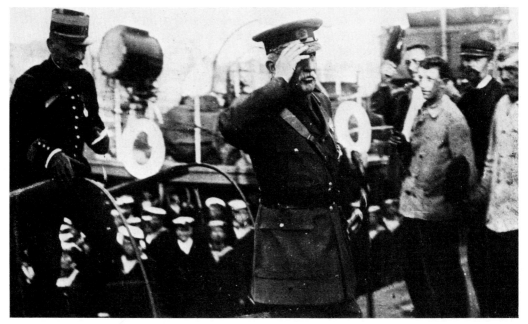

5. Field Marshal Sir John French, C-in-C of the BEF, leaving HMS *Sentinel* on arrival at Boulogne on 14 August 1914. Behind him is Colonel Huguet, Head of the French Military Mission at GHQ.

Hundreds of volunteers lobbied the War Office and military friends to get themselves attached to the BEF as chauffeurs, dispatch riders, ADCs and even valets. Meanwhile, the momentum of mobilisation continued. 120,000 horses were collected for the BEF in twelve days and the authorities requisitioned dozens of lorries, buses and motor cars to bring the mechanical transport up to strength. Advance parties of the BEF left for France on 7 August. As units of the BEF moved off to railway stations they were cheered by enthusiastic crowds. Major Lord Bernard Gordon-Lennox, a Company Commander in the 2nd Battalion Grenadier Guards, was in a pensive mood when the battalion left Chelsea Barracks on 12 August:

> A date that is easily remembered and the more so in this special case as we left Chelsea
> Barracks to embark for an unknown destination to take our part in the War and to help
> the brave Frenchmen and Belgians. Queen Alexandra, Princess Victoria and Princess
> Henry came to see us off from Barracks and we were all presented to the former before
> leaving.[7]

To get the BEF to the ports of embarkation required an elaborate railway timetable and careful planning. A division required eighty trains and in addition others had to be provided for stores and equipment. Between 12 and 17 August the main elements of the BEF were transported to France.

Field Marshal Sir John French and his staff crossed to Le Havre on 14 August. All troops in Britain embarked from Southampton, except those in Ireland who embarked from Dublin, Cork and Belfast. Motor transport and petrol went from Avonmouth, stores and

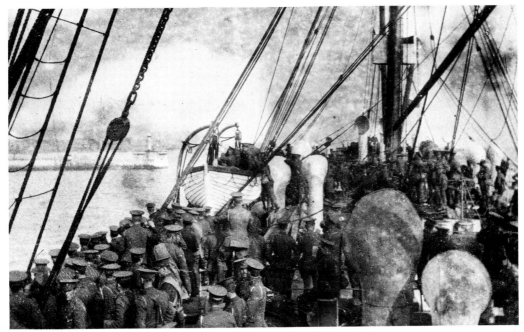

6. Crossing the Channel – the 11th Hussars in sight of Le Havre on 16 August 1914.

7. British Army officers cast a nonchalant eye over 'la belle France' from the side of their ship.

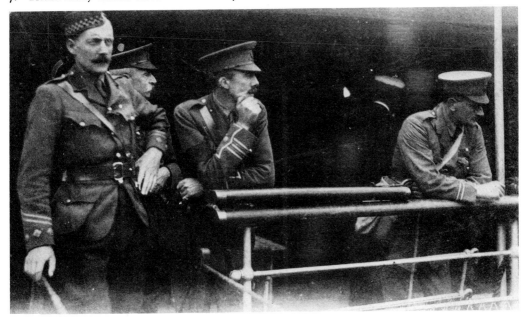

supplies from Newhaven and frozen meat and motor transport from Liverpool. The ports of disembarkation in France were Le Havre, Rouen and Boulogne. At first the ships were dispatched singly, both by day and night, and then in groups. The daily average of ships dispatched was thirteen, and throughout the whole period of movement not one member of the BEF lost his life through German naval action. The Royal Navy quietly and efficiently guaranteed the integrity of the Channel.

After a packed and uncomfortable crossing the troops saw their first glimpses of the French coast:

> We kept on slowly and as we neared the French coast we went close by several fishing boats and trawlers, the crews of which waved frantically at us and cheered us to the echo. We responded by singing the Marseillaise, which caused a continual ' 'eep, 'eep, 'ooray' in return. I have no doubt that we shall hear several more ' 'eep 'eeps.'[8]

Before the embarkation of the BEF a stern message from Lord Kitchener had been pasted inside every soldier's pay-book. Referring to military operations on the Continent Lord Kitchener's message read:

> In this new experience you may find temptations, both in wine and women. You must entirely resist both temptations, and while treating all women with perfect courtesy you should avoid any intimacy. Do your duty bravely. Fear God. Honour the King.

8. Following Lord Kitchener's advice – soldiers of the BEF being 'courteous' to French ladies at Boulogne.

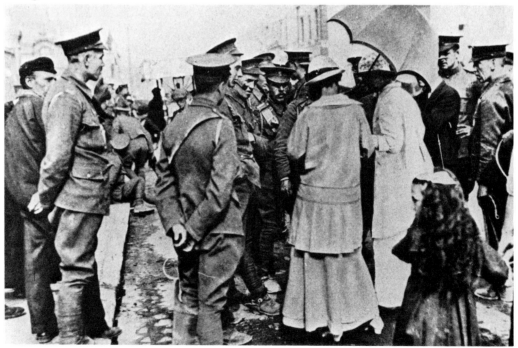

9. French civilians welcome the Scottish Rifles at the rest camp at Le Havre on 16 August 1914.

On arrival in France the soldiers of the BEF were met with wild enthusiasm which often made it difficult to observe Lord Kitchener's instructions. This enthusiasm was partly a sense of relief, for the French had feared that the British would not honour their commitment. After the tedious business of disembarkation, battalions marched through the town to their camps:

> With the sun on our backs and no air, everyone felt the heat very much, and the men started falling out, a few at first and then more. The inhabitants in their kindness were responsible for a good lot of this, as they persisted in giving the men drinks, among which was a very acrid form of cider, which had dire results. I have never seen march discipline so lax before, and I hope I never shall again.[9]

On the line of march they were also deluged with flowers and kisses. Demands for souvenirs meant that by the end of the route march few soldiers still had their cap badges or shoulder titles. The only French soldiers seen by the BEF at the disembarkation ports were elderly French reservists who scarcely impressed them with their soldierly bearing, but what the British did not then realise was that nearly every young man of military age was either at the front or being trained in the depots. When the soldiers were finally let out of their camps in small parties they did not always treat the local French people with proper respect, as many old soldiers looked upon them as yet another type of native:

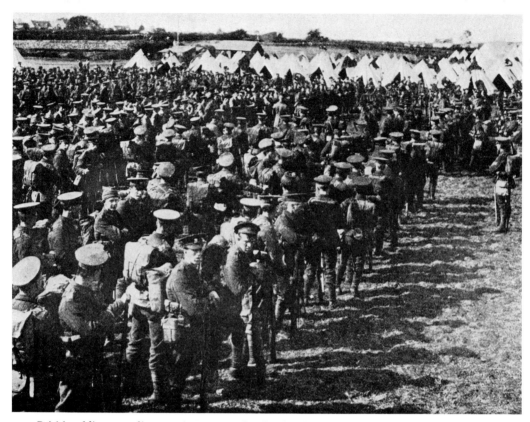

10. British soldiers parading at a base camp shortly after landing in France.

> Billy and I went out the following evening and called in a café. The landlord was very busy, the place being full of our chaps. Billy used to boast that no matter what new country he went to he could always make the natives understand what he required. He ordered a bottle of red wine, speaking in English, Hindustani and Chinese, with one French word to help him out. The landlord did not understand him, and Billy cursed him in good Hindustani and told him he did not understand his own language, threatening to knock hell out of him if he did not hurry up with the wine.[10]

Nor were some of the British soldiers fully appreciative in the traditional sense of the cultural heritage of France:

> Stevens and I visited the cathedral and we were very much taken up with the beautiful oil paintings and other objects of art inside. One old soldier who paid it a visit said it would be a fine place to loot.[11]

Whilst the BEF was disembarking, Sir John French and his staff were meeting the French Minister of War and then General Joffre, the French C-in-C, and General

12

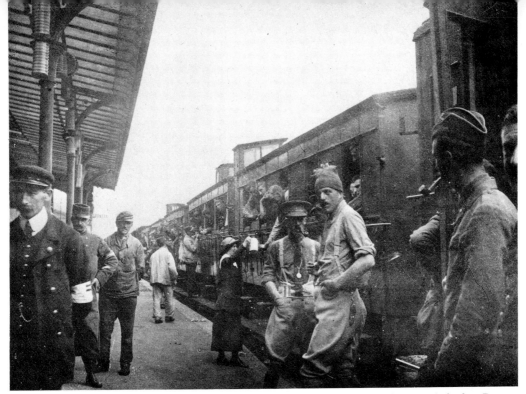

11. Tea and wads – the train carrying the 11th Hussars to the concentration area halted at Rouen station on 18 August 1914.

Lanrezac who commanded the Fifth Army which was concentrating south of Charleroi. The objective of the BEF was to move north and take up a position on the left flank of the Fifth Army in order to participate in an advance into Belgium where the Germans were being delayed by the Belgian forts and army. From 14 August units of the BEF began to move up by train, often in closed carriages and trucks stencilled '*Hommes 40, Chevaux 8*', to the area of concentration between Maubeuge and Le Cateau. Despite the lack of sleep, the train journey for the soldiers of the BEF was full of excitement with French crowds to cheer them at every railway station:

> All along the line, and at every station we stopped at were crowds of men, women and children all shouting and cheering 'Vivent les braves Anglais!' 'Vive l'Angleterre!' 'A bas les Boches!' – the latter accompanied by graphic gestures of cutting the throat! They thrust bread, cakes, fruit, chocolate, wine, flowers etc., on all, officers and men alike. At Arras a band and the Maire and a large number of other official townspeople were drawn up and the Maire made a long and impassioned speech of welcome to the Colonel and presented him with an enormous bouquet of flowers![12]

Although the British soldiers were rather touched by this enthusiasm they also felt overwhelmed:

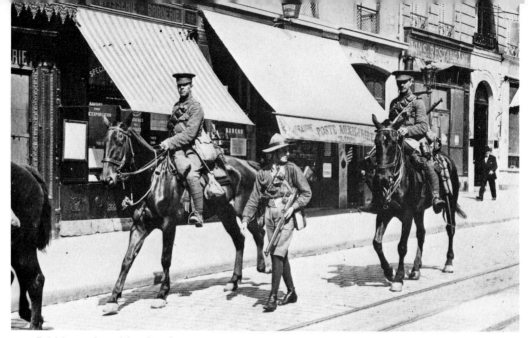

12. British cavalry with a Boy Scout pass through a French town, August 1914.

13. 'Stand Easy' for British troops in the area of concentration in northern France.

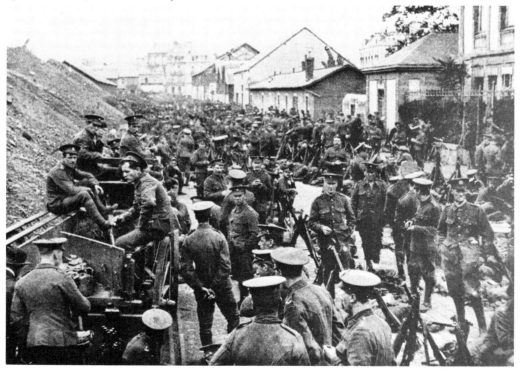

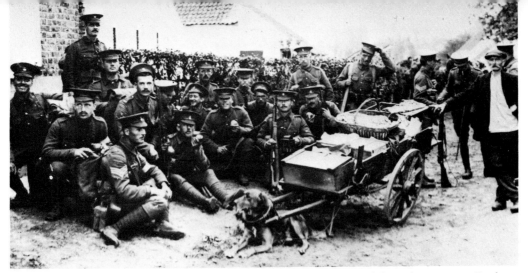

14. Soldiers of the Royal Welch Fusiliers resting by the roadside in Belgium, August 1914. In the foreground is a travelling Belgian fruit seller with his dog-cart.

> These French civilians were too excitable by far, and rather upsetting. Had we given
> them all they demanded as souvenirs we should have eventually fought naked at Mons,
> armed only with flowers and bon-bons.[13]

The concentration of the BEF was virtually complete by 20 August as the corps and divisions sorted themselves out. On the previous day British GHQ were informed that the 4th Division was also to be dispatched to the BEF immediately.

After they had arrived in their concentration area Commanding Officers of infantry battalions were particularly anxious to exercise their men in route marching:

> Went for a ten-mile route march in the morning, through Tupigny and back by Verly.
> The weather was hot, and the country hilly, so it was rather a test for unfit men. The
> reservists are certainly marching better than they were doing at Aldershot, but 6 fell out
> unconscious, to the heat and the unaccustomed pack.[14]

A number of officers were concerned that there should be no relaxing of discipline just because their soldiers were on active service. Indeed there appeared to be differing standards even amongst the Guards as Major Jeffreys of the Grenadiers noted:

> The 2nd Battalion Coldstream are also billeted in Grougis. They have told their men
> that now they are on Active Service they need not salute – a very bad beginning by
> slackening discipline, we think – and have told our men to be extra particular to salute
> Coldstream officers.[15]

All the units of the BEF now began to sort out their weapons, equipment and transport in preparation for a rapid forward deployment. During the period in which the BEF had been mobilised and transported to France, great events had been unfolding. Both the German and the French put into operation plans that had been prepared several years earlier and in which the BEF was to play a small but significant part.

2
Rival Plans and Armies

Henry Wilson: 'What would you say was the smallest British
force that would be of any practical assistance to
you in the event of a contest such as we have
been considering?'
Ferdinand Foch: 'A single private soldier, and we would take care
that he was killed.'

1909

In the decade before 1914 Europe had become divided into two armed camps. The
rivalries of the Great Powers had forced them to look for allies and prepare for a future
war. War indeed was possible over a variety of issues, and in particular, the question of the
instability of the Balkans, where Austria-Hungary and Russia competed for power and
influence. The Germans had entered into an alliance with Austria-Hungary with the
Italians loosely associated. The French and the Russians had also entered into an alliance,
with the objective of containing German power. The British had slowly been drawn into
the Franco-Russian alliance because of Germany's ambitions in Europe and overseas which
appeared to threaten the British Empire. But the British commitment to assist the French
in the event of war with Germany was not clearly defined beyond military staff talks and
secret understandings.

The problem for the Germans was that in the event of war they faced powerful enemies
on both their western and eastern frontiers whose combined forces were far greater than
those of Germany and her ally Austria-Hungary. The plan they adopted had been
conceived by von Schlieffen, Chief of the German General Staff from 1890 to 1905. He
calculated that Germany's greatest danger came from France which could mobilise
quickly. Since the Russian mobilisation scheme would take several weeks, this provided a
breathing space before any offensive could begin in the east. Germany, therefore, had to
launch a rapid offensive against France while holding the Russians back with a small
screening force. But there were great natural and artificial barriers along the French
frontier which, combined with the French Armies, made the chance of a surprise attack
being successful very unlikely. Schlieffen, however, planned to circumvent this by a wide
manoeuvre through Belgium which would sweep west parallel to the Channel coast before

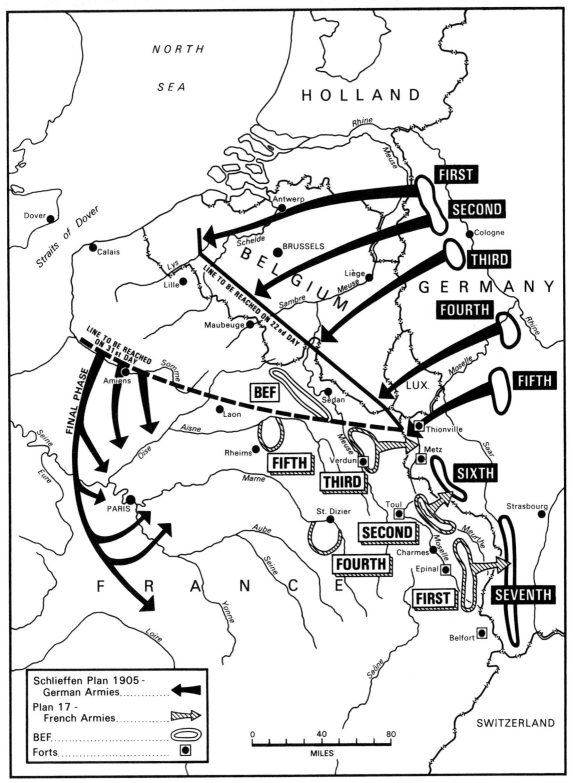

NORTH

SEA

HOLLAND

Rhine

Meuse

FIRST

SECOND

Cologne

THIRD

Dover

Straits of Dover

Calais

Antwerp

Schelde

B E L G I U M

BRUSSELS

Liège

Meuse

Sambre

G E R M A N Y

FOURTH

Rhine

Moselle

FIFTH

LUX.

Lille

Lys

LINE TO BE REACHED ON 22nd DAY

Maubeuge

LINE TO BE REACHED ON 31st DAY

Somme

Amiens

FINAL PHASE

BEF

Laon

Sedan

Thionville

Metz

Saar

Aisne

Oise

Rheims

Verdun

FIFTH

SIXTH

Eure

Seine

Marne

THIRD

Toul

Strasbourg

PARIS

St. Dizier

SECOND

Charmes

Moselle

Meurthe

Aube

FOURTH

Epinal

F R A N C E

Seine

Yonne

FIRST

SEVENTH

Loire

Belfort

Saône

SWITZERLAND

Schlieffen Plan 1905 -
German Armies...............

Plan 17 -
French Armies...............

BEF.................................

Forts.................................

0 40 80

MILES

1. Rival war plans.

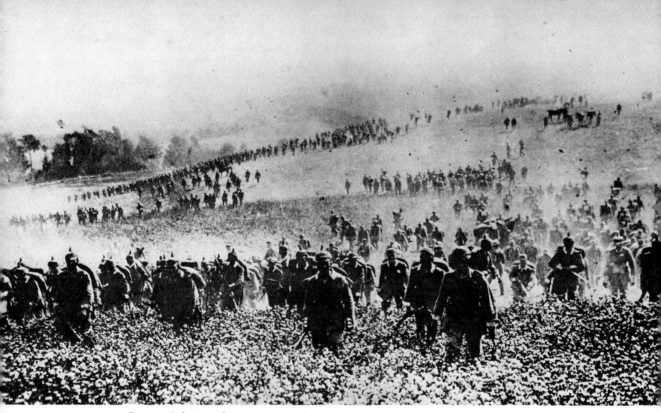

15. German infantry advance en masse in pre-war manoeuvres.

encircling Paris and enveloping the French Army against the German frontier positions in a nutcracker movement. Schlieffen had realised that by violating Belgian neutrality he might provoke the British into entering the conflict on the French side, but he was prepared for Britain to send an Expeditionary Force to northern France.

Schlieffen's plan was a gamble. The Germans had to take a calculated risk by leaving only one Army to defend East Prussia against the Russians. Of the seven Armies allocated to the west the majority were placed in the north to form the great envelopment movement through Belgium and northern France. Further south German forces would be outnumbered by the main French Army. The Schlieffen plan was only feasible if the Germans mobilised all their trained manpower and used their reserve formations as first-line troops. A great deal would depend upon the organisation, training and morale of the German Army.

The approximate mobilisable strength of the German Army in 1914, including reserves, was 5,020,700. Every physically fit man was liable for military service between the ages of seventeen and forty-five. The object of the system was to produce a huge reserve by which the active army could rapidly be expanded in war. In theory the German Army was commanded by the Kaiser, but in practice it was commanded by the Chief of the General Staff, Colonel-General von Moltke. Real command and responsibility lay in the hands of the commanders of higher formations and the officers of the General Staff. The German

Army in 1914 was a peace trained army, with only a few of its senior officers having seen service in the Franco-Prussian War of 1870–71. Some German soldiers had seen service overseas in Africa and China, and the Germans had sent military observers to the South African, Russo-Japanese and Balkan Wars. The German Army based its military operations on the enveloping movement. This involved moving in a crescent formation, so that whilst the enemy was held in the centre by a frontal attack, overlapping and encircling attacks could be made from either flank. The infantry were trained to attack in dense waves for shock effect, at intervals of about 500 yards, whilst the artillery and machine guns provided close fire support. The strength of the German Army lay in its 100,000 non-commissioned officers, its draconian discipline and the unquestioning obedience of its soldiers. Its weakness lay in its rigidity to orders and its lack of recent military experience.

For many Frenchmen before 1914, national policy was directed towards preparing for the inevitable war of revenge against Germany for the defeats of 1870–71 and the loss of the provinces of Alsace and Lorraine. Initially, the French plan after 1871 had been defensive, relying upon frontier fortresses and a decisive counter-attack. But in the decade before 1914 a new school of thought argued for the offensive whatever the circumstances. This became embodied in the new French War Plan XVII. The French created great fortified regions along the border with Germany from Switzerland to the Belgian frontier. They planned to concentrate their five armies along the frontier south of the Somme and to seize the initiative from the outset by attacking into Alsace and Lorraine. If the Germans decided to violate Belgian neutrality, then the two northern French Armies, the Fifth and the Fourth, could strike a German envelopment in the flank. No provision was made to meet a German envelopment carried out through Belgium west of the Meuse, or to cover the gap between the western flank of the Fifth Army and the sea. In staff conversations with the British the French had agreed that if the British sent an Expeditionary Force to the Continent it could be most usefully and conveniently concentrated on the left flank of the Fifth Army. Between the Fifth Army and the sea the French had only a few Territorial troops and some old fortresses. Not only did the French General Staff believe that the Germans would attack further south than they intended, they also seriously underestimated the number of divisions the Germans would use in the front line. To overcome their numerical disadvantage the French were relying upon the Russians mobilising and launching an offensive into East Prussia sooner than the Germans were expecting and thus diverting German forces from the west. So the French Plan XVII fitted in perfectly with the objectives of the Schlieffen Plan, whilst the proposed concentration of a British Expeditionary Force on the left flank of the French Armies would place it directly in front of the line of the German envelopment.

When mobilised the French Army had a strength of 1,071,000 men, which rose to 3,683,000 if the surplus reservists and Territorials were included. This still meant that the French would be outnumbered by the Germans at nearly 2:1. All Frenchmen were liable to serve with the colours for three years. But after that the amount of reserve training was extremely limited in comparison with the Germans. In the event of war, General Joffre would assume control of the French Armies as Commander-in-Chief with General Belin as Chief of Staff.

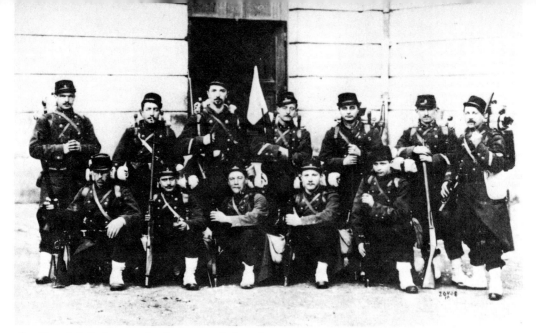

16. French infantry pose for the camera before the war.
17. French Hussars canter through a town with an airship overhead during Army manoeuvres in 1912.

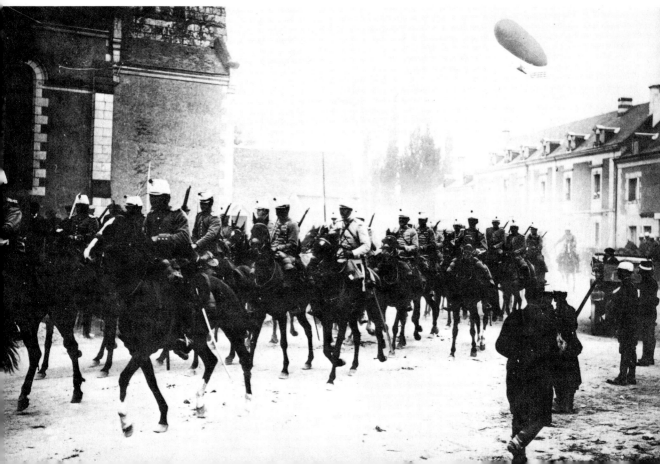

The French Army had more recent military experience than the German Army, as many of the officers and Regular soldiers had seen service in the colonies. Even so French tactical doctrine was far removed from the realities of the modern battlefield. The advocates of the offensive spirit in the French Army believed that élan was proof against bullets, and that the success of French arms under Napoleon had been due more to spiritual than physical factors. The French soldier was imbued with a sense of his moral superiority over the German and this reinforced his national pride which smarted under the defeats of 1870–71. Strategically as well as tactically the French Army planned for an immediate offensive whatever the circumstances.

Despite the fact that Belgium's independence and neutrality was guaranteed by the Great Powers, successive Belgian governments had made defensive preparations to protect their national integrity. From 1912 it was compulsory for all Belgian youths to serve with the colours and then serve with the reserve. In 1914 the Belgian Army consisted of a Field Army organised in six divisions and a cavalry division with the total strength of some 117,000 men. There were also in theory some 130,000 troops to garrison the fortresses. These fortresses were at Antwerp, Liège and Namur, and each of these towns had a girdle of forts some two miles out, built before the turn of the century. Liège and Namur were barrier forts on the Meuse, whilst Antwerp was the great rallying citadel for the Belgian Army and the civil population in the event of invasion by a powerful enemy. None of these fortresses could be defended à outrance, but depended upon field troops to garrison them properly. Finally, there were some 70,000 men of the Garde Civique, a volunteer force of a Home Guard nature.

The six divisions of the Belgian Army were stationed in peace so that they could quickly confront any enemy at short notice. Thus the 1st Division at Ghent faced Britain, the 2nd Division at Antwerp, Holland, the 3rd Division at Liège, Germany, the 4th Division at Namur and the 5th at Mons, France, whilst the 6th Division protected Brussels. Not only was the Belgian Army being reorganised in 1914 but the ordinary peace footing only required part of the recruit contingents to be with the colours, so that mobilisation meant recalling men on unlimited leave as well as reservists. The Belgian Army was under-equipped and inadequately armed, and with its ill-fitting blue uniforms and kepis appeared a poor version of the French Army. Under these circumstances, the Belgian Army was to acquit itself very well under the inspired leadership of King Albert.

Following the end of the South African War in 1902, successive British governments became increasingly aware of the fact that their main economic and military rival was Germany. Slowly British strategic perceptions moved away from considering their most likely threat to be Russian aggression against India and towards considering German aggressive intentions in Europe and overseas. British interests became more closely associated with French and Russian interests and a new understanding, an 'entente cordiale', was established with France in 1904. Concurrently with the political understanding a military understanding was established with France. As early as 1905 the War Office examined the possibility of British military support of Belgium in the event of Germany infringing her neutrality in an attack on France. Early in 1906 Richard Haldane, the new Liberal Secretary of State for War, gave permission to Major-General Grierson, the Director of Military Operations, to carry out unofficial staff conversations with the

French General Staff concerning possible co-operation in a future war against Germany. These talks continued over the next few years, but it was not until 1911 that the British Cabinet learnt collectively about what had been taking place.

From 1911 onwards the British and French General Staffs worked out in detail a scheme for the landing of a British Expeditionary Force in France, and for its concentration on the left flank of the French Armies around Maubeuge and Le Cateau. But there was no formal obligation by the British government to send the whole or any part of an Expeditionary Force to any particular point, or in fact to send it at all. Nevertheless, much of the military reorganisation of the British Army before 1914 was undertaken in order to provide for a continental Expeditionary Force. Major-General Henry Wilson, Director of Military Operations from 1910 to 1914, became obsessed with the idea of preparing for a future war against Germany and was a staunch francophile who worked closely with General Foch, an advocate of the offensive school of thought in the French Army. Despite French fears that the British had made no formal commitment to send an Expeditionary Force there were really no credible alternative military options open to a British government once the political decision had been made to fight Germany in August 1914.

The decade before 1914 had been a period of reform and reorganisation for the British Army. The South African War had shown that the British Army lacked the essential central organisation to provide sufficient military forces for service overseas. The Regular Army had been too small, and even the Reserves were understrength. Manpower had had to be provided by the Militia, Yeomanry and Volunteers, and finally from the Dominions and the Colonies. Apart from the organisation of the Army, the Command and Staff had been found inadequate, and there was an urgent need for better tactical training for soldiers.

In February 1904, the office of Commander-in-Chief was abolished and an Army Council was set up. This gave the Secretary of State for War a board of six advisers, four professional soldiers and two civilians. In 1905 it was agreed to constitute a General Staff whose function initially was to be primarily administrative but Richard Haldane enlarged its role and encouraged many of the ablest British officers to think widely about their profession. Special care was taken to separate the work of the General Staff as a department concerned with strategy and training, from that of the old Headquarters Staff, whose duties were purely administrative. The necessary training for officers of the Staff was undertaken at the Staff College, Camberley, and at the Indian Staff College, Quetta. Many senior British Army officers – such as Haig, Wilson, Rawlinson and Robertson – who were to help Haldane with his reforms were products of the Staff College of the 1890's, and they in turn influenced a younger generation of Staff officers after the South African War who were to hold responsible command and staff jobs with the BEF in 1914.

Given the increasing likelihood of a British continental military commitment, Haldane faced the problem of reorganising the existing military forces so as to increase their efficiency and provide for their rapid expansion during a period of crisis, and yet at the same time save money. Haldane had to work within the existing system which provided recruits for the Regular Army. Terms of service for the Regular Army were based on a voluntary system, and recruits were required to be between the ages of eighteen and twenty-five and to be medically fit. The majority of cavalry, infantry and artillery served

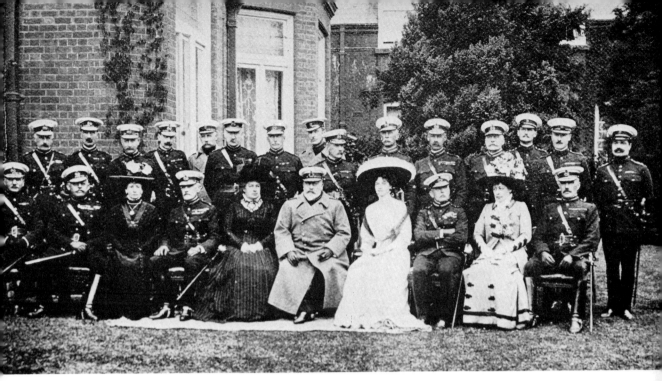

18. King Edward VII and senior British Army officers at Aldershot, May 1909. Commands indicated were those held in the BEF in 1914. Back row standing: Major-General H. M. Lawson; Brigadier-General C. T. McM. Kavanagh (GOC 7th Cavalry Brigade); Brigadier-General C. J. Mackenzie (GOC 3rd Division); Brigadier-General David Henderson (GOC RFC); Lieutenant-Colonel G. L. Holford; Major-General Sir Thomas Gallwey; Brigadier-General Sir Charles Fergusson (GOC 5th Division); Colonel Sir Arthur Davidson; Brigadier-General P. T. Buston; Brigadier-General F. Hammersley; Brigadier-General Sir Henry Rawlinson (GOC IV Corps); Brigadier-General The Hon. A. Henniker; Captain B. G. V. Way; Captain Clive Wigram; Lieutenant The Hon. M. V. B. Brett. Front row sitting: Major-General T. E. Stephenson; Major-General J. M. Grierson (GOC II Corps); Mrs Robertson; Lieutenant-General Sir Horace Smith-Dorrien (GOC II Corps); Mrs Stephenson; King Edward VII; Lady Smith-Dorrien; General Sir John French (C-in-C BEF); Lady Gallwey; Brigadier-General W. R. Robertson (QMG BEF).

for seven years with the colours and five with the reserve. Enlistment in the Army Service Corps was for three years with the colours and five with the reserve. Soldiers of good character who had completed eleven years service could re-engage to a limit of twenty-one years. After the experiences of the South African War, however, it was inconceivable that the existing system of a volunteer Regular Army with inadequate reserves including the Militia and the Volunteers could meet Haldane's requirements. In the military reorganisation of 1908 the objective was to provide the machinery and manpower to meet the requirements of Home Defence, Colonial garrisons and provide for an Expeditionary Force.

In the Regular Army the infantry was still organised along the lines laid down in the 1870's, with regiments affiliated to counties and boroughs, and with an average of two

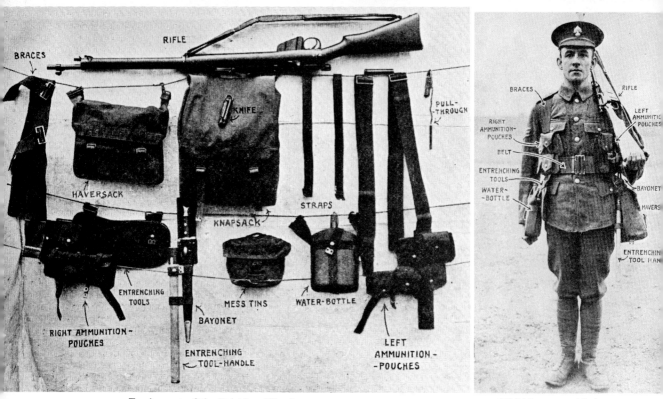

19. Equipment of the British soldier in 1914.

20. Webbing assembled on the soldier.

battalions to each regiment, so that for every battalion abroad at least one remained at home. In practice, after 1908, this meant that eighty-four infantry battalions remained at home, whilst seventy-three served abroad. The problem was that the Home Service battalions were always understrength having to feed the overseas battalions with trained recruits. Many of the soldiers in the Home Service battalions were either very young recruits or old soldiers about to be time-expired. To bring the Home Service battalions up to war establishment meant that sufficient reserves had to be available and the means to mobilise and equip them had to be effective. Similarly, the three Household and twenty-five line Cavalry regiments were reorganised to act as mounted infantry in addition to their traditional role as the *arme blanche*; and the artillery was reorganised so that the number of batteries which could be mobilised for war was increased from forty-two to eighty-one. Transport and medical services were similarly reorganised to meet the new roles demanded of them under the Haldane reforms, while in 1912 the Royal Flying Corps was established with eventually seven squadrons of aircraft.

The Home Service units of the Regular Army and the Reserves were organised into an Expeditionary Force consisting of six divisions of all arms and one cavalry division. The six divisions consisted each of three infantry brigades, each of four battalions, with additional divisional mounted troops, artillery, engineers, signal troops, supply and transport train and field ambulances. The total war establishment of each division was

24

some 18,000 men, of whom 12,000 were infantry with twenty-four machine guns, and 4,000 artillery with seventy-six guns, consisting of fifty-four 18-pdrs, eighteen 4.5-inch howitzers, and four 60-pdrs. An infantry battalion at war establishment consisted of thirty officers and 977 other ranks with two machine guns. Officers were armed with a pistol and could carry swords, whilst other ranks were issued with the new Short Lee Enfield Rifle. A field artillery battery of 18-pdrs consisted of five officers and 193 other ranks. The Cavalry Division consisted of four brigades of three cavalry regiments each, with divisional horse artillery, engineers, signal service and medical troops. The war establishment of the Cavalry Division was 9,000 soldiers and 10,000 horses, with twenty-four 13-pdrs and twenty-four machine guns. It was originally intended not to have any formation between General Headquarters and the six divisions, although the nucleus of one corps staff was maintained in peacetime at Aldershot.

Haldane was also determined to reorganise the Militia and Volunteers so that they could provide proper support for the Regular Army either by taking over the duties of Home Defence or by volunteering for service overseas. The old Militia was renamed the Special Reserve and became a means to supply quickly extra trained manpower for the Regular Army. After considerable opposition from local vested interests Haldane created the Territorial Force out of the Volunteers, whose establishment was some 300,000 strong and was organised upon the same lines as the Regular Army. The infantry battalions of the Territorial Force either provided additional battalions to the Regular battalions of an infantry regiment or they formed separate Territorial Force regiments. The Territorial Force also provided artillery, engineers, supply, transport and medical units, and with the infantry battalions these were organised into fourteen divisions each commanded by a major-general of the Regular Army with a small Regular staff. The Yeomanry became the second line to the cavalry and were reorganised into fourteen brigades. Units were expected to be fit for war service after six months continuous training following mobilisation. There was no liability for foreign service, but it was expected that the Territorial Force would reinforce the Regular Army, either by individual units or by complete divisions as they became ready. Despite Haldane's reorganisation of the Territorial Force it was below its establishment in 1914 and rather indifferently armed and equipped as priority was given to the Regular Army. The infantry was armed with the Long Lee Enfield Rifle with the short bayonet which the Regular Army had discarded in 1908. The artillery was armed with South African War guns converted for quick-firing, such as the 4.7-inch, 5-inch howitzers and 15-pdrs. Quite unfairly, the majority of Regulars viewed the Territorials with the traditional disdain of the professional soldier for the amateur.

In theory both the Regular Army and the Territorial Force had a standardised uniform by 1914. For other ranks the khaki service dress was very similar between units, although headdress varied. There was only one pattern of tunic and trousers, and two greatcoats. Officers' uniforms were privately made and rather varied in detail and materials used. The basic headdress for English, Irish and Welsh troops was the khaki service cap with the matching peak and brown leather chin strap, with metal badge at the front. Highlanders wore the Glengarry or tam o' shanter instead of the service cap, doublet instead of tunic, and either kilt with khaki apron, or pantaloons and puttees for Lowland Regiments. Rank

25

21. Colonial campaigning – British troops on manoeuvres near Quetta, India, 1911.

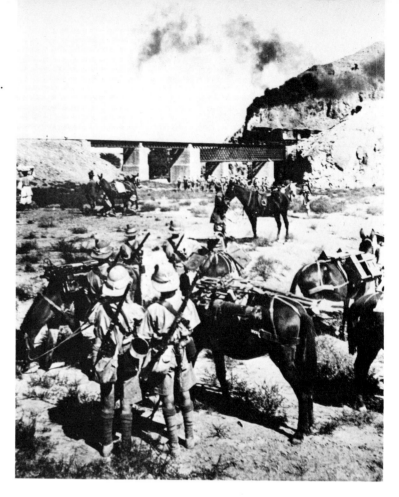

badges for officers were worn on each cuff, except for officers of the Guards and Household Cavalry who wore them on their shoulder straps. The Royal Flying Corps had a special khaki service dress, the tunic of which was known as the 'maternity' jacket. But officers attached to the RFC continued to wear regimental uniform.

It was hoped that, in the event of war in Europe, the British government would be able to withdraw Regular units from overseas who could either be replaced by Dominion and colonial troops or by units of the Territorial Force. One of the largest military forces in the British Empire was the Indian Army which underwent a similar reorganisation as the British Army after the South African War. In 1913 the Government of India reluctantly agreed that the British government might count upon the assistance of two divisions and one cavalry brigade in the event of a European war.

In addition to the physical reorganisation of the British Army, a considerable effort was made to work out the details of mobilisation in the event of war. A War book was compiled which laid down procedures to be followed in the process of mobilisation, and essential documents were prepared in advance. Negotiations had to be conducted with the private

railway companies and shipping lines to prepare the necessary plans and to ensure the smooth transportation and concentration of the Expeditionary Force in the event of war. These plans assumed that the Expeditionary Force would be sent to France.

In many respects the Expeditionary Force of 1914 was the best organised, best trained and best equipped that the British Army had ever sent to war. But it had a number of serious defects. Haldane's reforms had only been initiated in the decade before 1914 and this allowed little time for the necessary changes to be completed and accepted by the Army. The reorganisation of the Regular Army and the creation of the Territorial Force had also to be achieved in the face of financial stringency. The organisation of the Expeditionary Force was very much a paper exercise at the higher level as it was difficult to concentrate units above brigade level in peacetime. Although mobilisation was practised frequently, and every winter certain units were brought up to war establishment, the Reservists and horses required to complete them had to be represented by men and animals from other units. Given the fact that the demands of colonial garrisons had priority and that recruits came in at all times of the year it was almost impossible to practise a full mobilisation of the Expeditionary Force. Although individual officers had been told of their probable appointments in the Expeditionary Force in the event of war, there was a shortage of staff officers which would only be remedied on mobilisation. The lack of any organisation at a higher level was a traditional weakness of the British Army which preferred ad hoc arrangements and placed too great an emphasis on the regimental structure.

Although the British Army had a wide experience of campaigning at a great distance from its bases over difficult terrain and had learnt to appreciate the importance of logistics and communications, the arrangements for supply and transportation for the Expeditionary Force were inadequate. To support the Expeditionary Force, pre-war plans provided for the establishment of supply lines from the main bases at French ports to the operational army in the field. Trains would carry the supplies as far forward as possible and then transportation would consist of mobile columns working between the railheads and field forces. In 1912, the divisional transport had been separated from the regimental transport. Despite the addition of motorised vehicles to the divisional transport, the majority of the transport of the Expeditionary Force consisted of horse and mule drawn wagons. These required strict march discipline and good organisation, and in the event of either a speedy advance or a chaotic retreat, good co-ordination. The transport of the Expeditionary Force was inadequate to fulfil its functions and there were serious problems over co-ordination given competing authorities, and the fact that the British Army's communications were in a state of transition in 1914.

The South African War had also revealed serious weaknesses in the Army's combined training and an almost total lack of individual training. The Boers proved themselves better at field craft and marksmanship than the British Regulars and these lessons were painfully learnt and remembered. After the war the Army prepared a series of handbooks on tactical training and doctrine which drew together the lessons learnt and laid down general principles. By 1909, the most important manual was the revised *Field Service Regulations: Part I (Operations)*. This manual, along with other training handbooks, was the main guide for the Army on tactics. The problem was that as the South African War

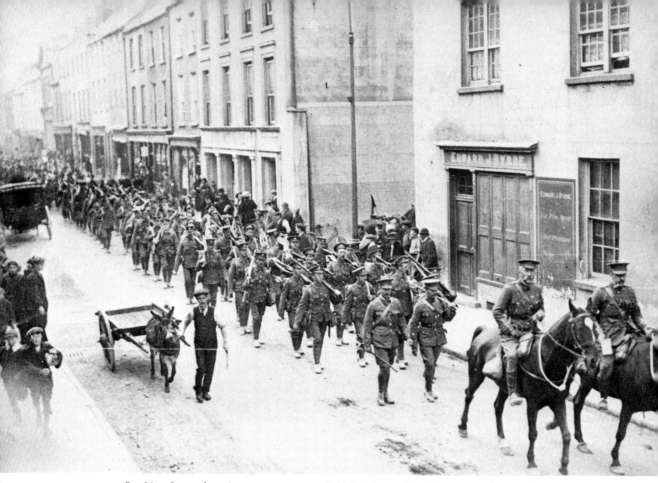

22. Looking forward to the wet canteen – a British infantry battalion passes through Curragh at the end of a route march.

receded in the minds of the Army it became possible for theoretical doctrine to outweigh practical experience. In 1902 the Army had rightly laid stress on the devastating impact of firepower on the modern battlefield and an emphasis was placed on tactical skill and caution in the offensive and the strength of the defensive. By 1909 greater stress was placed on the need to take the offensive and to engage the enemy, with a new belief in the importance of will power, and less attention was given to the problems of moving across hostile terrain in the face of modern firepower.

A regular annual routine of training was carried through usually beginning in the winter with individual training including the use of arms, route marching, bayonet fighting, scouting and signalling, culminating in platoon and troop exercises. In the spring training was by squadrons, companies and batteries, followed by cavalry regiments, infantry battalions and artillery brigades, and then brigade and divisional exercises, finishing with the army manoeuvres in the autumn. There were difficulties, however, in achieving realistic training. In Home Service units, many of the soldiers were hardly more than

23. A meeting of umpires – British Army manoeuvres, 1913. The officer third from the right is Lieutenant-General Sir Archibald Murray, who was Chief of Staff to the BEF in 1914 and suffered a nervous collapse during the retreat from Mons. The tall officer gesticulating in the centre is Major-General Henry Wilson, who was sub-Chief of Staff to the BEF in 1914 and who had been responsible for the pre-war staff conversations with the French.

recruits and there were insufficient numbers at every level of command. The Army had innumerable problems in finding large enough areas outside the usual training areas to practise training for formations above brigade level. It was extremely difficult to put any degree of realism into peacetime training. Commanding officers were uncertain whether their next tour of duty might not be in Africa, India, China or mobilised for a European war. There was a reluctance to use field entrenchments and to take into account the effect of modern firepower, particularly quick-firing guns and machine guns. Infantry, artillery and cavalry all too often operated in large formations in open country defying the lessons of South Africa. In heavy guns, howitzers, high explosive shells, trench mortars, hand grenades and much of the equipment needed for prolonged trench warfare or siege warfare, the British Army was almost totally deficient. This was due to a combination of factors. Financial stringency forced the Army to make choices over priorities, and there were genuine as well as petty disagreements between the cavalry, infantry and artillery over such priorities. The British Army did not expect to have to fight the kind of war which required the weapons and equipment associated with prolonged trench or siege warfare. The main British military experience in the nineteenth century had been colonial campaigning, which basically required different training, weapons and equipment to an as yet hypothetical European war. The British Army learnt many lessons from the South African War, and closely observed the Russo-Japanese and Balkan Wars, but often contradictory evidence emerged over whether firepower assisted the attacker or defender, over the place and role of the machine gun and the future of cavalry.

The British Army was less extreme in its views on the necessity at all times for offensive action than either the German or French Armies. The core of tactical training in the British Army before 1914 was preparing the infantry and artillery to work together for the attack and counter-attack. For the infantry this meant developing the combination of fire

24. Advance to contact – British infantry move across country with field officers mounted on horses during the Army manoeuvres in 1913.

25. Royal Horse Artillery 13-pdrs practise giving direct fire support to British infantry during Army manoeuvres in Ireland in 1913.

26. Cavalry machine gunners in action under the watchful eyes of umpires and officers' wives during Army manoeuvres in 1913.

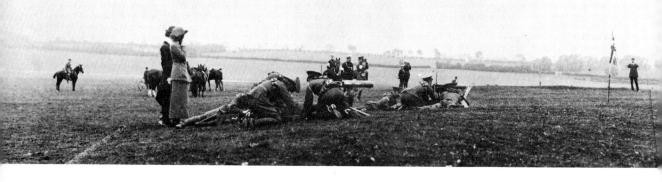

and movement. Once the enemy had been located and a decision made how and where to attack, the enemy was approached by platoons, companies or even battalions under cover of the fire of the remainder and of the artillery which usually deployed in the open. The infantry advanced in small parties spread out in wide intervals, or in a diamond formation. A strong firing line was then built up within 200 yards of the enemy, which would be reinforced by reserves so as to increase the volume of firepower. When fire superiority had been achieved, a bayonet assault would be delivered. Considerable emphasis was placed on the psychological and physical value of the bayonet. Machine guns were seen as providing additional firepower in the firing line, but were often viewed as an encumbrance during exercises. In 1909, the School of Musketry at Hythe had suggested that each battalion should have six machine guns instead of two, but this was refused on financial grounds. The lessons of the Boer marksmanship combined with the shortage of machine guns meant that the Army placed great emphasis on musketry training for soldiers with the objective of producing accuracy and volume of firepower. Communications on the battlefield were difficult and this meant that commanders at all levels had to be close to the firing line to maintain tactical control. Training for tactical defence in the field was practised and also the defensive preparations for buildings. But digging field entrenchments was not popular on exercises and some senior officers believed it sapped the offensive spirit of the troops.

The role of cavalry was that of reconnaissance, protection and pursuit. Cavalry formed a screen in front of the advancing army and reported the movements of the enemy. They could also be used as a mobile reserve to be moved to a threatened point to hold the line until the infantry or artillery arrived. It was believed that, given the right circumstances, cavalry could attack a surprised or demoralised enemy and pursue him from the battlefield. Modern firepower had limited the effectiveness of cavalry but the British Army had used cavalry extensively in South Africa and the cavalry themselves believed that they could still undertake their traditional roles. In 1914, British cavalry, like German and French

27. British cavalry adopting an infantry role in Army manoeuvres on Salisbury Plain in 1913.

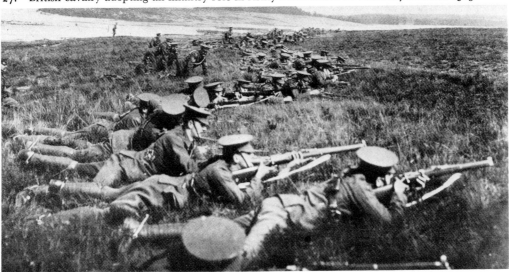

31

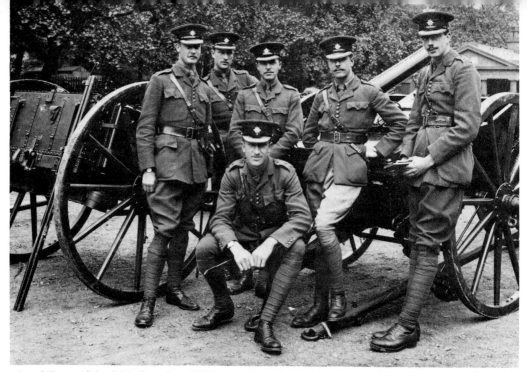

28. Officers of the Irish Guards at Wellington Barracks in August 1914. The officer second from the right is Lieutenant The Honourable Harold Alexander, later Field Marshal Viscount Alexander.

cavalry, combined the roles of mounted infantry and traditional horsed cavalry prepared for shock action. British cavalry were armed with rifles and swords, and in some cases lances. In peacetime British cavalry were taught to look after their horses and on exercises spent as much time walking them as riding them, thus preserving and extending their endurance and usefulness.

Amongst many British officers before 1914 there was a growing feeling of the inevitability of a European war. International tension and the preparations behind the Expeditionary Force helped to foster this state of mind. But despite an intense study of war at the Staff College and a flood of articles on military affairs in learned journals, no positive steps were taken by the Army Council to instruct the Army in the knowledge of the likely theatre of war or about the main potential enemy, the German Army. At war games and manoeuvres it was strictly forbidden to classify the enemy as the Germans. The average regimental officer and soldier was ignorant about the organisation of the German Army and its methods of war. Informed military opinion in Britain and on the continent expected a short war lasting only a few months because this was the objective of all the strategic plans and because it was thought financially impossible to conduct a war for longer. Nevertheless, individual senior officers in the British Army, like Douglas Haig, believed before 1914 that under certain circumstances a future war might last for two to three years.

The British Army of 1914 was a carefully structured organisation. There were sharp professional and social differences between the officers, non-commissioned officers and other

32

ranks. The majority of officers came not from the great aristocratic families but from the professional middle classes and landed gentry. They were the products of the great public schools, and if they were destined for the cavalry, infantry, Indian Army or Army Service Corps then they attended the Royal Military College, Sandhurst, whilst those who were going into the gunners, sappers or Army Ordnance attended the Royal Military Academy, Woolwich. Although the purchase of commissions had been abolished in the 1870's, a form of financial quality control was maintained in that, apart from those serving in the Indian Army or one of the technical arms, it was very difficult for an officer to live on his pay, and thus a private income was essential. There was a considerable element of self-recruitment, with sons following their fathers into the same regiment or moving on to a better one, and there were close social and family ties between officers. This gave a sense of stability and social cohesion to British Army officers but also encouraged an inward-looking and at times philistine attitude. Unlike German Army officers, British officers were discouraged from ostentatious displays of militarism and were encouraged to follow the pursuits and life style of an English country gentleman. They were persuaded to give their total loyalty and all their interests to their regiment, and unlike previous generations, officers were expected to know their soldiers and work closely with their NCOs. There had always been a tradition that it was somehow disloyal to the regiment for an officer to think of attending the Staff College, but in the decade before 1914, this had begun to change. For those officers who became bored by regimental life, extensive leave and hearty sports, there were many opportunities for detached service with the Indian or Egyptian Armies or the King's African Rifles, or perhaps a posting as an adjutant to a Territorial unit. Although many British Army officers had very narrow interests they were far more professional after the South African War than at any period up to that time.

The British soldier, the rank and file, was recruited from a wide range of backgrounds, but the majority came from the urban and agricultural working classes. Although conditions of service for the private soldier had improved immeasurably since the nineteenth century it was still rough and harsh. Many young men joined the Army to get a square meal, to escape from squalid home backgrounds or because they were unemployed. Ireland, Scotland, the north-east and north-west and London still provided the majority of recruits. Recruits were trained at their unit depot and then posted to a battalion, squadron or battery. Private soldiers were not expected to show any initiative and many of them lacked even an elementary education. Discipline in the old Regular Army was strict and field punishment was frequently awarded even on active service. But for many recruits, military life was preferable to what they had experienced in civil life. They were given a purpose in life, a regimental family and a self pride which many of them had never experienced. The soldier's loyalty was to his regiment or battery, and within the military family an immediate loyalty to his 'muckers'; he expected his officer to be a gentleman and to show courage in battle. The hobbies and interests of the private soldier were simple and reflected his working-class background – beer, girls, music-halls and gambling. Long-service Regular soldiers spent many years abroad in India or Africa and became real 'old sweats', with a smattering of Hindustani and an 'Old Bill's' approach to soldering – never volunteer and always make yourself comfortable. The best long-service soldiers became non-commissioned officers and the essential link between the officers and the rank

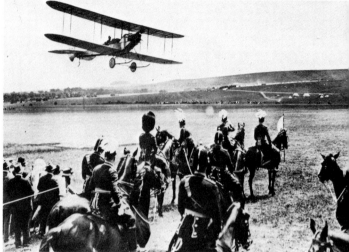

29. 'Old Bill' – a typical British soldier in August 1914. Many of the Regulars and Reservists were middle-aged men.

30. The future flying over the past – Lieutenant-General Sir Horace Smith-Dorrien taking the salute at the first Air Review on 22 May 1913.

and file. A good NCO had to have a strong personality, self-confidence and a lively repartee. The day-to-day administration of private soldiers and a lot of the basic drill and training was left in his hands.

The strength of the British Army in 1914 lay in its regimental organisation which encouraged the professionalism and loyalty of officers, NCOs and soldiers. But each group accepted its place and role in society and the Army, and gave its respect and loyalty to the other groups.

In 1914 the Home Establishment of the Regular Army numbered 125,209. There were 77,130 British troops stationed in India and 34,619 in the colonies. There were 145,090 on the Regular Army Reserve. In the event of mobilisation there would be approximately 270,000 soldiers available within the United Kingdom for immediate service. But this figure included those soldiers who would remain on the Home Establishment at depots, training schools and attached to the Territorial Force. In addition there was the National Reserve formed in 1910, which registered and organised all officers and men who had served in and left either the Army or the Navy and were no longer on the Regular Reserve. In the event of mobilisation many of these men could reinforce existing Regular units, replace Regulars at depots and fill up vacancies in the Territorial Force. By 1914 the British government had tapped and organised every available source of voluntary manpower for the Army without resorting to conscription. If there was a European war then the consensus of informed military opinion was that it would be a short war and that the British Army was as effectively organised and trained to fight as circumstances permitted.

34

3
The Encounter Battles

'Superior numbers on the battlefield are an undoubted
advantage, but skill, better organisation, and training, and
above all a firm determination in all ranks to conquer at any
cost, are the chief factors of success.' *Field Service Regulations:
Part I (Operations).*

The Germans had crossed the Belgian frontier on 4 August but they were delayed until
16 August by the Belgian fortress town of Liège. The main Belgian Field Army retreated
to Antwerp on 20 August, the day the Germans entered Brussels. Belgian troops to the
south defended Namur until 22 August and then escaped south to the French lines.

31. German transport entering Brussels on 20 August 1914.

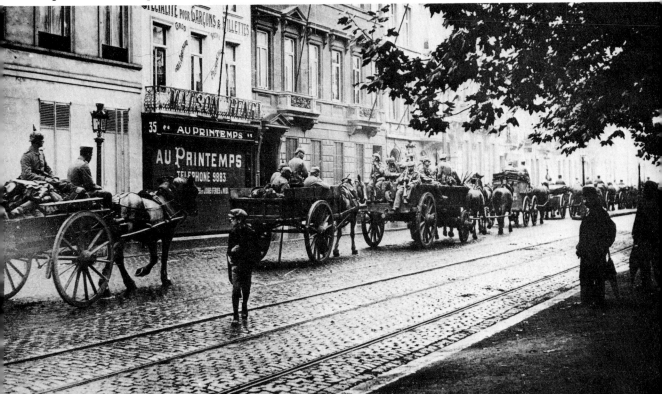

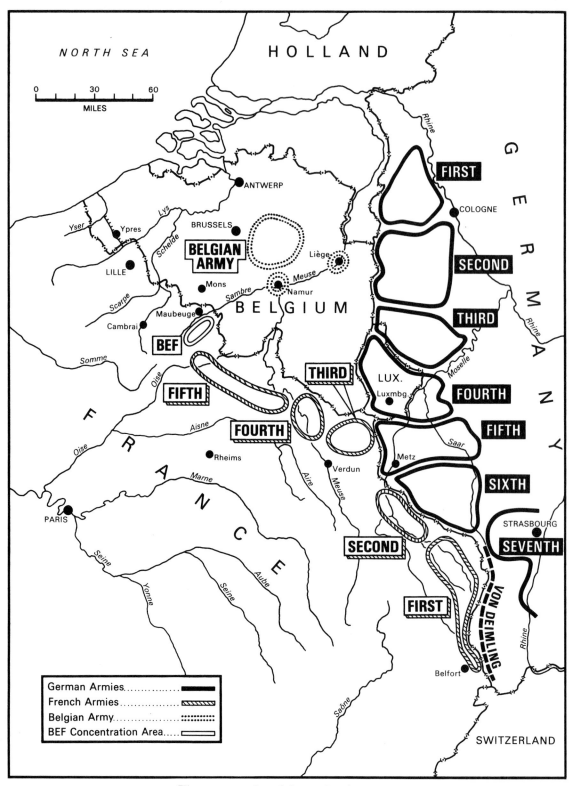

NORTH SEA

HOLLAND

0 30 60
MILES

GERMANY

ANTWERP

Lys

Yser

Ypres

BRUSSELS

BELGIAN
ARMY

Schelde

Liège

Meuse

Rhine

COLOGNE

FIRST

SECOND

Rhine

LILLE

Mons

Sambre

Namur

BELGIUM

THIRD

Scarpe

Maubeuge

Cambrai

BEF

Somme

FIFTH

Oise

Aisne

Oise

FRANCE

Rheims

FOURTH

Marne

THIRD

LUX.

Luxmbg.

Moselle

FOURTH

FIFTH

Saar

Metz

SIXTH

Aire

Verdun

Meuse

STRASBOURG

SEVENTH

PARIS

Seine

SECOND

Yonne

Seine

Aube

FIRST

VON DEIMLING

Rhine

Belfort

Saône

SWITZERLAND

German Armies...............
French Armies...............
Belgian Army...............
BEF Concentration Area.....

2. The concentration of the armies, August 1914.

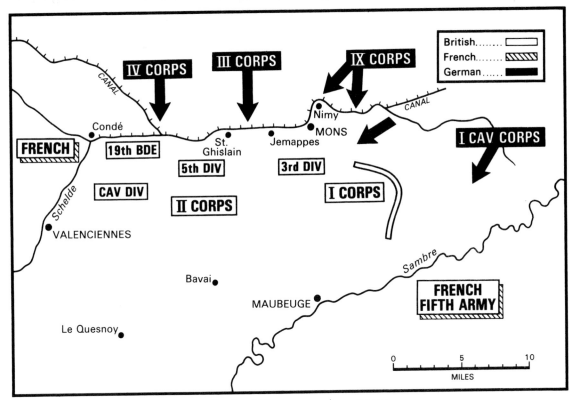

3. Battle of Mons, 23–24 August 1914.

Further to the east the main thrust of the French Plan XVII had gone badly wrong. On 20 August the French Second Army was seriously defeated by the Germans near Metz. Joffre's mind was concentrated on his offensive along the frontier with Germany and he did not realise the overwhelming disaster which threatened his left flank from the great German envelopment movement through Belgium. Indeed, he believed that Lanrezac's Fifth Army with the support of the BEF was about to strike at the exposed right wing of the German Army. None of the senior commanders on either side was able to discern the enemy's movements with any degree of accuracy, and their armies blundered towards each other like blinded dinosaurs. There was considerable confusion amongst the Germans as to whether the BEF had landed and, if it had, whether that was any threat to German plans. On 19 August the Kaiser issued his 'contemptible little Army' Order of the Day, whilst von Moltke, the Chief of the General Staff, thought it an advantage if the BEF had in fact landed, as they could be defeated along with the Belgians and French.

The Allied plan on the left flank was that Lanrezac's Fifth Army was to advance on the Sambre with the BEF on his left flank and beyond them General Sordet's Cavalry Corps which would have to move across the rear of the BEF to take up position. This Allied force would then be in position to strike at the German First Army at the far right of the German line. But far from the Germans being enveloped it was the Allies whose advance placed them in a pocket with the German Third Army to the east, the German Second

37

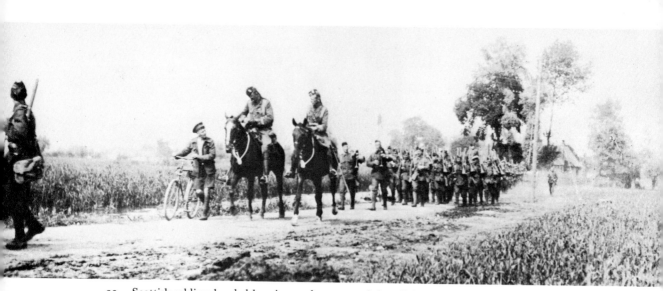

32. Scottish soldiers headed by pipers advance north into Belgium, August 1914.

Army to the north and the German First Army to the west where it was advancing on the open Allied left flank. But this situation was unknown to the officers and men of the BEF who began to prepare for the march north to a line covered by the Mons-Condé canal.

On 21 August the BEF began its advance towards Mons with the cavalry scouting ahead. The weather was very warm and sultry, and the marching infantry suffered exhaustion from the heat. The hard, irregular French pavé roads with their cobble stones made marching particularly painful, and many of the reservists had to fall out as their feet were not yet hardened to ammunition boots. As the infantry marched along the transport and artillery crashed and slid along beside them. Many officers and men wore canvas neck covers over their service hats to protect them against the sun. But the men were cheerful and confident as they marched:

> The woods and mellow fields resounded with our songs. *Tipperary* was a great favourite, as were also *The Long Trail* and *One More Mile to Go* . . . But the refrain which sticks more than all the others from that period is that about the man who went to mow the meadow. There is nothing of what the Americans call 'uplift' in this rather depressing tune, but to my mind it is always woven into the sound and pattern of the marching feet of our soldiers of 1914.[16]

In the afternoon advance units of the BEF began to cross the old battlefield of Malplaquet where a British Army under Marlborough had defeated a French Army two hundred years before. The first British cavalry patrols entered Mons on the 21st to be met by startled Belgian civilians who were questioned as to the whereabouts of the Germans. On the following day the main body of the BEF began to reach the Mons-Condé canal which ran from the west of Mons. The canal to the west of Mons was covered by Smith-Dorrien's II Corps and the salient to the east of Mons by Haig's I Corps.

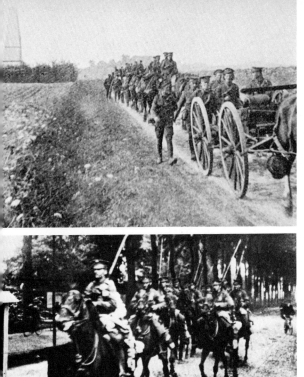

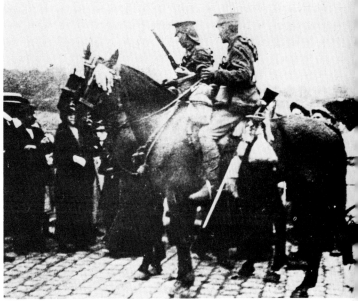

33.	Advance on Mons – British troops passing the battlefield and monument of Malplaquet on Saturday 22 August 1914.

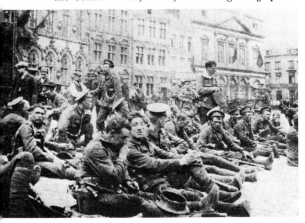

34.	The first British cavalry to reach Mons – troopers of the 9th Lancers on 21 August 1914.
36.	'A' Company of the 4th Battalion Royal Fusiliers, 7th Brigade, 3rd Division, resting in the Grand' Place, Mons, on 22 August 1914.

35.	'Where are the Boche?' A patrol of the 18th Hussars talking to Belgian civilians on the outskirts of Mons on 21 August 1914.
37.	An officer and troopers of the 4th Dragoons in position in a white sand depot near the Mons canal on 22 August 1914.

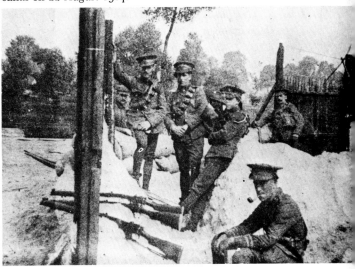

38. Belgian civilians help British soldiers barricade a house in Mons on 22 August 1914.

General Smith-Dorrien found Field Marshal Sir John French a little tetchy and somewhat vague as to the the deployment of II Corps:

> When I arrived before Mons the C-in-C told me 'to give battle on the line of the Condé Canal,' and when I asked whether this meant the offensive or the defensive, he told me to obey orders.[17]

Scattered contacts were made with the advancing German First Army which was startled to find the British at Mons:

> Reports coming back along the column seemed to confirm the fact that the English were in front of us. English soldiers? We knew what they looked like by the comic papers; short scarlet tunics with small caps set at an angle on their heads, or bearskins with the chin-strap under the lip instead of under the chin. There was much joking about this, and Bismarck's remark of sending the police to arrest the English Army.[18]

The Germans intended to strike the Allied left flank and this meant an attack against the British II Corps. The BEF began to prepare a defensive position along the canal and around and in Mons and the surrounding villages. The area around Mons was an important coal-mining region and was not particularly suitable for a battle as fields of fire were limited by buildings, slag heaps and deep ditches.

The infantry and engineers began to dig field entrenchments and to barricade Mons and some of the villages. The local Belgians willingly assisted them, lending their picks and shovels. The position of the BEF was precarious because the Germans had eight divisions to the British four, and six of them were concentrated in the west against the 3rd and 5th

39. Soldiers of the Northumberland Fusiliers build a barricade across the road between Mons and Jemappes on 23 August 1914.

40. Belgian civilians help British soldiers to build barricades between Mons and Quesney on 23 August 1914.

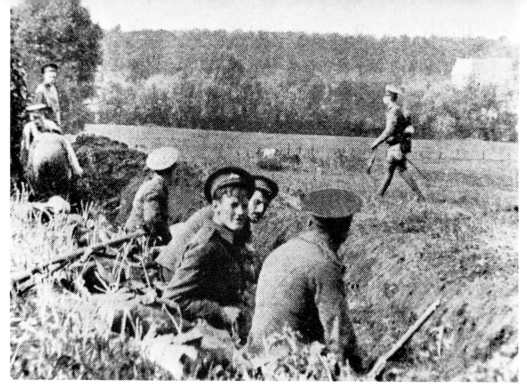

41. Battle of Mons – soldiers of the 1st Battalion The Lincolnshire Regiment digging trenches outside Mons on 23 August 1914.

Divisions of II Corps. The Germans began their attack on the BEF at 9 am on 23 August. For the soldiers of the BEF the first day of the first battle of the war seemed unreal, as Belgian civilians went to Mass and the church bells rang:

> It was difficult to realise that there was a war on. The local people strolled round, dressed in their Sunday clothes, and the men fraternised with them. They were, of course, very interested in our proceedings; they were in excellent spirits, and totally oblivious of any possibly impending cataclysm.[19]

The battle of Mons developed into a series of small actions with senior officers being able to exercise only limited control. The heaviest fighting took place along the canal to the west of Mons where the Germans launched a series of very heavy attacks against II Corps. At first the British troops found being under shell-fire something of a novelty:

> The salvo of shells passed over our heads, and burst about eighty yards in rear with a terrific clattering crash. We were highly interested. More came, and still more, all going over. The heads of our curious men appeared above the trenches looking back to see the bursts. 'Look,' they shouted, 'a black one,' or 'One only,' or 'Four more whites.' Some laughingly imagined themselves on butt duty at home, and shouted advice to the German gunners. 'Washout,' 'Another miss,' 'Lower your sights!'[20]

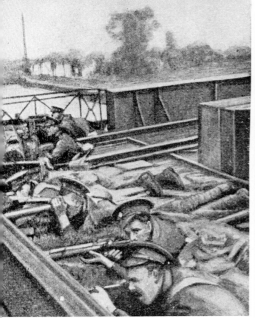

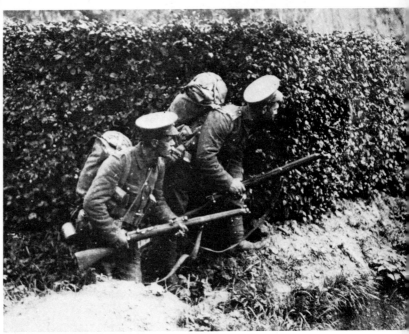

42. British infantry firing at the Germans from a position on the Mons–Condé Canal on 23 August 1914.

43. Two British infantrymen at an advanced post under cover of a hedge in Belgium, August 1914.

But the British infantry were able to demonstrate their firepower from their field entrenchments so that the Germans believed that the BEF was issued with hundreds of machine guns. The densely packed lines of advancing Germans were shot down in large numbers. Corporal John Lucy of the Royal Irish Rifles saw the effect:

> Our rapid fire was appalling even to us, and the worst marksmen could not miss, as he had only to fire into the 'brown' of the masses of the unfortunate enemy, who on the fronts of our two companies were continually and uselessly reinforced at the short range of three hundred yards. Such tactics amazed us, and after the first shock of seeing men slowly and helplessly falling down as they were hit, gave us a great sense of power and pleasure.[21]

But the Germans learnt to use their artillery to soften up the British positions and by 3 pm had managed to cross the canal west of Mons. Walter Bloem, a Reserve Captain of the German 12th Brandenberg Grenadiers, came face to face with a British soldier:

> I had scarcely spoken when a man appeared not five paces away from behind the horses – a man in a grey-brown uniform, no, in a grey-brown golfing suit with a flat-topped cloth cap. Could this be a soldier? Certainly not a French soldier, nor a Belgian, then he must be an English one.[22]

The fighting continued until dusk with the front line positions of the BEF straggling

along the canal. Despite their losses, mainly through German artillery fire, the British soldiers of II Corps were remarkably self composed at the end of the day's fighting:

> The general depression in the vicinity of the gun limbers was dispersed by the inevitable comic incident. A conscientious young soldier was noticed engrossed in counting his empty cartridge cases, which he carefully cleaned and put back into their clips. The idiocy of picking up empty cases in battle – an automatic peace-time rifle-range habit – sent a whole company into fits of laughter.[23]

Isolated pockets of men still held out even where the Germans had crossed. But the overall position of the BEF was dangerous, for whilst the battle had raged at Mons, Lanrezac's Fifth Army had been engaged to the east of Charleroi, and by evening had begun to retreat. When this news reached British GHQ, Sir John French gave the order to withdraw from Mons in the early hours of the 24th. No other course was possible as the Fifth Army was retiring on the right flank, and on the left there were no troops except for some French Territorials.

About 4 am on 24 August the BEF began to withdraw south of Mons, covered on the left by the cavalry. The withdrawal was brilliantly executed and few Germans realised that the BEF had gone until the morning:

> Up to all the tricks of the trade from their experiences of small wars, the English veterans brilliantly understood how to slip off at the last moment.[24]

Such a withdrawal at night after a day's battle was far from easy given the exhaustion of the troops, their scattered positions and the immediate presence of a powerful enemy. The BEF had suffered 1,600 casualties, all of whom, apart from forty, had been in II Corps.

The officers and men of the BEF could not understand, however, why they were retreating as they believed they had beaten the Germans; but although the Regulars and Reservists of the BEF had proven that their tactics and training had more than matched the Germans, the battle had given them some nasty surprises. Few had expected the volume

44. A photograph taken a day after the Canal from Mons to Jemappes was bridged by Engineers of the German 6th Division under fire from the 1st Battalion Northumberland Fusiliers on 24 August 1914.

45. Staff of the 9th Brigade sheltering against a wall during the action at Frammeries on 24 August 1914.

of firepower which the German artillery had produced. All ranks had learnt that it was almost impossible to move across open ground under heavy fire without incurring heavy casualties. But the Germans had also experienced some nasty surprises at the battle of Mons:

> A bad defeat, there could be no gainsaying it; in our first battle we had been badly beaten, and by the English – by the English we had so laughed at a few hours before.[25]

The BEF retreated south on the 24th with II Corps on the left of I Corps. At one point the two corps lost contact because they were physically separated by the Forest of Mormal. Haig's I Corps maintained a tenuous contact with Lanrezac's Fifth Army to the right, but it seemed that the British and the French were unable to co-ordinate the extent of their withdrawals. In front of the line of the BEF's retreat, General Sordet's Cavalry Corps was still atempting to move westwards to cover the Allied left flank, thus increasing the confusion. And yet the withdrawal was orderly and not a rout as Captain Bloem observed:

> The traces of a hasty departure, though not of a disorderly rout, were everywhere apparent: broken-down cars, burnt supplies, and so on, but no rifles and equipment lying about.[26]

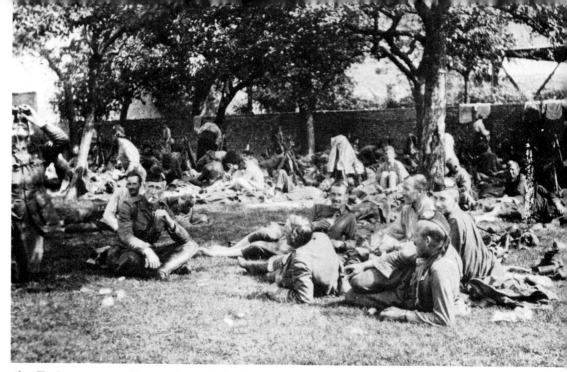

46. Taube spotting – officers and men of the Scottish Rifles halted at a farm during the retreat from Mons on 24 August 1914. On the left an officer looks at a German aircraft which had been shadowing the battalion.

47. British cavalry screening the BEF during the retreat from Mons.

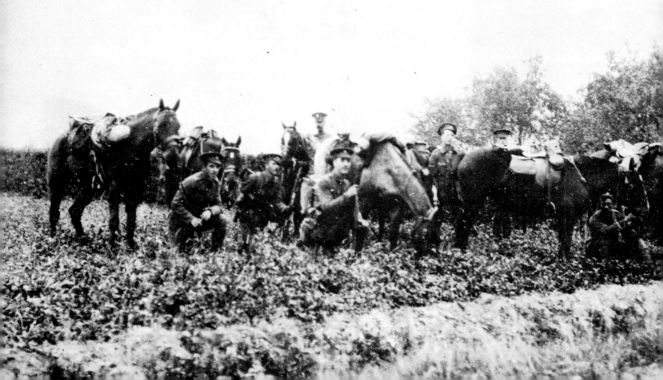

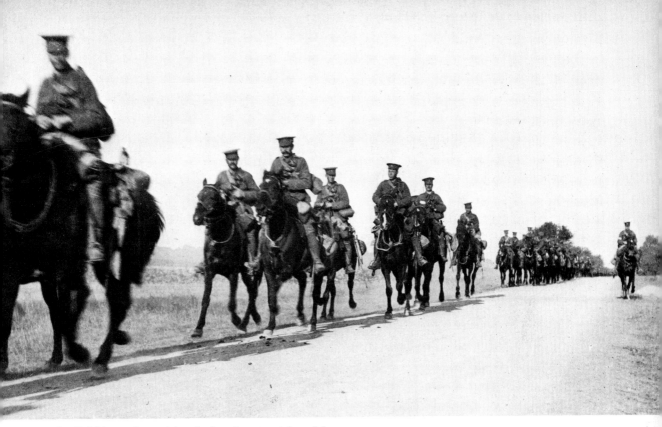

48. British cavalry retiring during the retreat from Mons.

Further to the east, the French Third and Fourth Armies were also in retreat and yet Joffre had still not grasped the extent of the threat to his left flank. Throughout 24 and 25 August the BEF retreated south with officers and men exhausted by lack of sleep and marching. The weather was still hot and the roads were thick with dust as troops, transport and refugees streamed south. The German First Army closely followed and attempted to work round the right flank of II Corps and thus envelop the BEF. That they failed to do this on the 24th was due to the action of the British cavalry in screening the BEF. Captain Arthur Osburn of the RAMC, attached to the 4th Dragoon Guards, observed the action of the British cavalry screening the retreat:

> Over the brown masses of surging horsemen charging across the rather dreary plain
> beneath a lowering sky on that sultry afternoon came white feathery bursts of shrapnel.
> The threatening sky, the restless symmetrical movements, the whole scene reminded me
> in some strange way of Milton's description of the legions of dark angels practising for
> giant warfare with St Michael on the plains of hell.[27]

The lack of initiative shown by the Germans, who were perhaps even more exhausted than the BEF as they had been marching and fighting for a longer period of time, also

47

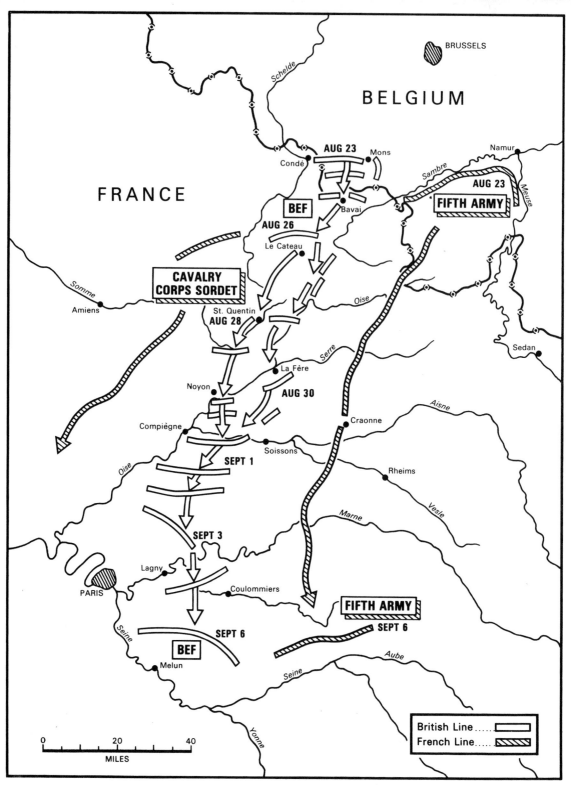

BRUSSELS

BELGIUM

FRANCE

Schelde

Namur

Mons
Condé
AUG 23

Sambre

Meuse

AUG 23
FIFTH ARMY

BEF

Bavai

AUG 26

Le Cateau

CAVALRY
CORPS SORDET

Somme

Oise

Amiens

St. Quentin
AUG 28

Serre

Sedan

La Fère

Noyon

AUG 30

Aisne

Compiègne

Craonne

Soissons

Rheims

Oise

Vesle

Marne

SEPT 1

SEPT 3

Lagny

Coulommiers

FIFTH ARMY

PARIS

SEPT 6

Seine

BEF

SEPT 6

Melun

Aube

Seine

Yonne

British Line
French Line

0 20 40
MILES

4. Retreat from Mons.

enabled the BEF to escape encirclement. But the Germans were kept going by the prospect of victory and the momentum of their advance.

By nightfall on 25 August II Corps was strung out along its line of retreat and severely threatened by the German line of march. The Corps had been reinforced on the previous day by the 4th Division, but due to the speed of its movement from Britain, the division had arrived without its transport, medical services and engineers. A violent thunderstorm on the evening of the 25th soaked the weary troops and added to the confusion. Sir John French decided to continue the retreat on the 26th as he believed that the Germans were close to enveloping the BEF. So orders were given to both corps to begin their march at 5.30 am. Although Haig's corps had been attacked on the 25th, it was able to continue the retreat in some order. Smith-Dorrien decided that the II Corps would not be able to continue the retreat before the Germans began to attack, and therefore decided to fight a holding battle to the west and north of Le Cateau. But Smith-Dorrien's decision was not popular with Sir John French who told him, 'If you stand to fight there will be another Sedan.'[28] II Corps was in a far worse state than I Corps because they had taken the brunt of the German attacks at Mons, and in retrospect they appear to have been less well organised and disciplined than Haig's I Corps. The Germans were so close behind the BEF that a fire fight developed in the streets of Le Cateau. The Royal Welch Fusiliers found themselves undertaking a drill movement more in keeping with colonial campaigning:

> We entered Le Cateau by a long, straggling street. I could see the Battalion incline right-handed into what was obviously the Market Place. Suddenly, there was a clatter of horses' feet behind. Looking round I saw some Uhlans coming up the road. I believe the following is the command I gave: 'Right wheel; double march; halt; right turn; front rank kneeling, rear rank standing, three rounds rapid, fire.'[29]

Before dawn on the 26th II Corps began to take up battle positions around Le Cateau, digging field entrenchments among the sugar-beet fields and in front of farms and houses. Captain Jack, a Staff Captain with 19th Brigade, observed the preparations for the defensive battle:

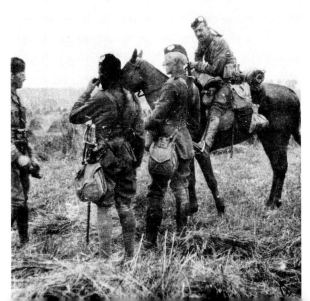

49. An officers' consultation before the battle of Le Cateau on 25 August 1914.

As we passed through the infantry of the 5th Division, arranged in the usual firing line, supports and reserves, they were entrenching as well as they could with their wretched little tools, augmented by some village picks and spades; the field batteries were trotting to their stations, many of these only 200 to 400 yards behind the foremost infantry and practically in the open as there had not been time to 'dig in'.[30]

The Germans began a series of attacks with heavy artillery fire support from 6 am and the battle continued throughout the day. Once again the fire discipline of the British infantry and the close support of the Royal Artillery broke up the German assaults. The cavalry prevented the Germans from working round the flanks, and by evening II Corps had begun to withdraw from Le Cateau to continue its retreat unmolested. But the battle had cost II Corps a further 7,812 casualties. Some units of II Corps never received the order to withdraw and were eventually surrounded by the Germans:

As a result of the terrible shell and machine gun fire from the front flanks, the advanced trenches of the right and centre brigades beside close support batteries of this division were being overrun by the waves of enemy assisted at 1,000 yards range, or under, by field guns. Our artillery with superb courage attempted to save their pieces, the teams galloping straight through the corn sheaves under annihilating rifle fire.[31]

Many soldiers were separated from their units and wandered aimlessly in the dark before joining up with different units or blundering into the German positions.

From 26 to 28 August the BEF retreated some further thirty-five miles to a line south of St Quentin. By this stage the majority of soldiers of the BEF were completely exhausted. Few had time for more than three or four hours sleep each night, and the long marches through the heat of the day began to tell. In particular, the Reservists began to fall out in increasing numbers with swollen and raw feet:

The men were discarding their equipment in a wholesale fashion, in spite of orders to the contrary; also many of them fell out, and rejoined again towards dusk. They had been riding on limbers and wagons, and officers' chargers, and generally looked worse than those of us who kept going all day . . . My feet were sore, water was scarce: in fact, it was issued in half-pints, as we were not allowed to touch the native water. The regulations were kept in force in that respect – so much so that two men were put under arrest and sentenced to field punishment for stealing bread from an empty house.[32]

At every halt it became increasingly difficult for officers and NCOs to get the men back on the line of march. Some never heard the order and others pretended not to, preferring the risk of being captured to another march:

I shall never forget the last halt we were to have that night. As usual, everybody – officers and men – threw themselves down just at the edge of the road. When the whistle blew for 'Fall in' many of the men lay where they were, not in any mutinous spirit but just because they were physically incapable of getting up. My platoon was the rear platoon of the Company, which was the rear Company of the Battalion. 'Payker' and I went round, actually kicking the men till they got up threatening, with our revolvers

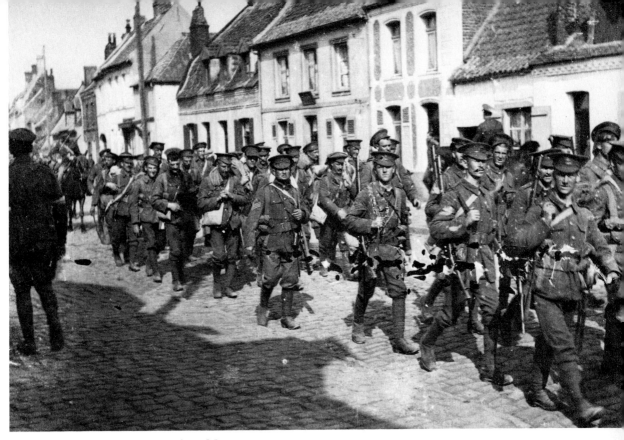

50. British troops on the retreat from Mons.

drawn, to shoot any man who did not fall in at once. We were reeling about like drunken
men ourselves, past hoping for any rest, but knowing we had to go on. At last we got
them on the move, and struggled along in the rear to prevent any men from falling
out.[33]

The retreat was particularly tiring for the cavalry and artillery who had the job of
watering, feeding and resting their weary horses before their own comfort. In some units
discipline began to break down because of the demoralising effect of the retreat, the lack of
sleep, the widespread intake of wine pressed on the thirsty men by the local population and
the hot weather. In the confusion some units were reduced to less than half their strength.
Those units that held together and had few men fall out did so out of a sense of regimental
pride, discipline and the example set by the officers and NCOs. Leadership and discipline
were particularly important for those troops actually forming the rearguard:

The hardest time of all was when one's particular regiment found rearguard; then we
often had to march back a few miles along the way we had come, dig trenches, hold the
enemy the whole of the day, and then at night continue the march until we picked up the
main body again. Often times on reaching the main body it was found that they were

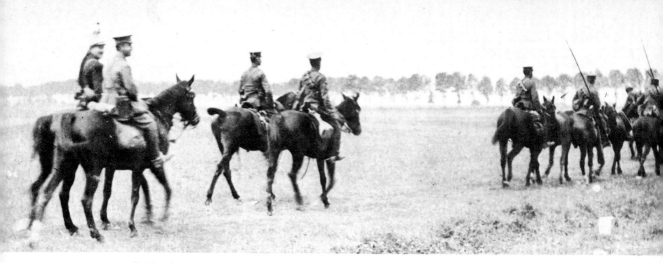

51. British lancers with a French liaison officer during the retreat from Mons.

just ready to start again, so the rearguard would be obliged to continue their march
without intermission.[34]

Apart from the pressing fear of being captured by the Germans, one of the major
reasons behind the demoralisation of the troops was that they could not understand why
they were retreating. Time and time again they were halted to dig field entrenchments only
to be told on completion to abandon them and continue the retreat. Road congestion was
bad because units became separated from their transport and bottle-necks occurred in towns
and villages. French and Belgian refugees also added to the confusion:

An additional difficulty on the road, and one very corruptible to the morale of the troops,
was the continuous stream of refugees going along the same roads as ourselves. The
terrible tragedy of those poor people! Hobbling along the road with all their worldly
goods piled up, layer on layer, on crazy hand-carts, perambulators, wheelbarrows,
farm-carts etc., with generally the old grandfather and grandmother on top of all the
goods, and all the rest of the family, women and children that is (as all the younger men

52. French refugees stream south past British soldiers during the retreat from Mons.

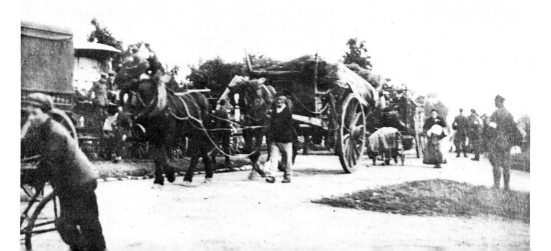

were with the forces), trailing along in the dust as best they could. Needless to say, the men insisted on sharing their meagre rations of bully beef and biscuits with them, and often, if they got the chance, took a hand to push their nondescript vehicles. But it was terrible and it was demoralising.[35]

Throughout the retreat there was a continual fear of spies operating behind the Allied lines, and the accuracy of German artillery fire persuaded many soldiers in the BEF that the Germans had a network of spies posing as French and Belgian soldiers and civilians. Dozens of innocent Belgians and Frenchmen were arrested and shot by both the British and the French on the suspicion of being spies. Fear and suspicion also caused dissension between the Allies. The British had a low opinion of the French Army because the only real soldiers they had seen had been the French Territorials and the romantically dressed French cavalry. Equally, the French had a low opinion of the BEF because they believed the British were always complaining and were too ready 'to do a bunk'.

The logistical problems of supplying the BEF during the retreat from Mons were immense. All the lines of communication, transport and supply facilities were based upon the assumption that the BEF would be advancing into Belgium, not retreating south to Paris. The Quartermaster-General of the BEF, Major-General Robertson, had hastily to reorganise the transportation and supply of the BEF, but all the lines of communication were disrupted, the forward dumps overrun, and it was almost impossible to find out where units were who required food and ammunition. Robertson resorted to dumping food

53. Death of a spy – a British firing squad shoot a Belgian civilian suspected of spying for the Germans.

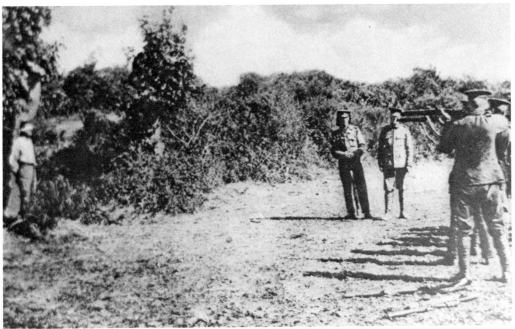

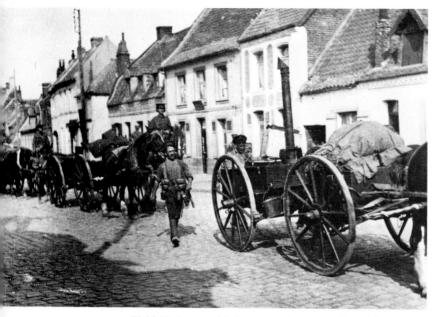

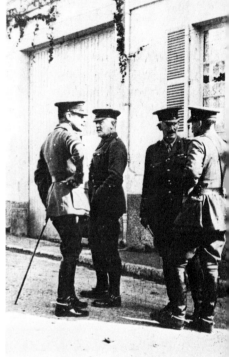

54. Field kitchens and infantry on the retreat from Mons.
55. Lieutenant-General Sir Douglas Haig, Major-General Monro, Brigadier-General Gough and Colonel Perceval consult in a French street during the retreat from Mons.

and ammunition along the projected line of retreat in the hope that the majority of units would get some supplies. The retreat from Mons was, apart from anything else, a Quartermaster's nightmare.

It was also a nightmare for GHQ and the senior field commanders. British GHQ's mood had swung from excessive optimism before the battle of Mons to excessive pessmism after the battle of Le Cateau. It had become more demoralised than the retreating soldiers:

> While the CO talked to the Staff we halted, and I was accosted by a Sandhurst contemporary, now at GHQ. Obviously very agitated, he began at once, 'Isn't it awful! the French on our right have been heavily defeated, and we got a bad knock yesterday', and declared that we should have to retreat behind the Seine. Having concluded this dreadful story, he clasped both my hands, shook them warmly, and exclaiming, 'God bless you, old chap', he entered a particularly luxurious Rolls-Royce, which disappeared displaying two large cases of Fortnum and Mason on the luggage grid.[36]

Continually on the move and only too well aware of the danger from the German envelopment movement, Sir John French and his staff believed that the BEF had suffered a major defeat at Le Cateau and was on the point of total collapse. Those staff officers who went out into the field saw all too readily the obvious exhaustion of the troops, the

54

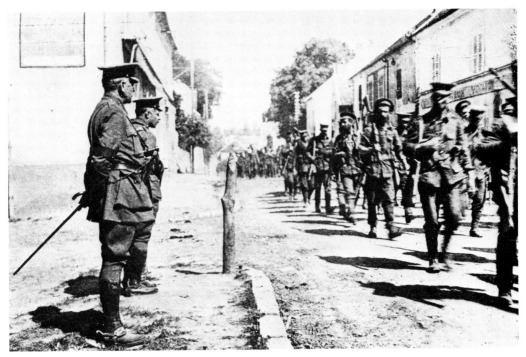

56. Major-General Monro and Colonel Malcom cast an expert eye over the weary soldiers of the 2nd Division during the retreat from Mons.

stragglers, the confusion and the fear. This did not prevent some of the Staff from taking rather a flippant attitude on occasions:

> I heard one young staff officer being amused – until quelled – at the difference between this Retreat and the Real Professional Retreat performed at Aldershot in perfect order.[37]

What the Staff did not see was that many units were not demoralised and broken, and that the rearguard actions being fought were keeping the Germans at a distance. The divisional commanders were more sanguine than GHQ because they closely observed their soldiers and realised that they were far from total collapse. John Charteris, an officer on Haig's staff, recalls that:

> The worst moments were when an officer from GHQ arrived with a message that we should jettison ammunition, put exhausted men on the ammunition wagons and make off with what speed we could. Gough tore up the message.[38]

I Corps had escaped relatively lightly in the initial engagements and Haig was quietly confident. But it was in a pessimistic state of mind that Sir John French began seriously to consider removing the BEF from the line westwards towards the Channel and safety.
 And yet it was in these last desperate days of August with the Allied Armies in retreat

55

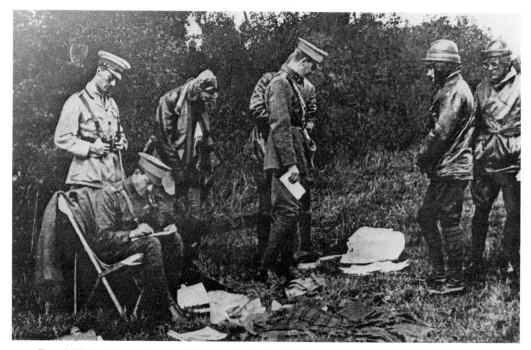

57. Royal Flying Corps pilots and observers being briefed before a reconnaissance.

and it appearing only a matter of time before the Germans would successfully complete the Schlieffen Plan, that Joffre began to reorganise his forces and prepare for the decisive counter-attack. He had at last realised that the real threat was to his left flank, and so he had started to form a new Sixth Army under General Maunoury which would operate on the left flank of the BEF. But if the Allied left flank was to be held, then it was imperative that the BEF remain in position. Sir John French was persuaded not to withdraw after a personal appeal from Joffre and a hasty visit from Kitchener on 1 September. Then whilst the Allies were reorganising in the midst of the great retreat, the Germans began to make a series of errors. The German First Army began a turning movement eastwards away from Paris and in front of the retreating BEF and Fifth Army, because its commander, von Kluck, believed that the BEF was beaten and thought he could now decisively strike the French in the flank. It was this movement eastwards which began to expose the whole of the German right flank to the Allies. On 3 September the Royal Flying Corps reported the change in direction of the German advance. It became obvious to General Galliéni, the Military Governor of Paris, that the German right flank along the River Marne was fully exposed. He set the new Sixth Army on the move towards the Marne on 4 September and Joffre prepared to halt the whole Allied retreat and commence a counter-attack on 6 September. The great retreat had come to an end, and it was the eve of the battle of the Marne.

As the BEF halted on the line of retreat on 5 September some fifteen miles south-east of Paris there was a great sense of relief amongst the soldiers. They had retreated nearly

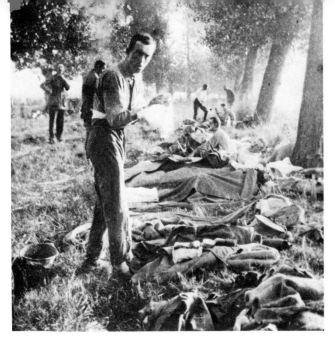

58. Lieutenant Arkwright, 11th Hussars, at ablutions on the final day of the retreat from Mons, 5 September 1914.

two hundred miles in thirteen days since the battle of Mons, and one officer noted that on average mounted men had had three hours' sleep per day and an infantryman four hours. Corporal John Lucy gives a vivid description of the effect this lack of sleep had on the retreating troops:

> I think it was about the tenth day when the frightful agony of sleeplessness began to smite us. Men slept while they marched, and they dreamed as they walked. They talked of their homes, of their wives and mothers, of their simple ambitions, of beer in cosy pubs, and they talked of fantasies. Commonplace sensible remarks turned to inane jibberings. The brains of the soldiers became clouded, while their feet moved automatically.[39]

The oft criticised staff had even less sleep as they worked to keep the BEF supplied and fed.

On 5 September there were nearly 20,000 men absent from the original numbers of the BEF, but the official returns showed a figure of 15,000 killed, wounded and missing. The artillery lost forty-two guns, and a considerable quantity of food, transport and equipment fell into enemy hands. But it was amazing how quickly the men recovered after resting for twenty-four hours:

> We all had a jolly good night's sleep. It was a treat to wake up naturally instead of being dragged out in the middle of the night. The day was spent eating and sleeping. A mail was received and our first newspapers, the latter telling us more than we knew ourselves. The first Orderly Room since leaving Rouen was held, and one or two offenders realised that discipline was not quite dead.[40]

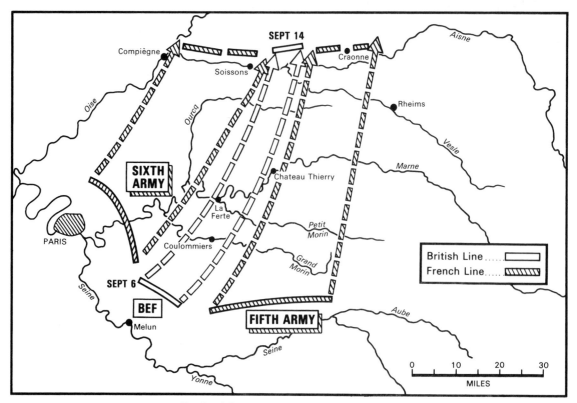

5. Battle of the Marne and advance to the Aisne.

Sleep, plenty of food and a chance to wash, clean and replace kit, and the fact that the retreat was over soon raised spirits. Deficiencies in manpower were made up as stragglers came in and the first reinforcements from home arrived:

> . . . reinforcements from England joined us, and the difference in their appearance and ours was amazing. They looked plump, clean, tidy, and very wide-awake. Whereas we were filthy, thin and haggard. Most of us had beards; what equipment was left was torn; instead of boots we had puttees, rags, old shoes, field boots – anything and everything wrapped round our feet. Our hats were the same, women's hats, peasants' hats, caps, any old covering, while our trousers were mostly in ribbons. The officers were in a similar condition.[41]

The BEF had already been reorganised on 31 August when a III Corps was formed consisting of the 4th Division and eventually, when it was sent over from Ireland, the 6th Division.

The Allied order of battle for the advance on the left flank consisted of the Sixth Army on the far left, then the BEF, with the Fifth Army on its right flank, and in turn a new Ninth Army under Foch on its right. The country over which the Allies were going to attack was part of a high plateau, well cultivated, but with woods and villages, dissected

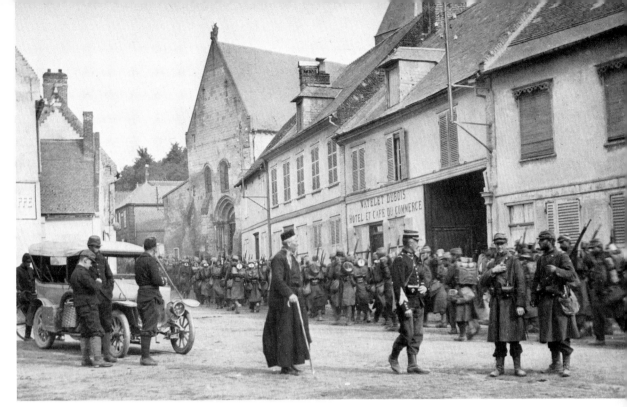

59. French troops advance to the Marne, 6 September 1914.

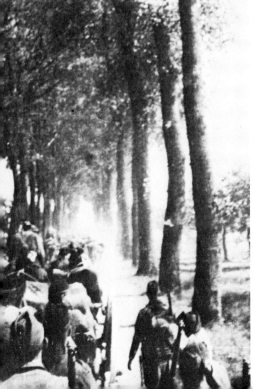

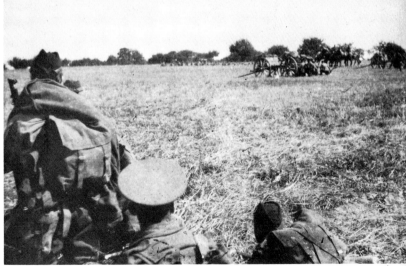

61. Soldiers of the Scottish Rifles watch British 18-pdrs
come into action during the battle of the Marne.

60. The Scottish Rifles march down a
poplar lined road during the advance
to the Aisne.

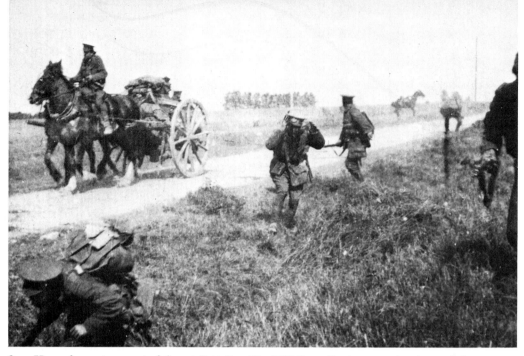

62. Horse-drawn transport of the 1st Battalion The Middlesex Regiment under shrapnel fire at Signy Signets on 8 September 1914.

by a series of rivers running east–west – the Grand Morin, Petit Morin, Marne, Ourcq, Vesle and Aisne. The majority of these rivers were unfordable except at the bridge crossings, and these made very good defensive positions if the Germans cared to use them. The Allied advance began well, and the Germans had difficulty in dealing with this new threat to their line of march as they moved eastwards. On 7 September the BEF crossed the Grand Morin and had had only sporadic contact with the German First Army. The men of the BEF were in good spirits now that they were advancing and were cheered to see the first signs of a breakdown in German discipline – empty wine bottles and abandoned equipment. On 8 September the BEF crossed the Petit Morin and even reached the Marne in places. But the problem for the Allies was to maintain the same extent of advance along the whole front without destroying the momentum. The Germans were forced to redeploy their forces in the face of the Allied attack, and on 8 September a gap occurred between the German First and Second Armies which was directly in advance of the BEF. On 9 September the BEF crossed the Marne, and the Germans, believing that they faced defeat, panicked and began to retreat to the Aisne.

 The Allied victory on the Marne was less a battle than a series of manoeuvres and engagements, which resulted in the Germans losing their nerve and thus the strategic initiative in the west. For the BEF, the advance to the Marne had been a matter of route marches, bridging rivers and streams, and a number of fire-fights over difficult terrain in the face of German rearguards. But even the need for stealth and surprise was sometimes undermined by one's own side:

60

63. A British padre and Bavarian prisoners taken in a skirmish on the Marne on 10 September 1914.

64. The pursuit to the Aisne – soldiers of the Scottish Rifles with French troops after a skirmish on 10 September 1914.

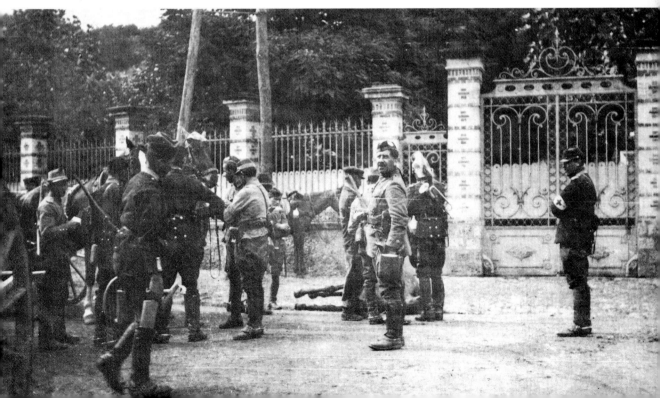

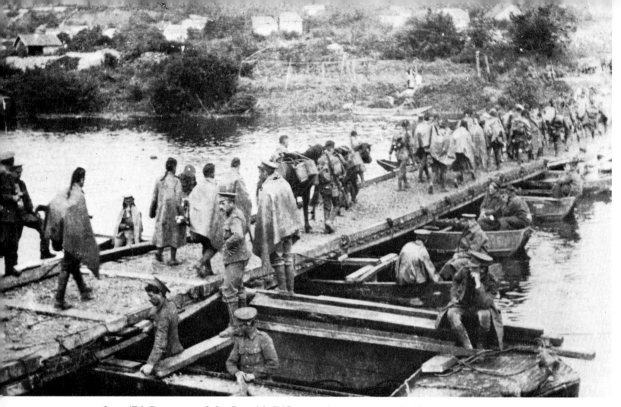

65. 'D' Company of the Scottish Rifles crossing a pontoon bridge over the Marne built by the Royal Engineers.

> We moved off as soon as it was dark, 7.30 pm to cross the Marne by a pontoon bridge that was expected to be ready soon after daylight. No smoking or striking matches was allowed, and we marched in silence. Suddenly a glare in the sky was seen in front of us, and a large Staff car with an enormous headlight appeared over the rise, coming towards us. One of my front section of fours observed to his neighbour ' 'ere's a bloke what's lit a cigarette.'[42]

The Royal Engineers had excelled themselves at repairing damaged bridges and building improvised ones, usually in the face of fierce German opposition. Unfortunately, the Allies were unable to exploit their victory on the Marne by a rapid advance against the retreating Germans which might have turned into a rout. Both the British and the French were tired, and the field commanders were very cautious. Problems of supplying and feeding the advancing troops meant that to a certain extent they had to live off the land:

> Our rations were very scarce at this time. Bread we never saw; a man's daily rations were four army biscuits, a pound tin of bully beef and a small portion of tea and sugar. Each man was his own cook and we helped our rations out with anything we could scrounge. We never knew what it was to have our equipment off and even at night when we sometimes got down in a field for an all-night's rest we were not allowed to take it off.[43]

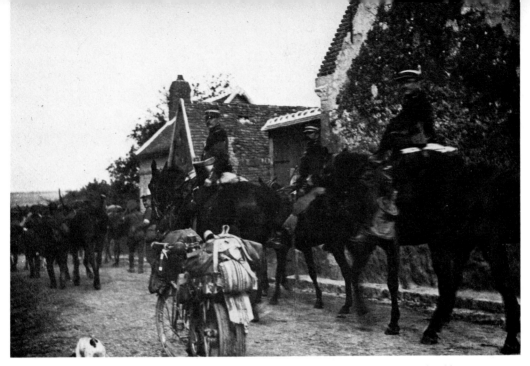

66. French cavalry mounted, British cavalry dismounted, during the advance to the Aisne.

So the Germans retreated in a reasonably orderly fashion to the Vesle and then to the Aisne.

The Germans decided to make the line of the Aisne their main defensive position. The river wound through a valley some 300 feet below the surrounding hills, was about 200 feet wide and difficult to ford. The Germans destroyed most of the bridges as their troops retreated across them and placed machine guns and artillery on the far bank amongst the steep, wooded ravines. An approaching enemy had to descend through the steep, wooded ravines on the other side and cross the bottom of the open valley before attempting to ford the river and begin the steep ascent on the far side.

The Allies continued their slow advance to the Aisne on 11 and 12 September through a steady downpour of rain:

> Off at 7 am and the usual long weary halts with lots of gunning going on all around us. Heavy showers at intervals, but at about 1 pm it came on a regular downpour: the wretched men got soaked. No. 2 Company were especially badly off as we had lost all our greatcoats and water-proof sheets at Landrecies. We plugged on in the rain which came down harder and harder. We reached Oulchy–le Chateau about 5 pm where we went into billets. No. 2 had an iron-monger's shop and we soon had fires going, and the men were enabled to dry their sodden clothes. The state of this shop and policies when we arrived was pitiable. The Dutchmen (Germans) had been in it, and absolutely ransacked the place. Every drawer was overturned and the floors were feet-deep with every sort of article, wearing apparel, gramophone records smashed to atoms, food, glasses etc., and

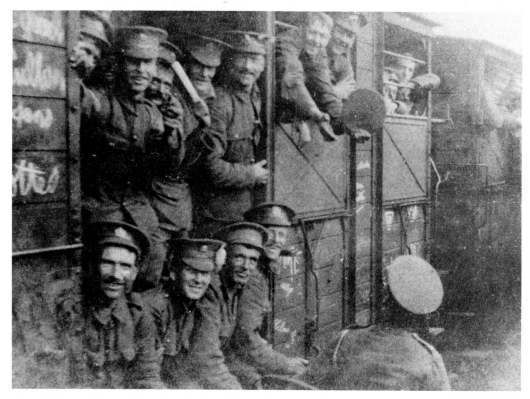

67. Soldiers of the 2nd Battalion York and Lancs Regiment in cattle trucks en route to the Aisne, September 1914.

> all the tables had glasses and unfinished food; other less sanitary signs were everywhere apparent – the filthy brutes.[44]

The rain failed to dampen the spirits of British GHQ whose senior officers, led by Henry Wilson, were optimistically forecasting that the war would be over in a matter of weeks with the Germans pushed back behind the Rhine:

> Berthelot asked me when I thought we should cross into Germany, and I replied that unless we made some serious blunder we ought to be at Elsenborn in 4 weeks.[45]

The BEF was sandwiched between two French Armies in its line of advance. On 12 September, GHQ issued orders for the three corps to cross the Aisne the next day and to advance five miles beyond the river east of Soissons to take up a position along the Chemin des Dames. The advanced units of the BEF crossed the Aisne surprisingly easily on the morning of the 13th as the Germans had failed to destroy all the bridges. But the Germans recovered quickly and their heavy howitzers began to destroy the temporary pontoon bridges built by the Engineers and caused a lot of casualties. The French had also crossed

64

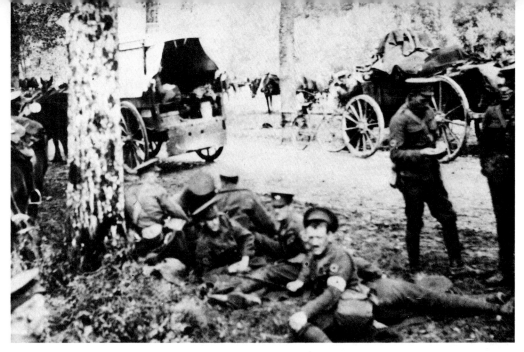

68. A field ambulance halted on the line of march during the advance to the Aisne.

69. British wounded being evacuated from Braine during the pursuit to the Aisne on 13 September 1914.

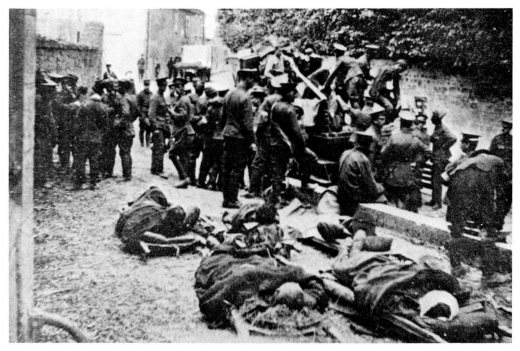

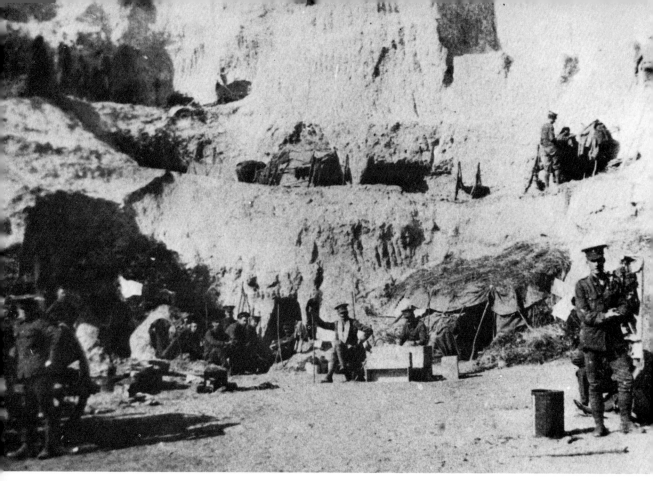

70. Headquarters of the York and Lancs on the Aisne.

the Aisne on either flank, but met equally stiff resistance. Having crossed the river the
difficulties facing the BEF had only just begun, because they then had to storm the heights
in the face of well entrenched German infantry and artillery. Furthermore, the Germans
were bringing up reinforcements and launched counter-attacks so that far from continuing
to advance, the Allies were hard pressed not to be pushed back across the river. Allied
artillery on the southern heights could not fire effectively, and few guns could find suitable
positions on the north shore.

 With the Germans attempting to hold the heights on the northern side of the Aisne and
the Allies trying to push them off, a bloody attritional battle developed. The Germans
counter-attacked in mass formations and were only stopped by the disciplined firepower
of the British infantry. What forced the British to give ground was the devastating fire of
the German artillery. On 16 September Sir John French reluctantly ordered the BEF to
entrench along the northern bank of the Aisne. In effect this meant digging in where
soldiers lay and making separate field entrenchments into a continuous line. Both sides
were exhausted and for the next few days spent most of the time strengthening their trench

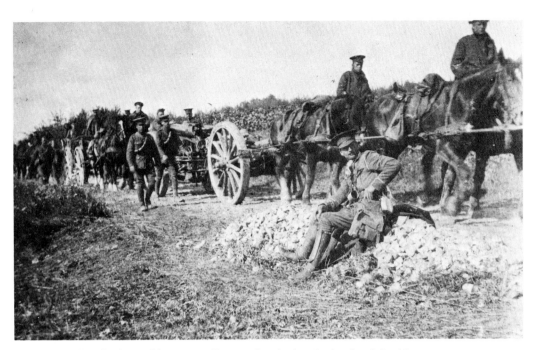

71. British 60-pdrs 'on trek' pass an officer resting during the battle of the Aisne.

system. The Germans had several advantages over the BEF including the fact that in general they were occupying the higher ground. They were better prepared for trench warfare with their howitzers, supplies of bombs and barbed wire. The BEF had to extemporise with what was available. Many infantry battalions lacked even the basic entrenching tools which had been lost during the retreat. The BEF had very little barbed wire or sandbags to strengthen the trenches:

> It rained practically incessantly all day Wednesday, the 16th, and by now everybody was getting into the most awful mess. This plateau was chalk and we were all smothered with slimy white chalk, hands, faces, uniforms – everything. It was impossible to shave, as, notwithstanding all the rain, the only water obtainable had to be used, and very sparingly at that, for drinking purposes. Trench digging was a pretty hopeless job, as we had no shovels (some eventually came up on Thursday night from the R.E.), and entrenching tools were useless in hard chalk. We had no barbed wire either, so wiring the line was out of the question.[46]

The Royal Artillery had few howitzers and even the field artillery was already short of shells. There were massive logistical problems in supplying the fighting units on the north side of the Aisne across a river under fire.

But the BEF was strengthened by further reinforcements from the reserve, and GHQ began to sort out a system whereby units could be relieved and given some rest from the front line. The old soldiers of the BEF began to adapt to the conditions of semi-permanent

67

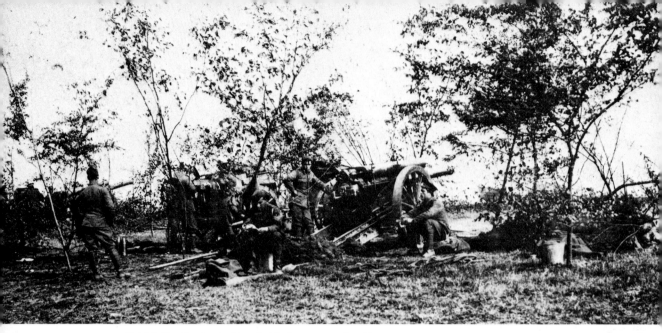

72. British 6o-pdrs in position behind cover on the Aisne.
73. Company dug-outs of the York and Lancs on the Aisne.

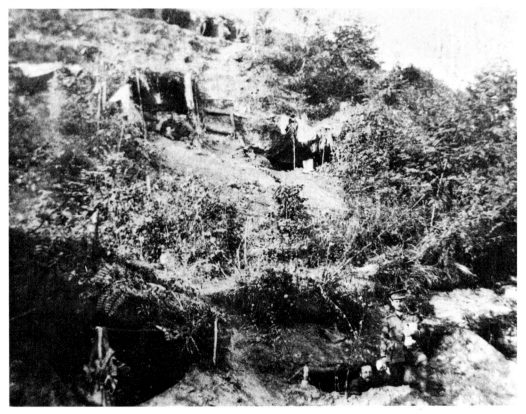

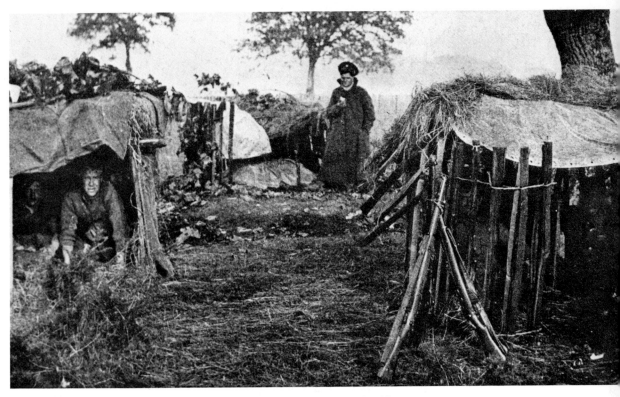

74. British soldiers looking like scarecrows in improvised shelters on the Aisne.

trench warfare, digging themselves shelters amongst the trees and living in the caves behind the heights. However, the terror of waiting in those caves listening to a German attack in progress strained the nerves of the British soldiers:

> We had hardly entered the caves when the Germans counter-attacked, and we were at once ordered to stand up and fall in ready to go and help our people outside. The sound of the battle heard from the caves was awe-inspiring. Clouds of smoke from bursting shells obscured the already dim light which filtered through the cave mouth. Heavy ground shells crumpled into the earth roof of our shelter and shook us. Projectiles whined and crashed at varying distances, and machine-guns rat-tat-tatted. The indistinct figures of stretcher-bearers collecting dead and wounded moved unceasingly in the cloudy light of the cave mouth. We felt trapped, and wished ourselves outside fighting, instead of standing restless in the semi-darkness. The appalling noise of the conflict outside made us all very anxious as to the progress of the enemy counter-attack. We got nervy and fidgeted and avoided each other's eyes. One interested soldier at the cave mouth morbidly occupied himself by passing in the names of the latest dead and wounded.[47]

The weather alternated between fine periods and then torrential rain for several days. The rain produced deep mud and flooded the primitive trenches and shelters making life

69

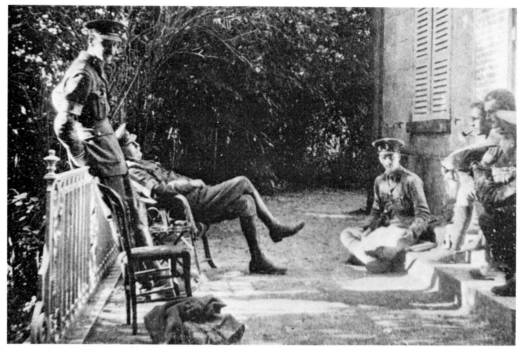

75. Brigadier-General Shaw and staff of the 9th Brigade at their headquarters on the Aisne, 22 September 1914.

76. Captain Maitland of the Essex Regiment and his machine gun in a front-line trench on the Aisne. The officer on the far left is a Forward Observation Officer of the Royal Artillery.

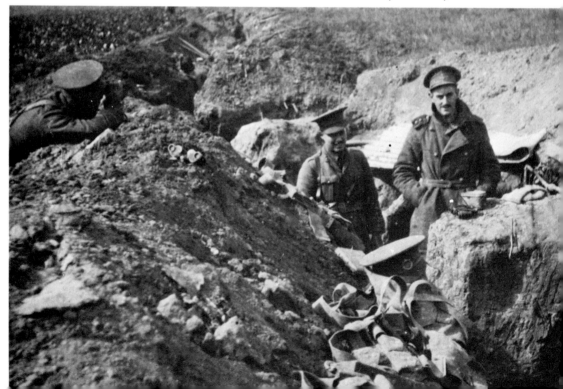

miserable for all ranks. At least one Commanding Officer wondered how his men stood the danger and discomfort:

> The men are splendid and I think their bravery in disregarding danger is largely due to British stupidity. I don't think they realise their danger, which is a great blessing for them, and makes them stand like rocks, when the highly strung foreigners can't stick it. But the men are tired, I can see that. They have not had one day's rest since they started, to refit and wash etc., and the difficulty of keeping them awake at night is extreme, in fact the officers (and I have only 10 Company Officers) have to keep at them all night to keep them awake.[48]

On 20 and then 26 September the Germans launched heavy attacks on the British positions but were driven back with heavy casualties. Lieutenant Needham led his platoon of the 1st Battalion The Northamptonshire Regiment in a counter-attack against the Germans:

> . . . at about 1.30 pm the Germans launched an attack on our line in pouring rain and considerable strength. 'C' Company were ordered up to reinforce the right of the line and to launch a counter-attack . . . We reached the road (Chemin des Dames) and lay down there for a few minutes to get our breath. Then 'Payker' gave the order to fix bayonets and a few minutes later to charge. Over the bank we went, 'Payker' shouting 'Come on the Cobblers!' and the men cheering like hell. I ran as hard and as best as I could over the roots with my drawn sword in one hand and my revolver in the other, stumbling over and cursing the roots and expecting every moment to be tripped up by my sword scabbard![49]

Although the British were able to hold their position on the Aisne it was at the cost of heavy casualties, particularly amongst the infantry:

> The next few minutes reminded me of Butler's picture of the Crimean roll-call, when the senior NCOs listed our casualties from the information given by the survivors: '08, Corrigan?' 'Dead, Sergeant.' 'I saw him too.' 'Right, killed in action. Anyone seen 23, Murphy?' No answer. 'Right. Missing.' 'What about MacRory. Anyone see MacRory coming back after he was hit?' No answer. 'Right, wounded and missing,' and the sergeant's stubby pencil scribbled on.[50]

At the end of September British GHQ faced the depressing prospect that static warfare had developed and the BEF would be worn down in a series of attritional battles.

But the centre of strategic operations was now beginning to shift from the Aisne to Flanders where the fate of Antwerp and the Belgian Army was in the balance, and it appeared to both sides that a vacuum existed which if exploited could enable one or other of them to complete the elusive envelopment and thus win the war. During the German advance through Belgium the investment of Antwerp had been left to second-line troops. Winston Churchill, the Secretary of State for the Navy, had seen the importance of Antwerp in tying down German troops and the opportunity offered for action against the German right flank from the Channel coast. At the end of August he had landed British marines at Ostend but had been forced to withdraw them after a few days. Neither Kitchener nor Sir

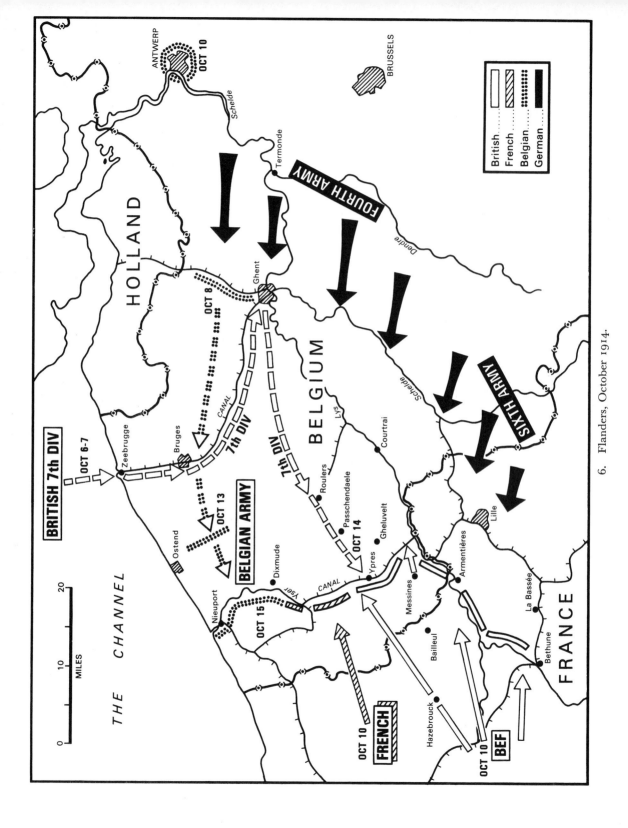

6. Flanders, October 1914.

77. Middle-aged Royal Marine Reservists filling their water-bottles by the roadside at Ostend on 28 August 1914.

John French were interested in diverting what few military reserves were available to what they considered a 'sideshow' and it was only at the end of September when the Germans began to bombard Antwerp seriously and the capture of the Belgian Field Army seemed imminent, that operations in Flanders began to take on a new importance. Falkenhayn, who had replaced Moltke as Chief of the German General Staff after the failure on the Marne, had already decided to transfer an Army from Lorraine to Flanders with the objective of enveloping the Allied left flank and capturing Calais. This force would be strengthened with the troops besieging Antwerp when the town eventually fell.

In the last week of September Churchill sent the Royal Naval Division to Flanders, a force which had been cobbled together from marines, sailors, reservists and volunteers. After landing it proceeded along the coast and reinforced the Belgians in Antwerp. In addition the British Cabinet agreed to send two Regular Divisions, the 7th and the 3rd Cavalry Division, formed from Regular units brought back from overseas, to land at Zeebrugge. These two divisions under the command of Lieutenant-General Sir Henry Rawlinson were to co-operate with French forces to support the Belgian Army at Antwerp.

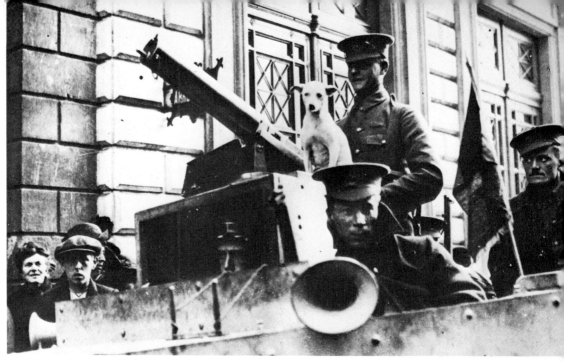

78. British Royal Marines
and mascot in an armoured
car in Antwerp, October 1914.
79. The Race to the Sea –
French cavalry on the march
past the Scottish Rifles who
are in bivouacs under the
trees on 5 October 1914.

80. Train halt in France – officers of the East Lancashire Regiment stretch their legs in the early morning of 11 October 1914.

Joffre, like Falkenhayn, had begun to see the opportunities and dangers offered by the open flank along the Channel coast, and also began to shift forces to the west. This appeared an ideal opportunity to move the BEF from its static positions along the Aisne nearer to its ports of supply, and to allow Sir John French to participate in the expected war of manoeuvre. So, from 1 October the BEF was gradually transferred to the north, being relieved by French divisions, and was to act in concert with the French Armies of the North commanded by General Foch. II Corps went first, then the Cavalry, now a corps of two divisions, then III Corps and finally I Corps on 14 October. The infantry were sent by rail and the cavalry marched:

> In the afternoon we marched to Fismes, and left by train at 6.20 pm. We had to crowd 45 men into trucks intended for 40, and even then had to leave the whole of B Company behind, to come on by the next train . . . The officers were fairly well off, some in carriages and some in open trucks with the wagons, but the men were very crowded.[51]

On 7 October the British 7th Division disembarked at Zeebrugge and was urged by the local Belgian authorities to hasten to Antwerp where the position was desperate. But Major-General Capper, the divisional commander, had no intention of being caught in the Antwerp trap. Instead, he proceeded to Bruges, sending his infantry and dismounted troops by rail and the transport by road. By the evening of 7 October the division was concentrated at Bruges and billeted in the town. With the collapse of Antwerp a matter of a

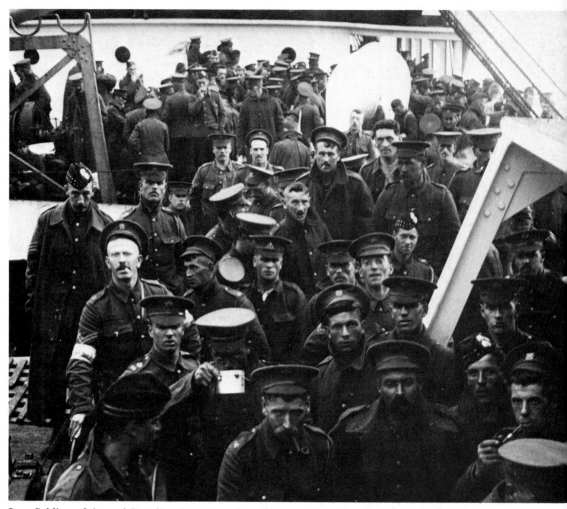

81. Soldiers of the 2nd Battalion Scots Guards and the 2nd Battalion Gordon Highlanders on board the ss *Lake Michigan* at Dover on 6 October 1914.

few days away, the Belgian Field Army and the Royal Naval Division evacuated the town by sea and road. Those units leaving by land headed south-west to link up with the 7th Division and the 3rd Cavalry Division which had also landed. The 7th Division proceeded to Ghent and dug field entrenchments on the outskirts of the town to cover the withdrawal of the Belgians and the Royal Naval Division. For the next few days Rawlinson's two divisions acted as a screen for these forces, whilst withdrawing in good order to link up with the BEF concentrating near Ypres. Between 12 and 14 October the 7th Division and the 3rd Cavalry Division with elements of the Royal Naval Division marched south to take up a position on the left flank of the BEF. As they marched the autumn leaves began to fall from the trees by the side of the road.

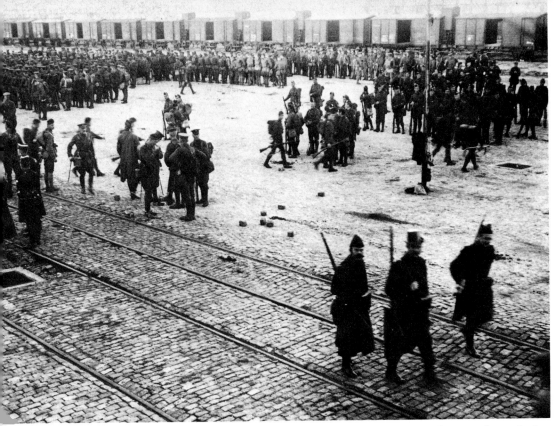

82. The Scots Guards and the Gordons disembarking at Zeebrugge by the railway yards watched by Belgian Civic Guards on 7 October 1914.

83. The Scots Guards en route by train from Zeebrugge to Ghent on 7 October 1914.

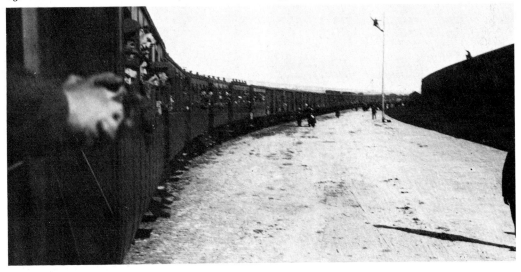

84. Wounded
British marines being
evacuated by bus from
Antwerp on 8 October
1914.
85. Walking
wounded – British
marines and Belgian
soldiers withdraw
from Antwerp.

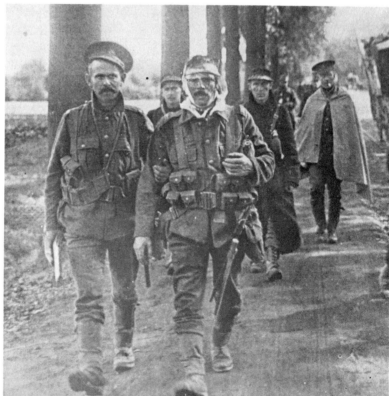

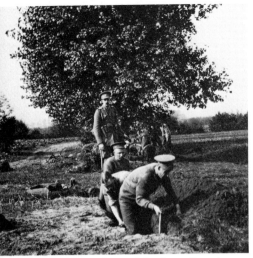

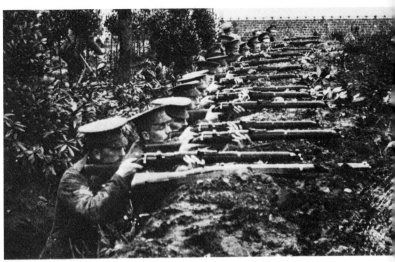

86. An officer of the Scots Guards supervising trench digging in a field outside Ghent on 9 October 1914.

87. Soldiers of the Scots Guards prepared to meet the expected German attack on Ghent on 9 October 1914.

88. Waiting for the Germans – soldiers of the Scots Guards snatch a hasty meal in an improvised trench outside Ghent on 9 October 1914.

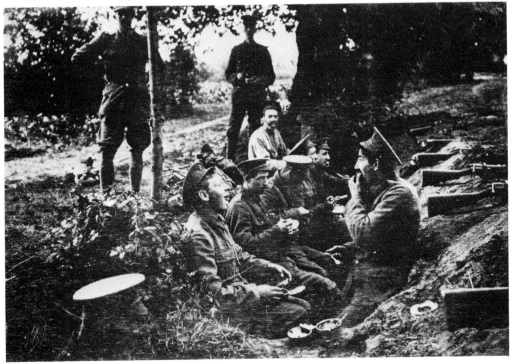

89. Lieutenant-
Colonel Bolton,
Officer Commanding
the Scots Guards,
consulting with a
Belgian General in
Ghent on 11 October
1914.

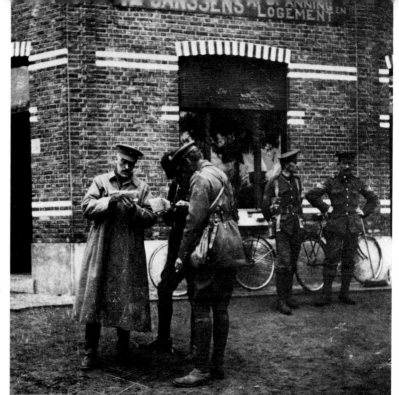

90. The Scots Guards
on the march
withdrawing from
Roulers to Ypres on
14 October 1914. In
the background
signallers work on the
telephone lines.

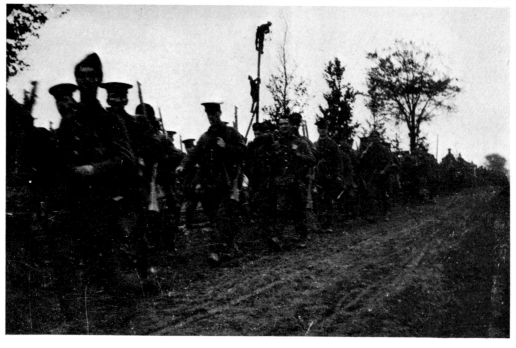

4
The Battle of Ypres

The countryside over which the Allies and the Germans planned to launch their respective offensives had a number of important topographical features. East of a line drawn north from Arras to Calais on the coast is the Flanders Plain, bounded to the south-east by a series of canals. The Flanders Plain is nearly dead flat and is broken only by a line of hills running eastwards which becomes a ridge east of Ypres, passing north-west through Wytschaete, Gheluvelt and Passchendaele. The ten miles of coastal zone is barely above sea level and is a dreary expanse of grass fields broken by canals, drainage dykes and roads on causeways. Nearly all parts of the Flanders Plain had a very high water table which rose in the autumn, thus any natural depression such as a ditch, or excavation such as a trench rapidly filled with water and caved in. Any large-scale movement of transport soon turned the ground into an expanse of mud. The southern part of the plain was well cultivated, with small villages, isolated houses, and small fields divided by hedgerows with trees in them. The countryside in autumn and winter was far from ideal for the conducting of military operations, with the movement of infantry and artillery limited and that of cavalry almost impossible. Given the flatness of the area, any slight rise in the ground gave an immediate point of observation and increased the importance of buildings and trees. South of the La Bassée Canal was a large mining area similar to Mons, with slag heaps, pit heads and narrow rows of miners' terrace cottages.

Flanders was an area of old and decaying towns and prosperous villages, with three great manufacturing centres around Lille, Tourçoing and Roubaix. It was a highly cultivated area producing tobacco, vegetables, hops, corn and alcohol. Ypres was an historic town which owed its original prosperity to the cloth trade, but had since fallen on hard times. The main roads were quite unsuitable for heavy traffic and soon broke up in winter. The local Belgian and French populations were dour and hard-working and

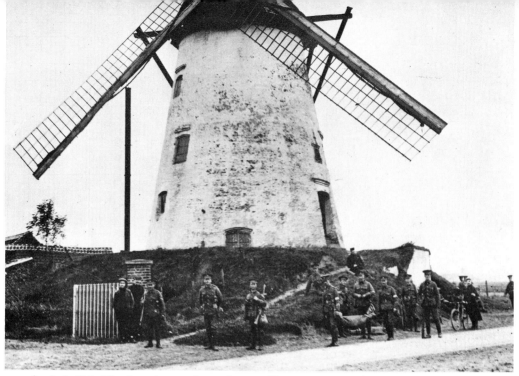

91. A windmill in Flanders about to be used as a military post by British soldiers.

92. Transport of the Scots Guards and infantry and cavalry of the 7th Division in the congested town square of Thielt on 13 October 1914.

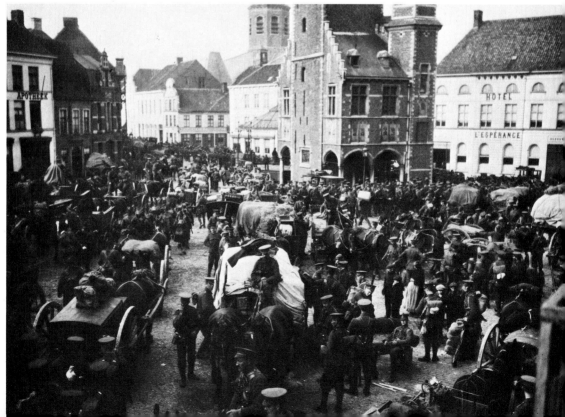

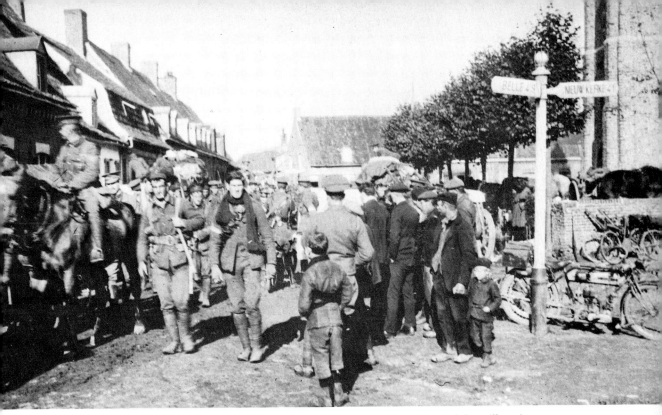

93. A column of British troops watched by curious civilians move through a Belgian village in Flanders.

extremely suspicious of their own governments as well as of foreigners. Flanders had been the cockpit of Europe for many centuries. Countless battles and skirmishes had been fought over the land, and the larger towns all bore witness to this, being girded by fortifications.

As Antwerp capitulated on 10 October the Germans and the Allies began to deploy their new forces in Flanders and tentatively probe each other's front looking for a weak point. On the Allied side French and British units were put in piecemeal as they arrived from the Aisne to link up with the Belgian Army and the French forces holding the coastal area and southwards to the outskirts of Ypres. The BEF was deployed south of Ypres with, on the right, II Corps west of La Bassée, then to the north III Corps at Armentières, the Cavalry Corps at Messines, and eventually IV Corps, as Rawlinson's command had become, covering the north-east of Ypres. I Corps was not to arrive until 20 October. French cavalry and infantry covered the many gaps between the British corps and provided some element of reserves. French cavalry acting in an infantry role provided a fascinating spectacle for the soldiers of the BEF:

A trench relief by our Ally's cavalry was a most interesting sight. As the French had no field-service uniform until 'horizon blue' was issued in 1915, they were in their full cuirassier dress: enormous white metal helmet with horsehair hangings: breastplate

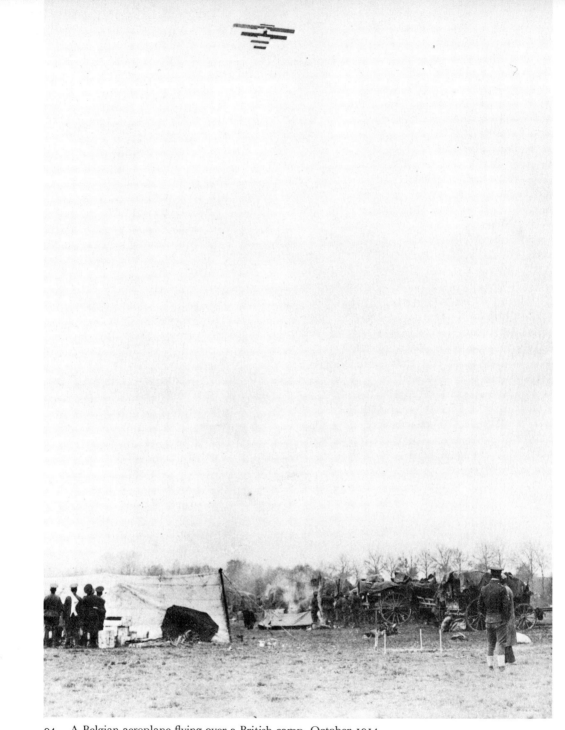

94. A Belgian aeroplane flying over a British camp, October 1914.

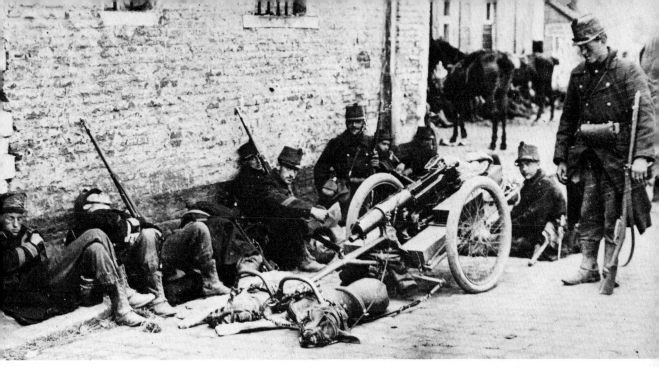

95. Total exhaustion – Belgian infantry and their dog-drawn machine gun rest by the side of the road, October 1914.

97. French heavy cavalry passing British artillery near Zelobes, Flanders, 13 October 1914.

96. Royal Flying Corps ground crew undergoing small arms drill on an airfield in Flanders, October 1914.

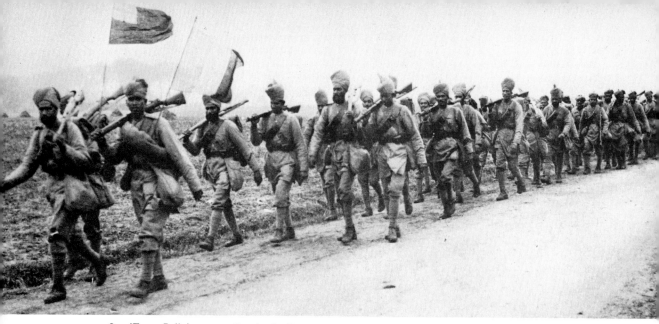

98. 'From Injia's sunny clime' – Indian troops march to the front near Ypres, October 1914.
99. 'Entente cordiale' – British and French soldiers in an obviously posed photograph playing cards outside a café in Flanders, October 1914. The two British soldiers sitting at the left are dispatch riders.

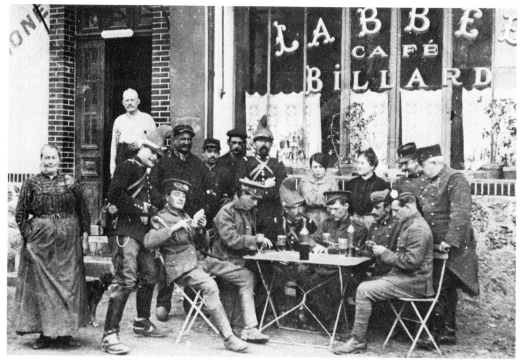

100. British artillery and infantry in column pass French Hussars near Ypres.

covered with cloth, over a dark blue tunic: red breeches and black leggings. They advanced to the line in single file carrying a carbine, like a popgun, in the left hand, and a lance in the right, and an enormous sabre was hooked up on the left hip. When asked why they carried lances, they said that their popguns were no use, and, having no bayonets, they wanted something to deal with the enemy if he came to close quarters.[52]

The only reinforcements available to the BEF were the Indian Corps, which had been sent on from Egypt and had begun disembarking at Marseilles, and 8th Division, made up of Regulars from overseas which would not be available until the beginning of November.

The BEF was now a larger and different force from what it had been in August. Although by 4 October the BEF had suffered some 31,709 casualties, its continual reinforcement over the same period had increased its total strength from 120,000 to nearly 200,000 men. Despite the fact that some units had been badly mauled in the first two months of fighting, the majority had been brought up to strength with the last drafts of Reservists. But there were few Regulars and Reservists left to draft, and to meet future losses through battle or to increase the size of the BEF meant turning to the Territorial Force and the as yet untrained volunteers being formed into Kitchener's New Armies. The Regulars tended, of course, to look down on the Territorials as amateurs and viewed the New Armies with horror. They wanted volunteers, but believed they should be trained in the depots of the Regular units and then sent as drafts to the Regular Army, not wasted in scratch formations.

The officers and men of the BEF were quite happy to exchange the attritional warfare on the Aisne for what they thought would be the more open warfare in Flanders, although they soon became depressed by the dismal countryside and its inhabitants. As the BEF

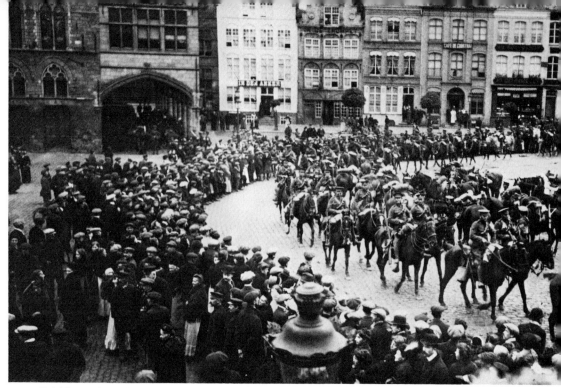

101. British cavalry ride through the Grand' Place in Ypres, 14 October 1914.
102. British infantry moving up to the front in Flanders.

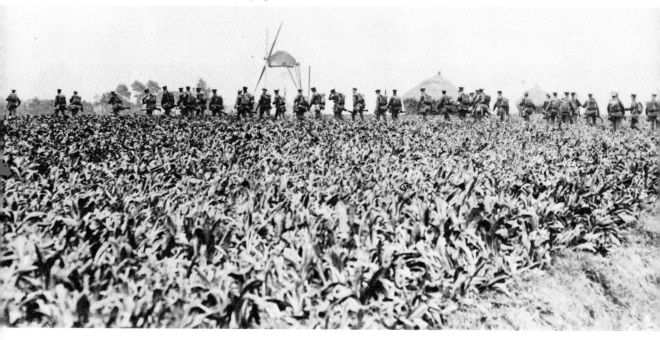

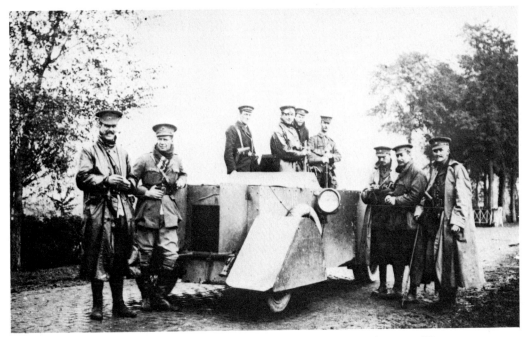

103. A British naval armoured car on the Menin Road near Hell Fire Corner at Ypres on
14 October 1914. On the right are officers of the Scots Guards.

took up its positions around Ypres a considerable amount of trekking was required before
formations reached their destinations, and so British and French troops marched and
counter-marched along the long, straight Flanders roads.

Despite the fact that Allied intelligence warned of increased German troop movements
in Flanders, both Foch and Sir John French were optimistic about their preparations for a
joint offensive. The only German troops encountered had been German cavalry who had
withdrawn in the face of Allied patrols. British troops deployed from the Aisne moved up
to the area around Ypres which was then undamaged:

> Marched off at 6 am to Ypres, through which we marched. Crowds of people in the
> streets to see us march through, and there appeared to be a tremendous lot of priests and
> nuns. Rather a nice old town, with narrow, cobbled-stoned streets, and some fine
> buildings.[53]

Between 11 and 20 October the BEF began to fight a series of engagements to push the
Germans out of Flanders. In the south II Corps began to fight around La Bassée, while
further to the north the Cavalry Corps, III Corps and IV Corps advanced at
Armentières and Messines. But the advance was slow and cautious for a number of
reasons. The countryside was difficult and the brigade and divisional commanders of the
BEF were very cautious about over-extending their forces. The weather was reasonably fine,
but for several hours each morning there was a thick mist. The German forces also

89

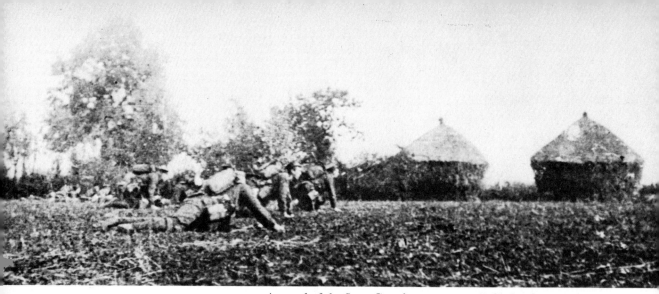

104. A patrol of the Scots Guards moves towards Gheluvelt on 20 October 1914.

105. The body of Drummer Steer, Scots Guards, who received a direct hit from a German shell whilst on patrol towards Gheluvelt on 20 October 1914.

106. German infantry on the line of march in Flanders, October 1914.

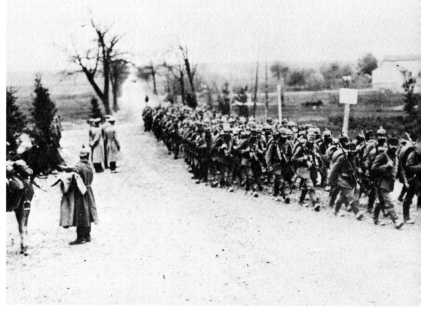

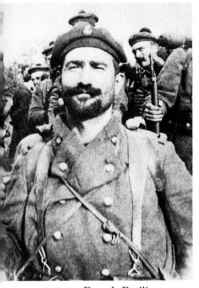

107. French Fusilier Marines of Admiral Ronarc'h's Brigade on the Yser front, October 1914.

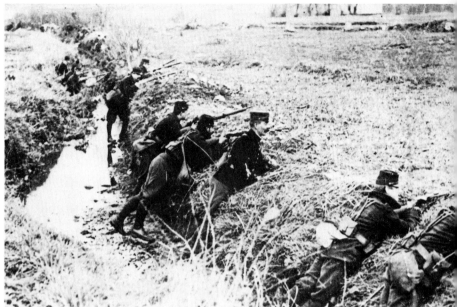

108. French cyclist troops lining a ditch in Flanders, October 1914.

conducted excellent defensive rearguard actions with machine gunners and riflemen occupying farm buildings and ditches to slow down the allied advance. The cavalry found it difficult to move across country, and the artillery was continually trying to find suitable gun positions.

Whilst the Allies carefully advanced, Falkenhayn was preparing his own forces for an offensive which would smash the Allied left flank and enable the Germans to take Calais. Apart from the Sixth Army which had been formed in Flanders, Falkenhayn formed a new Fourth Army out of the German III Reserve Corps, a Marine Division and four Reserve Corps made up of mainly volunteer university students and schoolboys. On 17 October the Fourth Army began to advance westward from the line Courtrai–Ostend towards Ypres. So, whilst the Allies were still attempting to maintain the momentum of their own offensive against stiffening German resistance, the Germans in turn were preparing their own powerful offensive in the same area.

The German offensive began on 20 October with a general attack on the whole front between the La Bassée canal in the south and the sea in the north. They very nearly broke through in the north along the Yser, and it was not until the 28th that the Belgians and the French marines under Admiral Ronarc'h were able to beat them back. In the south around La Bassée, Armentières and Messines, II and III Corps with the Cavalry Corps found themselves on the defensive and had to dig rudimentary trenches and use the natural features of the ground for cover against heavy German artillery bombardments. Around Ypres the Germans were stopped by the timely arrival of Haig's I Corps from the Aisne. But German pressure to the north and south of Ypres produced a dangerous salient

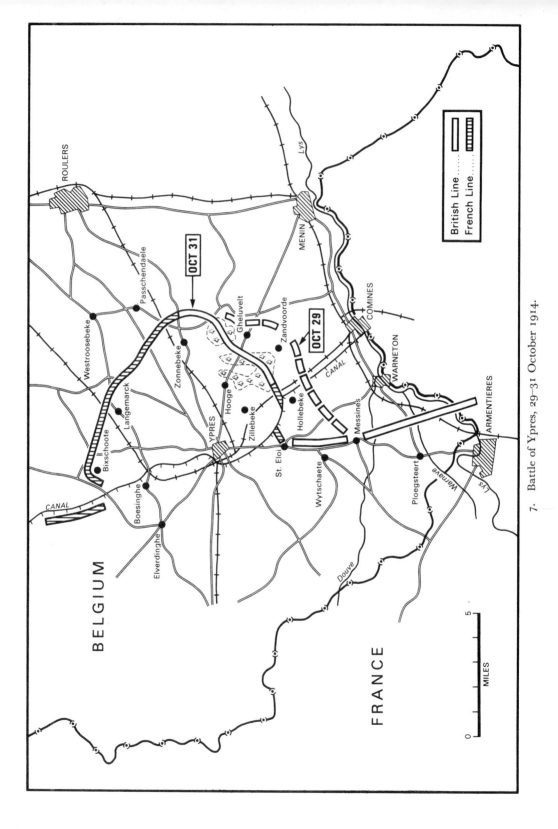

7. Battle of Ypres, 29–31 October 1914.

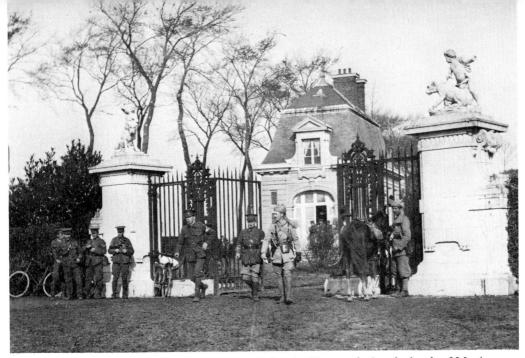

109. Officers of the 2nd Cavalry Division leave Hollebeke Chateau during the battle of Messines, October 1914.

110. Digging trenches near Zandvoorde – 2nd Battalion Scots Guards, 20 October 1914.

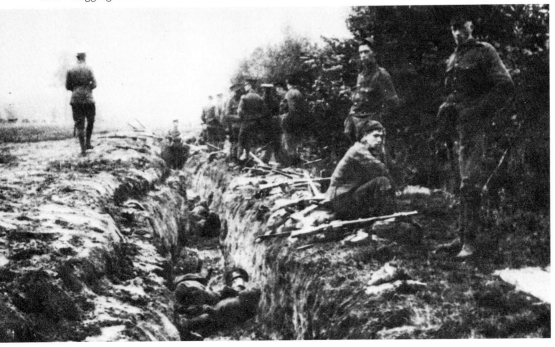

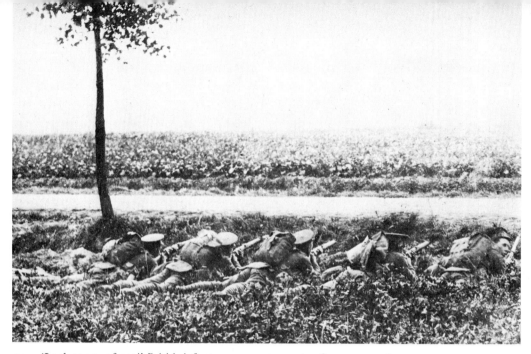

111. 'Look to your front!' British infantry prepare to meet a German attack.

which was difficult to defend. On 25 October the German Fourth Army made a determined effort to take Ypres by launching a powerful attack against the British 7th Division in the south of the salient. Captain H. M. Dillon of the 2nd Battalion Oxfordshire and Buckinghamshire Light Infantry wrote to his sister explaining what it was like to withstand such a German attack:

> A great grey mass of humanity was charging straight on to us not 50 yards off, about as far as our summer-house to the coach-house. Everybody's nerves were pretty well on edge, as I had warned them what to expect, and as I fired my rifle all the rest went off simultaneously. One saw the great mass of Germans quiver. In reality some fell, some fell over them, and others came on. I have never shot so much in such a short time; it could not have been more than a few seconds, and they were down. Suddenly, one man – I expect an officer – jumped up and came on. I fired and missed, seized the next rifle, and dropped him a few yards off. Then the whole lot came on again, and it was the most critical moment of my life. Twenty yards more and they would have been over us in thousands, but our fire must have been fearful, and at the very last moment they did the most foolish thing they possibly could have done. Some of the leading men turned to the left for some reason, and they all followed like a great flock of sheep. We did not lose much time, I can give you my oath. My right hand is one huge bruise from banging the bolt up and down. I don't think one could have missed at the distance, and just for one short minute or two we poured the ammunition into them in boxfuls. My rifles were red hot at the finish, I know, and that was the end of the battle for me. The firing died down, and out of the darkness a great moan came. Men with their legs and arms off trying to crawl away; others, who could not move, gasping out their last

94

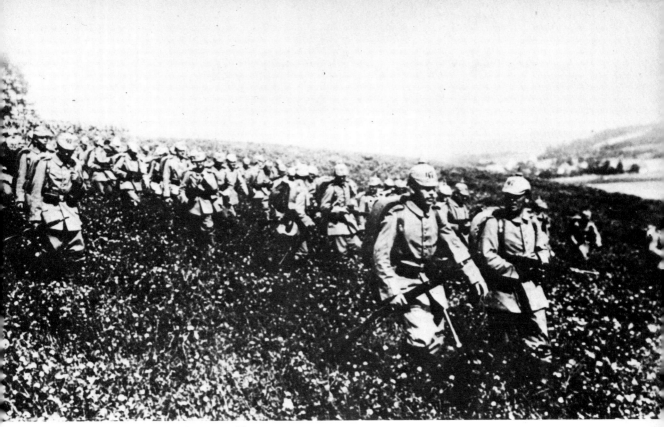

112. German infantry advancing at Ypres.

113. German dead in front of the trenches of the Scottish Rifles after an attack on 'Ritchie's Farm' during the battle of Armentières, on 29 October 1914.

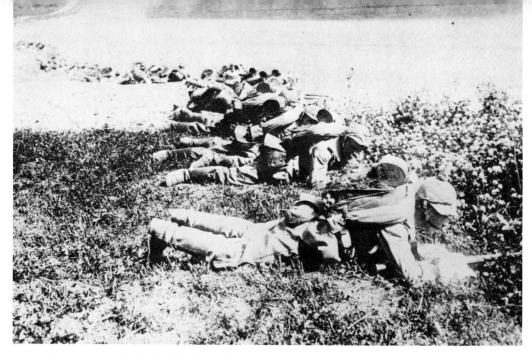

114. German troops deploy in Flanders, October 1914.

moments with the cold night wind biting into their broken bodies, and the livid red glare of a farmhouse showing up clumps of grey devils killed by the men on my left further down. A weird, awful scene![54]

Although the division suffered very heavy casualties, the line was held through sheer determination. Many of the German casualties were amongst the student volunteers whose bravery was witnessed by Rudolf Binding, a German cavalry officer:

> . . . these young fellows we have, only just trained, are too helpless, particularly when the officers have been killed. Our light infantry battalion, almost all Marburg students, the best troops we have as regards musketry, have suffered terribly from enemy shell-fire. In the next division, just such young souls, the intellectual flower of Germany, went singing into an attack on Langemarck, just as vain and just as costly.[55]

Between 20 and 29 October the Germans continued to send in massed attacks around Ypres after prolonged artillery bombardments:

> Some of the enemy had now come out of the trees and no doubt intended to advance a little way under cover of their barrage. But the shelling was not severe enough to prevent us opening up a rapid fire at them. I don't think any of them ran twenty yards before he was dropped. To good, trained, pre-war soldiers who kept their nerve, ten men holding a trench could easily stop fifty who were trying to take it, advancing from a distance of four hundred yards.[56]

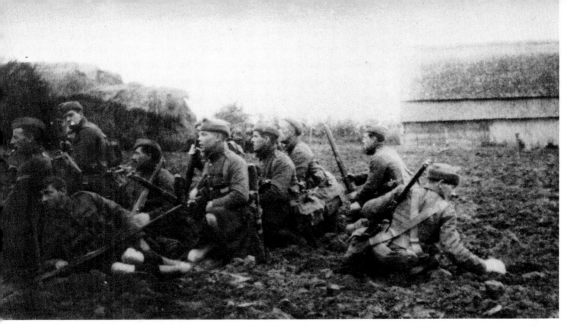

115. A patrol of the Gordons watch and wait on the edge of a field near Ypres.

The British line held although it was pushed back in several places. On 31 October the Germans attacked at Gheluvelt to the east of Ypres with seven fresh divisions brought from the Aisne. These divisions were backed up with plenty of artillery support, and the assault fell on the 1st, 2nd and 7th Divisions, and on the Cavalry Corps:

> It had been an awful day – far the heaviest shelling since the Aisne, or in fact during the War so far, and it was more than anything their good digging which enabled our men to hang on. Our short lengths of deep trench were very difficult to spot and only a few got direct hits. The men were steady as rocks and when the German infantry came on they withered away under our rifle fire.[57]

116. A long way from the north-west frontier – soldiers of the 129th Baluchies man a breastwork outside Wytschaete in October 1914.

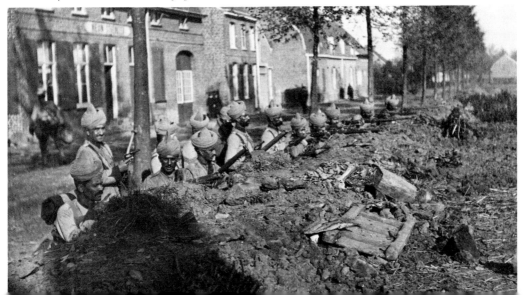

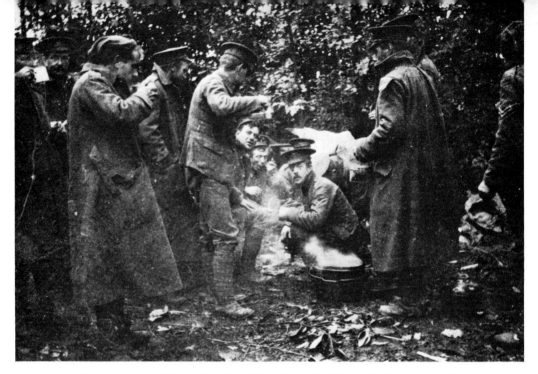

117. Issue of hot cocoa to soldiers of the Scots Guards on the Menin Road on 27 October 1914.
118. French wounded talk to a member of the British Army Chauffeurs Corps, recruited from volunteer gentlemen, outside Ypres.

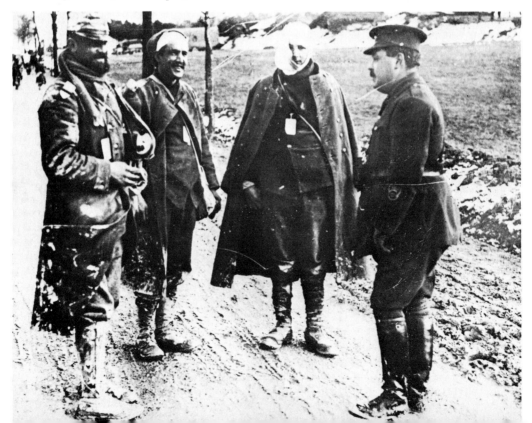

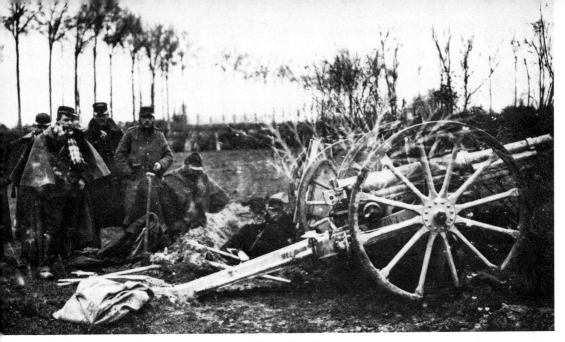

119. A French '75' hastily dug-in near Ypres, October 1914.

This was the day of crisis at Ypres when the Germans nearly broke through the BEF. They actually succeeded in taking Gheluvelt and it appeared that all was lost when a weakened battalion of the Worcestershire Regiment counter-attacked and drove them back. Before this counter-attack it seemed that the Germans might be able to push through to Ypres as there were virtually no British reserves available. Haig sent Charteris, an officer on his staff, forward to see what was happening:

> You cannot imagine the scene. The road was full of troops retreating, stragglers,
> wounded men, artillery and wagons, a terrible sight. All the time there was the noise of
> a terrific bombardment. It was impossible to get any clear idea of the situation. Nobody
> knew anything except what was happening on his immediate front and that was always
> the same story. The Germans were attacking in overwhelming strength and our men
> were being driven back but fighting every inch of the way. The only glimmer of hope
> was that a counter-attack was being organised. When I got back to our own HQ (at the
> White Chateau) I found that D.H. had ridden forward himself and Gough was organising
> the mess servants for fighting it out in the chateau. Gough was quite unruffled, and
> amused me by saying, 'It don't matter a damn what happens here. God won't let those
> b . . . win.'[58]

The battle on the 31st was a real regimental soldier's battle, and every man counted, as brigade and divisional commanders led their men forward:

> On the road a dismounted cavalry regiment passed us on their way to the muttering
> battle line, their sabres strapped to their sides, and their spurs still on their boots. They
> carried their rifles awkwardly at ease, and marched stiffly. A queer sight for infantry.[59]

99

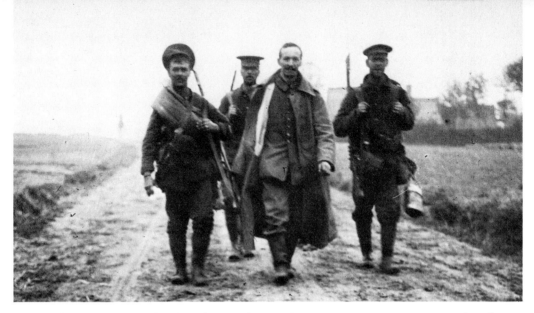

120. A German prisoner being brought back from the line by three soldiers of the Scots Guards outside Ypres.

Any troops that were available were used to reinforce the front line:

> I saw Webber leading his company of R.E.s out: the only officer left. He was cheery as ever, smoking his pipe with the bowl upside down, a spare pipe stuck in the waist-belt of his Sam Browne belt, and told me with great pride that his R.E. company had delivered an infantry attack, and performed great deeds.[60]

Some of the chaos and confusion was caused when senior officers were killed and wounded:

121. The view from a front-line trench of the Scottish Rifles.

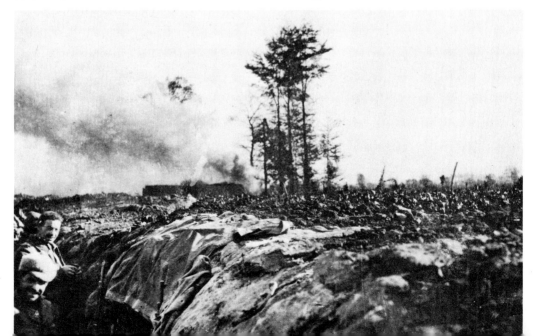

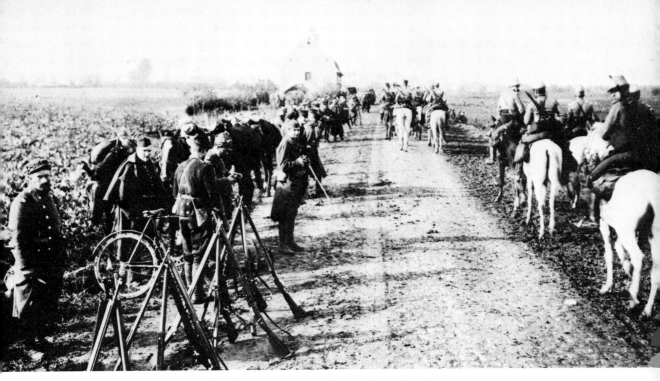

122. French Hussars passing French infantry on a road near Ypres, October 1914.

I rode on about a mile and found some staff officers and asked for General Bulfin and was told he had been wounded and that Cavan was taking over command of all troops in the neighbourhood.[61]

But Messines Ridge was lost by the Cavalry, and some ground to the north. The Germans were to make one more major attack on the Gheluvelt sector on 11 November, but were again driven back by counter-attacks:

Before the shelling ceased we were ordered to man the trench: 'STAND TO, STAND TO, EVERYONE,' and our rifles lined our broken parapets. The man of my section on my immediate left kept his head down. I grasped his arm and shook him savagely: 'For Christ's sake, get up, you bloody fool. The Germans are coming.' He fell over sideways and on to his face when I released him, and exposed a pack covered with blood. He was dead, and my eyes came off him to my shoulder, which was spattered with his brains and tiny slivers of iridescent bone.[62]

After the failure of this attack the crisis in Flanders for the Allies was over although the Germans continued to launch attacks around Ypres until 22 November.

The battles around Ypres which lasted from 20 October until 11 November were fought out in the form of a traditional encounter battle. Both the Allies and the Germans intended

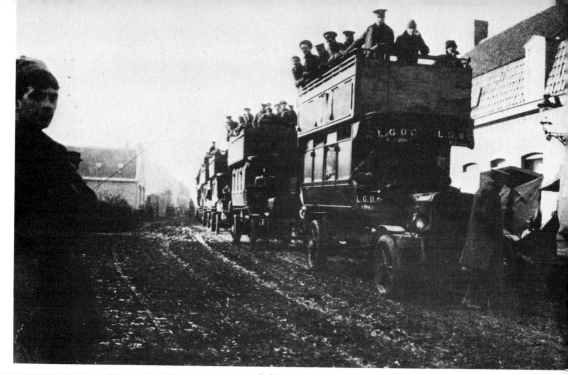

123. Soldiers of the 2nd Battalion Royal Warwickshire Regiment being transported through Dickebusch to Ypres on 6 November 1914.

124. British infantry in a trench outside Ypres.

125. Soldiers of the York and Lancs Regiment in a front-line trench at Bois Grenier, November 1914. Standards of dress tended to slip a little in the front line.

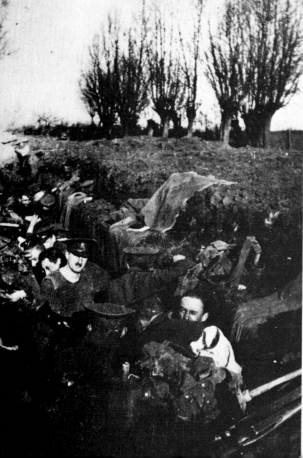

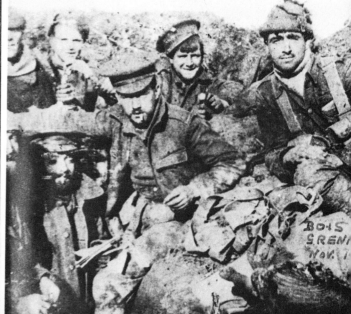

that it should be a decisive battle, but each side underestimated the strength and determination of the other. The outcome was a close run thing with the element of chance always present, and each side was reduced to using its final reserves of manpower before mutual exhaustion set in.

For the soldiers of the BEF it was a bloody three weeks. They found themselves fighting on the defensive from 20 October after a week of limited advances. The BEF was not prepared for the violence of the German attacks, and lacked the manpower, weapons and equipment to fight what turned out to be a fierce attritional battle. For the infantry, the fighting around Ypres was a nightmare of living in hastily dug trenches or in drainage ditches, repelling mass German infantry assaults after heavy artillery bombardments:

> We dug those trenches simply for fighting; they were breast-high with the front parapet on ground level and in each bay we stood shoulder to shoulder. We were so squeezed for room that whenever an officer passed along the trench one man would get behind the traverse if the officer wanted to stay awhile in the bay. No man was allowed to fire from behind the traverse: because the least deflection of his rifle would put a bullet through someone in the bay in front of him. Traverses were made to counteract enfilade rifle-fire. Sandbags were unknown at this time.[63]

Those who survived had learnt to dig deep:

> 26 October – Found us in trenches and digging like mad to improve them. Can't make out why every Battalion doesn't dig itself in properly. If they did they might never be turned out of their trenches like some of them have been lately.[64]

Some units stayed in one place for two weeks, others were moved around from place to place, filling in gaps in the line and making counter-attacks. Many soldiers lost all sense of time through the exhaustion of fighting, digging and lack of sleep. There were too few Engineers available to build proper field entrenchments:

> The night before a party of Engineers had come up to our trench and had driven some posts in the ground about fifteen yards in front with one strand of barbed wire stretching across them. It looked like a clothes line during the day. We had put a covering party about thirty yards in front of them while they were doing the work. The Old Soldier of the platoon remarked that the British Government must be terribly hard up, what with short rations, no rifle-oil, no shells, and now sending Engineers up to the front line to stretch one single bloody strand of barbed wire out, which he had no doubt was the only single bloody strand in the whole of France, and which a bloody giraffe could rise up and walk under. It was enough to make good soldiers weep tears of blood, he said, the way things were going on.[65]

In any case, the majority of the Engineers were kept back by brigade commanders as an emergency fighting force to plug gaps in the line.

The infantry lived in their rifle pits and trenches and washed and cooked as circumstances permitted. As the weather deteriorated, rain and sleet made living out in the open almost unbearable:

126. A primitive trench – this offered protection for men of the Scottish Rifles who had to cross the road at Armentières on 28 October 1914.

> A beastly day; cold, wet and raw; with nothing to do except squat in a cramped and damp dug-out. We've none of us had our clothes off for nearly a month, and our feet from being constantly wet are swollen and chilled.[66]

Mud not only made living in the trenches unbearable it also made it difficult for the troops to maintain their rifles in good condition:

> Rain and mud were by now causing a lot of trouble with rifles; and the supply of oil had given out. There was nowhere to lay or lean a rifle without its getting clogged with mud, or a plug into the muzzle, which caused the barrel to bulge or burst when a shot was fired. D Company had two ramrods to clear jammed barrels. Pass it along, the ramrod's wanted!' was constantly being called from the right or left of the company . . . The serviceable rifles of the Support Company had to be sent up to the front, leaving their owners practically unarmed. Once when things were rather threatening, the C.O. ordered those who had no rifles to arm themselves with picks and shovels.[67]

The Royal Artillery found it very difficult to give the infantry sufficient fire support as the Germans engaged in counter-battery fire and continually forced them to move positions. Furthermore, the Royal Artillery was very short of shells as the original shell allocation per gun for the estimated duration of the war had already been exceeded. By the end of October, therefore, some batteries rationed each gun to a few shells a day. The cavalry found themselves fighting as infantry at Ypres, their main value being that as they were mounted they could be moved from one threatened part of the front to another.

The attritional nature of the fighting meant that there were very heavy casualties amongst the infantry, and so cooks, grooms and clerks found themselves pressed into the

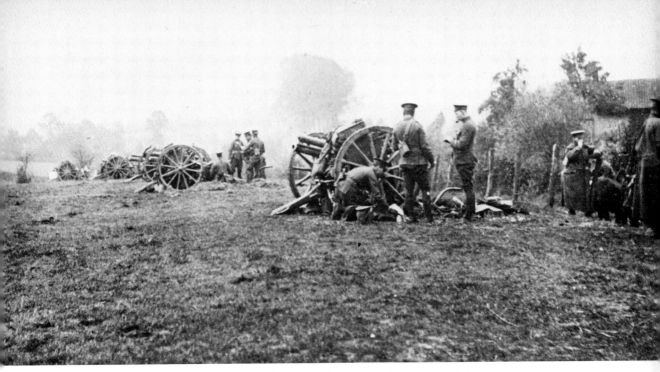

127. 'J' Battery Royal Horse Artillery coming into action at Wytschaete on 31 October 1914.
128. A British Household Cavalry trooper eating his rations in the field in Flanders in October 1914.

129. Brigadier-General Charles FitzClarence VC, GOC 1st Guards Brigade, killed in action whilst organising a counter-attack at Polygone Wood on 11 November 1914.

130. The offensive spirit – Major-General Thompson Capper, GOC 7th Division, knighted for his services during the battle of Ypres. He was later mortally wounded during the battle of Loos in September 1915.

line. Divisional, brigade and regimental officers were killed and wounded and junior officers found themselves taking over command. Major-General Lomax, GOC 1st Division, was mortally wounded and several of his staff killed during the fighting on 31 October, and Brigadier-General FitzClarence, GOC 1st Guards Brigade, was killed organising a counter-attack on 11 November. There were few 'Chateaux' Generals and staff officers in October 1914. Fifty-six staff officers were killed with the BEF between August and December 1914. Charteris claims that during the fighting at Ypres Major-General Capper, GOC 7th Division, was heard to say, 'No good officer has a right to be alive during a fight like this.' He also says of Capper:

> There is a story that he came into the Staff Mess one day and said, 'What! nobody on the Staff wounded today; that won't do!' and forthwith sent everyone available up to the first-line trenches on some mission or other.[68]

Some young officers were actually exhilarated by their experiences:

> I have not washed for a week, or had my boots off for a fortnight . . . It is all *the* best fun. I have never felt so well, or so happy, or enjoyed anything so much. It just suits my stolid health, and stolid nerves, and barbaric disposition. The fighting-excitement vitalizes everything, every sight and word and action. One loves one's fellow man so much more when one is bent on killing him.[69]

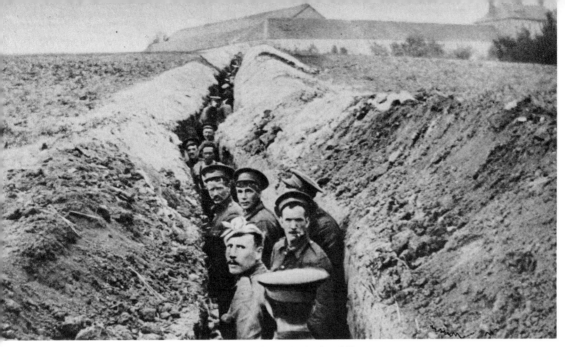

131. A primitive communication trench full of British soldiers.
132. 1st Battalion Grenadier Guards resting by the Menin Road, October 1914.

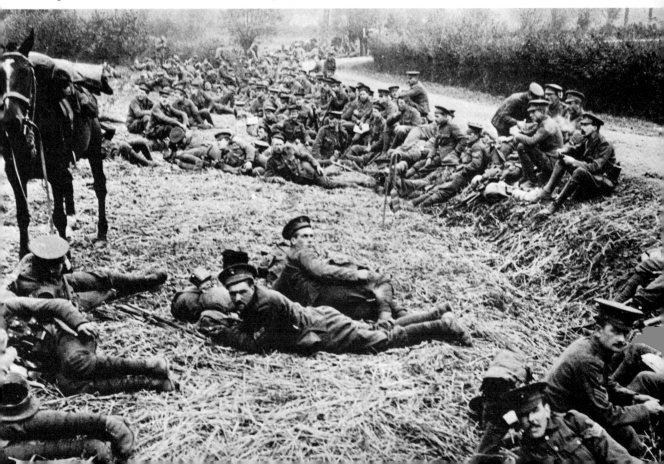

133. Battalion Headquarters of the York and Lancs Regiment, Ferme de Biez, Armentières,
October 1914. Recent casualties are buried in front of the farm buildings.

As a result of the ferocity of the German attacks on the BEF, Sir John French successfully
appealed to Foch to have French troops relieve the British where possible. In this way the
northern extent of the BEF's line progressively moved south of Ypres as the French took
over more and more of the line. By the time the last of the German attacks were made on
22 November, the Allied line had stabilised into some degree of formality. Field
entrenchments, rifle pits, ditches and buildings became linked in some sort of continuous
line, with sometimes a second line behind, and a sketchy communication trench leading to
the rear. Reliefs and reinforcements could then be got to the front line without
unnecessarily exposing themselves. On 15 November it began to snow, and both the
British and the Germans moved into any habitable buildings for warmth and comfort. But
enemy action could disrupt the comfortable routine:

> We managed to feed very well; there is a farmhouse close by where we used to cook our
> meals but just after we had had our breakfast and gone back to our trenches the other
> day the Germans put a shell into it and killed 2 men and 3 horses, so now we have our
> meals cooked in the farm and brought down after dark, and before daylight.[70]

The casualties of the BEF between 14 October and 30 November were 58,155, the
majority of whom were infantry. Of the eighty-four British infantry battalions at Ypres on
1 November, eighteen had fewer than 100 men, thirty-one fewer than 200 men, twenty-six
had fewer than 300 men, and only nine exceeded 300 men. The 7th Division lost 372
officers and 9,493 men between 14 October and 30 November, having borne the brunt of
some of the fiercest German attacks. The battle of Ypres had seen the death of the old
Regular Army.

108

134. Inside Battalion
Headquarters of the York and
Lancs Regiment – from left to
right, a company commander,
the CO and the adjutant.

135. Headquarters cooks York
and Lancs Regiment, October
1914.

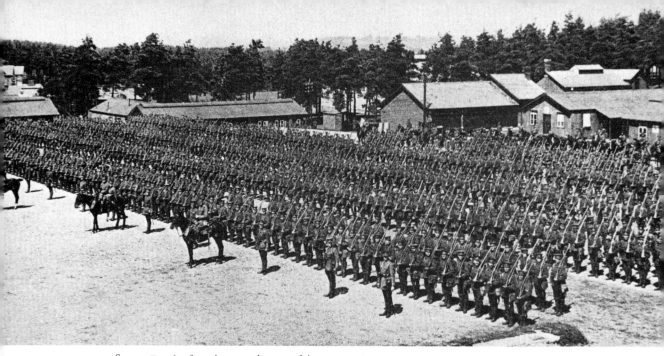

136-7. Death of an Army – the casualties amongst the infantry of the BEF between mobilisation in August and the end of the bitter fighting at Ypres in November 1914 can be seen by comparing these two photographs of the 1st Battalion The Queen's Royal Regiment, on mobilisation in August 1914 and on 9 November 1914.

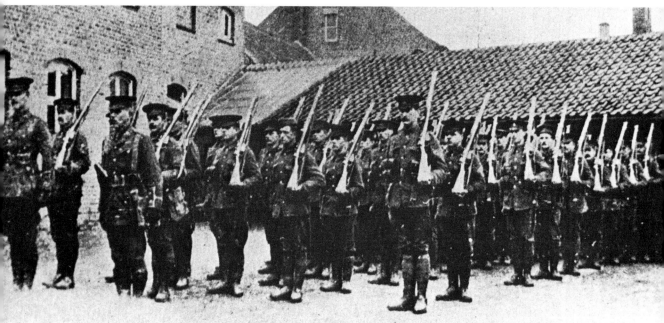

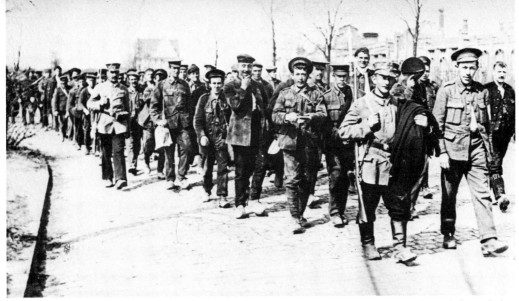

138. 'Old Contemptibles' taken prisoner of war by the Germans set out for a day's work from their camp at Teltow, near Berlin. Many of them have incomplete uniforms and have clogs on their feet.

The total casualties of the BEF between 5 August and 30 November 1914 was 86,237, and the greater proportion of them had been amongst the infantry of the first seven divisions. The French probably lost about 50,000 men at Ypres and the Germans lost 134,315 between 15 and 25 October just on the front from La Bassée and Gheluvelt. Their casualties had been particularly heavy amongst the university and schoolboy volunteers of the Reserve Corps, and their deaths in action became known to the Germans as the *Kindermord bei Ypern*, 'The Massacre of the Innocents at Ypres'.

Those who survived had learned to dig deep, and from now on the fighting would be a war of attrition in the trenches.

139. What the papers say – soldiers of the 7th Division discuss the war news during a roadside halt outside Ypres.

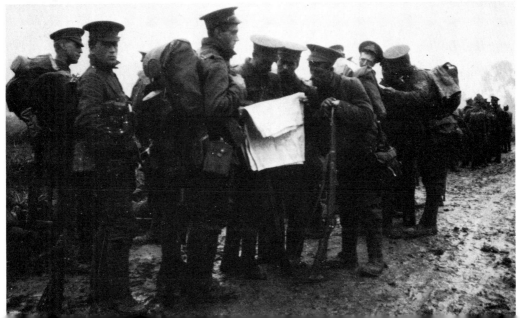

5

Aftermath

'Ypres saw the supreme vindication and the final sacrifice of the
old Regular Army. After the battle was over, very little survived,
save the memory of its spirit.'

B. H. Liddell Hart

From 15 November the Allies began to reorganise the distribution of their forces in
Flanders. The BEF was to hold a compact front of some twenty-one miles from the
southern end of the Ypres salient south to Givenchy, near the La Bassée canal. From north
to south the BEF was organised in the line with II, III, IV and Indian Corps in
succession, and I Corps and most of the Cavalry Corps held in reserve. Until the middle of
December both sides were occupied with improving their trench systems and reorganising
their forces. From the end of October the BEF had been reinforced with an increasing
number of Territorial units, one of which, the London Scottish, had fought magnificently
during the battle around Ypres. These Territorial units with the Indian Corps brought the
total strength of the BEF to 224,647 on 15 November.

Senior officers encouraged front-line troops to improve their trenches and to put out
wire obstacles. But there was a serious shortage of all trench tools and equipment. Rain and
snow meant that the water table rose and flooded the trenches so frequently that pumps
had to be used and in many areas barricades of sandbags above ground had to substitute
for trenches:

> A dreadful line in low-lying waterlogged country. Many of the trenches simply wet dykes
> into which the Indians had been driven when they lost their trenches. Such trenches as
> existed were full of water and mud and no better than the dykes. Several men had to be
> dug out of the mud into which they had sunk. Enemy continually sniping and the flat
> country swept by bullets in all directions. Battalion headquarters in a small and smelly
> farm with a bottomless pit in front of it. Very cold night: alternately snowing and
> raining.[71]

Materials for the construction of revetments and dug-outs had to be scrounged, and the
Territorials were amazed at the abilities of the old Regulars to make themselves

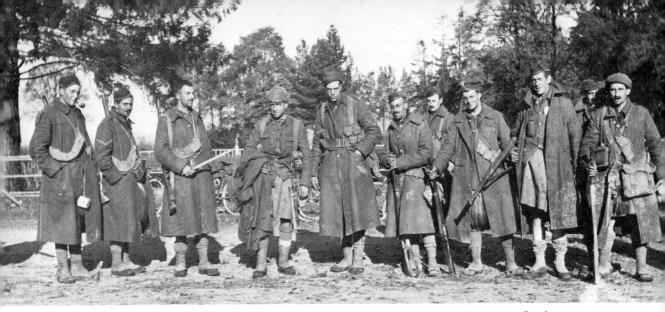

140. The face of battle – survivors of the London Scottish after the battle of Messines on 31 October 1914.

141. A British soldier operating a pump in a waterlogged trench at Ypres, December 1914.

142. Sergeant Coggan, York and Lancs Regiment, in charge of the machine-gun section in October 1914. Note the barricades of sandbags above ground level because of the waterlogged ground around Ypres which made digging trenches very difficult.

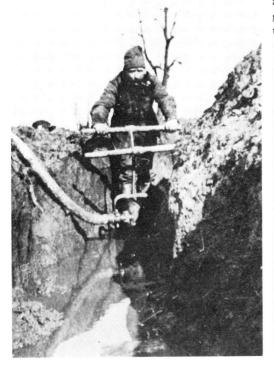

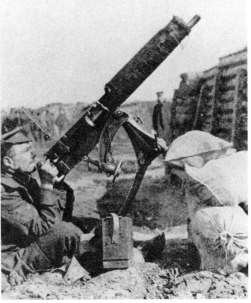

143. Barricades of sandbags erected across the Lille–Armentières railway at Rue de Bois by the York and Lancs Regiment, November 1914.

144. Sleeping accommodation in the front line – the rear of the Scottish Rifles' trenches showing 'bedrooms' in the Houplines sector on 18 November 1914.

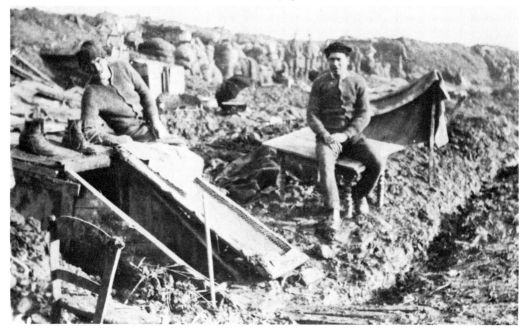

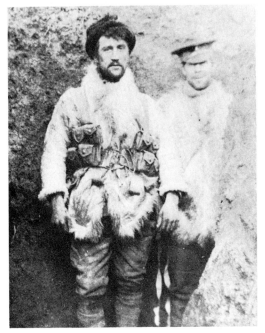 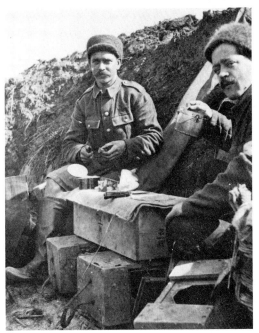

145. Winter goatskin jackets worn by soldiers of the York and Lancs Regiment in a front-line trench, November 1914.

146. Stretcher bearers of the Argyll and Sutherland Highlanders enjoying a genteel breakfast in the front line, November 1914.

comfortable. Re-equipping and re-fitting of units also proceeded with arrangements being made to provide baths behind the lines in converted breweries and farms, after which new clothes were issued to replace the smelly rags many of the Regulars had been wearing.

With the onset of cold weather appeals were made to the British public for warm clothing for the troops, and socks and cardigans began to appear provided by patriotic ladies. Limited issues of leather jerkins and goatskin coats were made and became the prized possession of many soldiers. The infantry began to get into a regular routine of duty at the front which meant a certain amount of time in the line, followed by a period in reserve 'resting'. In the line, apart from sniping and shelling, the main job was improving the trench system which was still primitive and informal by later standards. Apart from certain areas which had been extensively fought over or heavily shelled, the landscape still looked remarkably peaceful. Local Belgian and French people still lived near the front lines and farming was frequently carried out in range of the guns. The front line meandered across fields, along ditches, through villages and even through buildings, reflecting the situation when the fighting had finished. Sometimes the British and German front line trenches were a few yards apart, at other points several hundred yards distant. When units were out of the line 'resting', this usually meant hard labour repairing roads and moving stores. Life was easier for the gunners, sappers, drivers and storemen who worked from fixed gun positions or depots which enabled them to make themselves reasonably comfortable.

147. Informal armistice at the Rue de Bois in December 1914. Soldiers of the 2nd Battalion Argyll and Sutherland Highlanders construct a hurdle and mud breastwork after their trench had been flooded. The German trenches were in front of the trees to the left.

148. A frosty dawn in the trenches – making 'gunfire' tea in the Houplines sector on 18 November 1914.

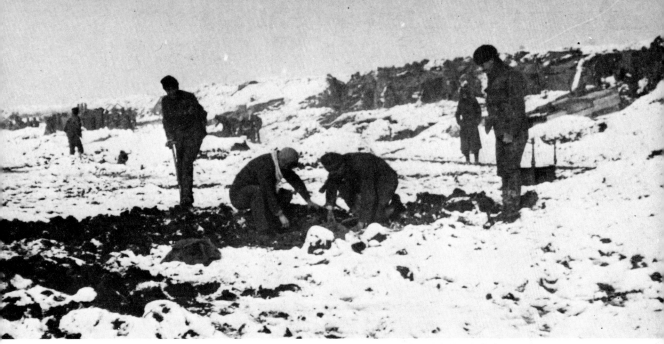

149. Men of the Scottish Rifles digging for potatoes in a snow-covered field behind their trench on 20 November 1914.

150. The view across no-man's land on 5 December 1914 – the ground in front of the Scottish Rifles trenches showing the primitive barbed wire and the obstacles and the German trenches two hundred yards away – the houses concealed German snipers.

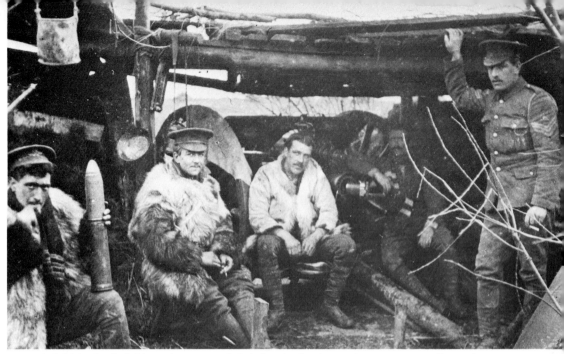

151. A British 18-pdr field gun in a concealed shelter in the Armentières sector on 7 December 1914. At this time the Royal Artillery were rationed to a few shells a day. Some of the gunners are wearing the goatskin jackets.

Behind the lines a whole range of organisations sprang up to supply the front line. Ordnance and transport parks were established, and new workshops were organised to provide equipment and weapons for trench warfare, ranging from periscopes to primitive hand grenades. It was the ambition of nearly every Regular 'Old Bill' to get a cushy number in the rear where warmth and safety could be found. They thought it unfair that these jobs should be taken by 'Johnnie-come-latelies', and believed they should go to the 'old sweats' who had done their bit. Many of the Regulars knew they had been lucky to survive the previous three months and were disturbed by the high changeover of personnel in their units. Familiar faces from peacetime soldiering had gone and the new men did not know the language and habits of 'real' soldiers:

> Two hundred more men had now joined us. We did not know most of them, and we were not greatly interested. They were a mixture of Special Reserve and Militia men, with one or two of our own old wounded sent back cured . . . In the reorganisation following the arrival of these fresh men we lost to a great degree our quality of being old regulars, though the spirit and traditions of the regiment never died. I lost Cordwain and Shea, the last of my section, and had to build again with four new men. These had not the smartness of the Regulars, and I could not take them rapidly to my heart. Their habits were unsoldierly, and repellent to me.[72]

Apart from sniping and artillery fire to disturb the peace, life at least behind the lines became much more relaxed for the British soldier. Local estaminets were encouraged to

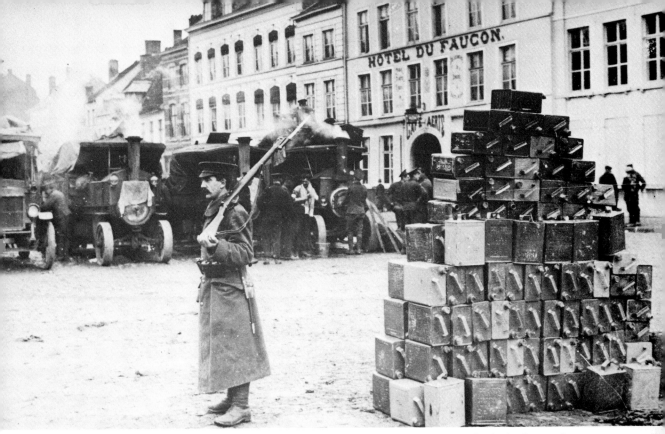

152. A British sentry guarding a motor transport petrol dump in a Belgian town. In the background are Army Service Corps traction engines.

153. Soldiers of the Scottish Rifles being given instruction in the handling of a machine gun in a deserted spinning mill in Armentières on 7 December 1914.

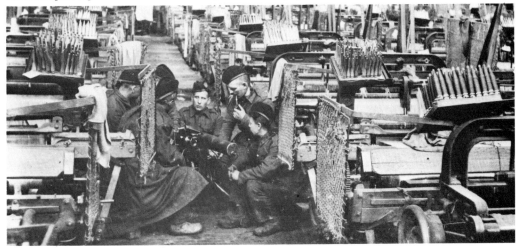

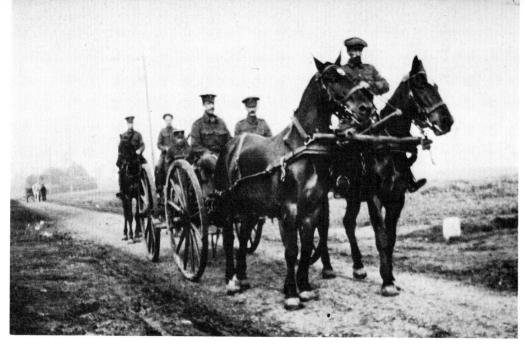

154. A Royal Engineers telephone cable wagon in Flanders, November 1914.
155. Cushy billets – British soldiers use a large greenhouse as a billet behind the lines near Ypres, November 1914. Their evident relaxation may be due to the large rum jars in the foreground.

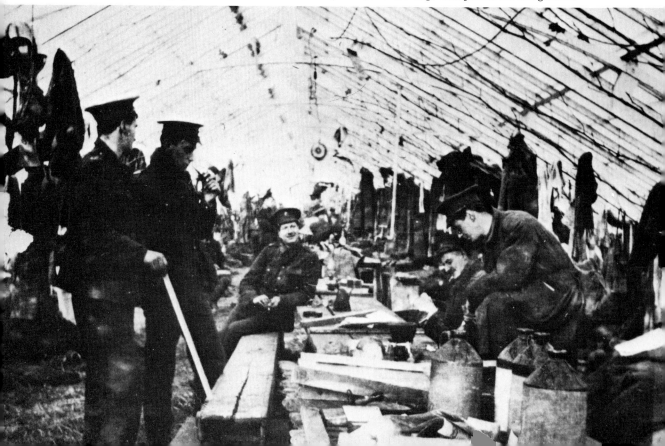

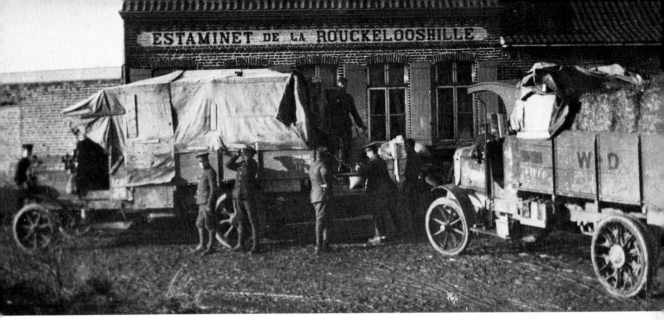

156. A local estaminet, Headquarters of the 1st Cavalry Brigade, December 1914.

157. Soldiers of a Territorial Force Royal Engineers unit sort out mail on the back of a GS wagon behind the lines, December 1914.

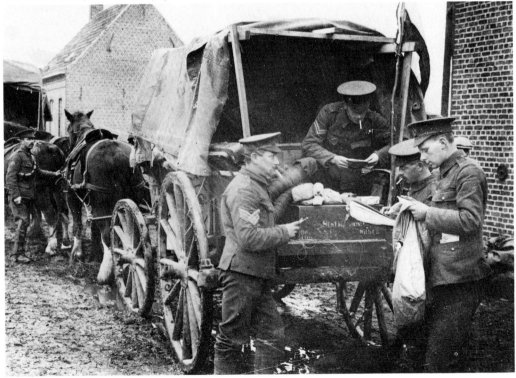

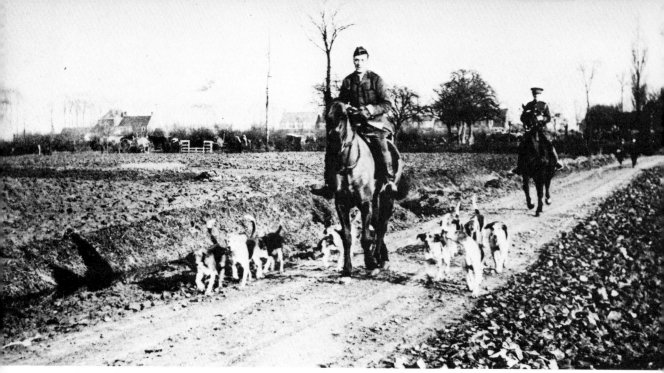

158. Following the drag – 2nd Cavalry Division pack of hounds behind the line at Vieux Berquin, November 1914.

provide food and drink, and races and football matches were organised. Some cavalry regiments played polo and even had packs of hounds sent over from England:

> There are numerous football matches, the ground densely lined with cheering partisans. Then you may hear at any time the sound of shot-guns and come across a party of officers shooting pheasants. There is a pack of beagles run by some cavalry units, and in the evenings there is always some form of smoking concert somewhere or other in the vicinity.[73]

The closeness of Britain meant that regular leave slowly became available, and although for the private soldier it was irregular and of short duration, it was something to be looked forward to with enormous anticipation:

> Today came the astonishing news that leave to England is to be granted to officers. One can hardly believe it. No one had ever dreamed of such a thing during the war. It seemed scarcely right that the officers should go on leave and not NCOs and men; but shortly afterwards further orders extended the grant of leave to NCOs and men.[74]

Leave boats began a regular pattern of service from the French Channel ports to the ports of southern England, and brought home closer to the soldier and the war closer to the civilian.

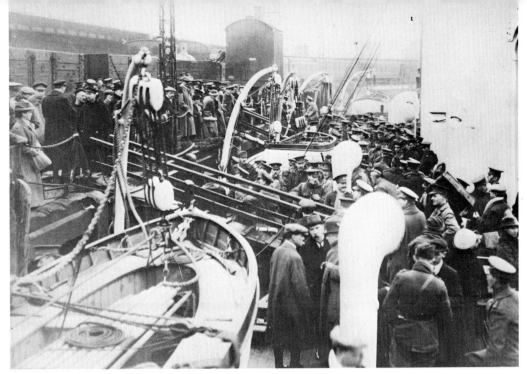

159. Farewell Blighty – British troops embarking for France after home leave, December 1914.
160. The Border Regiment marching off to the trenches past their CO, December 1914.

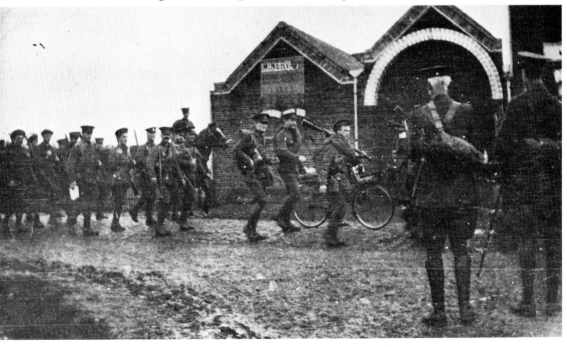

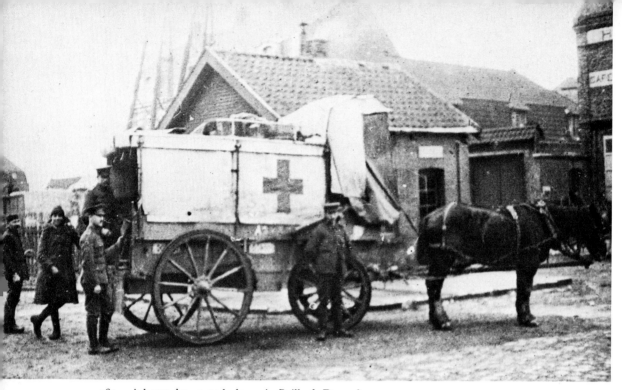

161. A horse-drawn ambulance in Bailleul, December 1914.

From 14 to 24 December the BEF launched a series of attacks in the area of Wytschaete with only limited success. Both sides began to realise that given sufficient time and the necessary materials to strengthen their trench systems it became increasingly difficult to break into and break through the enemy's line. Worried about the psychological effects of sustained trench warfare, GHQ encouraged battalions to raid the enemy's trenches and to dominate no-man's land. This was not always appreciated by the private soldier who preferred to live-and-let-live.

On 25 December 1914 the BEF was reorganised into two Armies reflecting the increase in its strength to 245,197 men. Christmas Day was also marked by the issue of a box of cigarettes or tobacco and a pipe to every officer and soldier of the BEF, a gift from Princess Mary. During Christmas Day there were informal truces on certain parts of the front, and British and German soldiers moved into no-man's land and took the opportunity to bury their dead and mend their wire. In some places British and German soldiers met, exchanged gifts, talked about home or how long the war would last, took snapshots of each other and sang carols:

> At 8.30 am I was looking out, and saw four Germans leave their trenches and come towards us; I told two of my men to go and meet them, *unarmed* (as the Germans were unarmed), and to see that they did not pass the halfway line. We were 350–400 yards apart at this point. My fellows were not very keen, not knowing what was up, so I went out alone, and met Barry, one of our Ensigns, also coming out from another part of the

162. Christmas Day truce 1914 – Rue de Bois, Armentières – two men of the York and Lancs Regiment in the foreground, on the skyline German soldiers.

163. Another view from the trenches of the York and Lancs Regiment during the Christmas Day truce showing barbed wire in no-man's land and Germans on the parapet of their trenches.

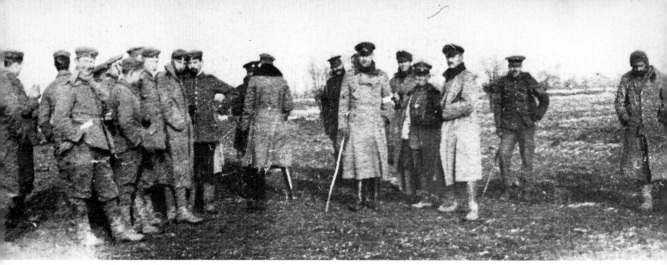

164. British and German soldiers meet in no-man's land during the Christmas truce.

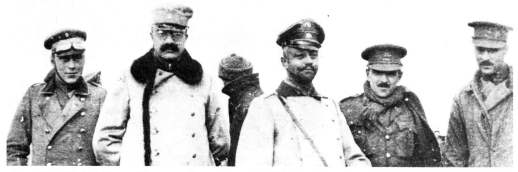

165. The Wicked Hun – German officers pose with British officers in no-man's land during the Christmas truce.

166. Over by Christmas – British and German soldiers fraternising in no-man's land at Ploegsteert on Christmas Day 1914.

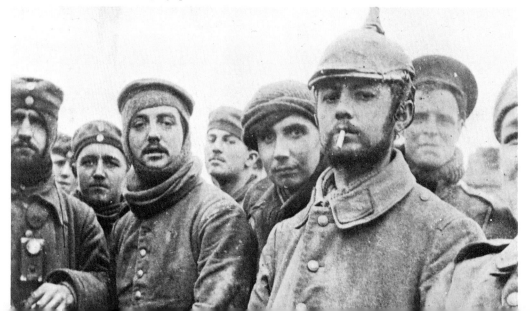

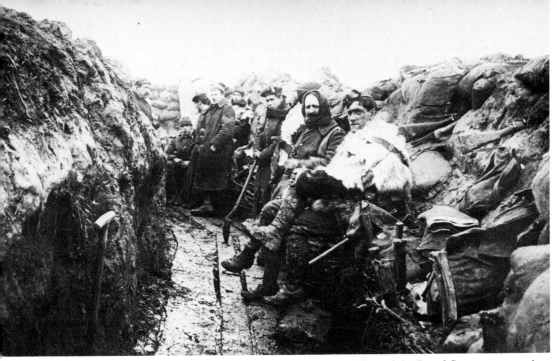

167. A typical front-line trench in December 1914 – these soldiers of the Royal Scots wear a variety of jackets and headdress. This waterlogged trench has duckboards and wattle sides to prevent the sandbags from collapsing.

line. By the time we got to them, they were ¾ of the way over, and much too near to our barbed wire, so I moved them back. They were three private soldiers and a stretcher-bearer, and their spokesman started off by saying that he thought it only right to come over and wish us a happy Christmas, and trusted us implicitly to keep the truce. He came from Suffolk where he had left his best girl and a 3½ h.p. motor bike! He told me that he could not get a letter to the girl and wanted to send one through me. I made him write out a postcard in front of me, in English, and I sent it off that night.[75]

By evening, both sides had returned to their trenches and prepared to renew hostilities the next day.

To the front line soldier the New Year of 1915 appeared a bleak and dismal prospect. For the survivors of the original BEF the New Year meant teaching new soldiers old tricks to become as professional as the pre-war Regulars. But not only was the Army different, so was the war, and by the standards of later battles the fighting of 1914 would appear relatively insignificant. Yet it must be remembered that in 1914 the weapons and equipment of the BEF were limited, and the infantry had little to rely upon except their expertise in using the Short Lee Enfield Rifle. The old Regular Army had been almost physically killed by the end of the first battle of Ypres, but its spirit marched on as the survivors were promoted to command the volunteers and conscripts at every level.

Although the pre-war Regular officers soon learnt to admire the volunteer and conscript soldiers under their command, they never quite replaced for them the pre-war

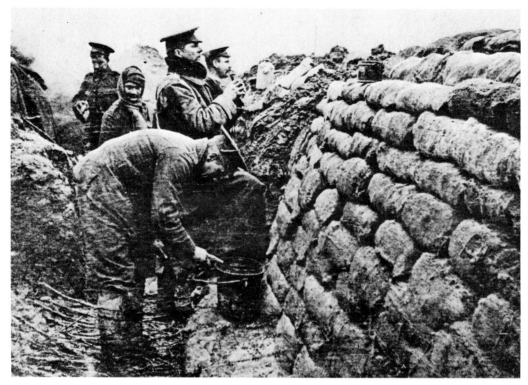

168. Prospects for the New Year – soldiers of the 2nd Battalion Scots Guards in the trenches near Fleurbaix on 5 January 1915.

Regular soldiers. It was with something akin to being a collector of *objets d'art* that a senior officer, later on in the war, would discover surviving Regular soldiers in an infantry battalion. This was the experience of Lieutenant-General Haking when inspecting the 2nd Battalion Royal Welch Fusiliers in March 1916:

> The General found that many of the men came out in August 1914. He was at home with these – he had just come from inspecting the 20th R.F. (a Kitchener Battalion). He chatted and chaffed, pinched their arms and ears, asked how many children they had, and if they could be doing with leave to get another. As he passed from one 1914 man to another he dug his elbow into the CO's ribs and exclaimed, 'You're a lucky fellow.' When he was over he said to the CO, 'That's been a treat. That's the sort we've known for thirty years.'[76]

But the Royal Welch Fusiliers were unusual in having so many Regulars still serving in 1916, and within a year most of them were dead or invalided home. The old Regular Army was not resurrected until after the Armistice in November 1918.

<div align="center">

Old Soldiers Never Die,
They Only Fade Away.

</div>

128

Epilogue

The original BEF of 1914 is remembered because of its battle honours and the suffering it endured which culminated in the bloody attritional fighting around Ypres in October and November 1914. The pre-war Regular soldiers and Reservists had in many respects a different attitude to soldiering and the war and a different sense of humour from the Territorials, volunteers and conscripts who later took their places at the front. They were professional soldiers trained to fight and to obey orders and not ask questions, and many of them had seen active service overseas before the war. They were, in truth, one of the finest forces that have fought for Britain overseas.

After the war, in 1925, the survivors of the BEF formed the 'Old Contemptibles' Association, as an old comrades and self-help organisation. Strictly speaking, to be eligible to become an 'Old Contemptible', a soldier had to have served in France and Belgium between 5 August and 22 November 1914, and in practice this meant any recipient of the 1914 Star.

This Bronze Star was authorised in April 1917, and was awarded to those who served in France or Belgium on the strength of a unit, or for service in either of those two countries between 5 August and midnight on 22–23 November 1914. In 1919 King George V sanctioned the award of a bar to this Star to all who had been under fire in France and Belgium during, or between, these dates. A large number of Territorial soldiers were eligible for the 1914 Star although they did not reach France until the middle of November. The Bronze Star measures $1\frac{3}{4}$ inches wide and $2\frac{1}{2}$ inches from top to bottom. The ring for suspension is stamped out solid with the piece. The Star has three points; the topmost is replaced by a crown at the top of which is a half-inch diameter ring for suspension. Across the face are two crossed swords. In the centre on a scroll is the date '1914', and on two further scrolls one above and one below the date are the months 'AUG' and 'NOV'. The colours of the ribbon are red, white and blue shaded and watered. Approximately 378,000 1914 Stars were issued, but it is not known how many of these were awarded the bar.

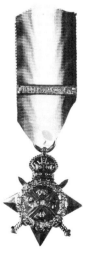

169. The 1914 Star.

Note on the Illustrations

In order to compile a pictorial history of the 'Old Contemptibles' one must turn to photographic archives, regimental museums and newspapers and magazines of the period. The Victorian and Edwardian public had been used to seeing wars illustrated in newspapers and magazines through the engraved drawings of war artists at the front. War artists such as Melton Prior and Frederic Villiers had accompanied armies on campaigns and had sketched battles and details of military life for a home-based artist to convert into an illustration for a newspaper or magazine. Many of the original sketches were very accurate, although frequently they were altered for final reproduction to meet an editor's interpretation of what he thought the public wanted to see. Heroics, but not too much blood, particularly if it was British. By the turn of the century the engraved sketch was being successfully challenged by the reproduction of half-tone photographs. Photography had become popular and accessible to the Victorians and by the time of the South African War in 1899 there had been a technical revolution with the mass production of cheap cameras which ushered in the era of the snapshot. It was common practice by the 1900's for many newspapers to use photographs, yet this development in newspaper illustration did not lead to a demand for war photographs. Newspapers still preferred to use the highly dramatised view of battles by artists on the spot rather than the static images taken after the event by photographers. There were more artists' pictures used in newspapers and magazines during the South African War than original photographs.

This practice persisted even during the First World War, when newspapers such as the *Daily Mail* and magazines such as the *Illustrated London News* preferred again to rely upon the imagination of professional artists like Richard Caton Woodville to depict scenes of battle. Unfortunately, many of these drawings bore little resemblance to the realities of modern European war, and were really an extension of the images of Victorian colonial campaigns and romanticised schoolboy history of the fife and drum variety.

The problem was that, not only did newspapers prefer the impressions of the war artist to those of the photographer at the beginning of the First World War, but it was almost impossible for newspapers to get any impression of the war at the front because of the strict military censorship. From the first days of the war, Lord Kitchener, the new Secretary of State for War, forbade war correspondents to go to France. Kitchener had a pathological dislike of war correspondents going back to his experiences in South Africa and the Sudan, where he cursed them as 'drunken swabs'. The military authorities believed that war correspondents were irresponsible trouble-makers who might indirectly provide the enemy with intelligence. For photographers, the situation was much worse. No civilian photographer was allowed near the front, and the penalty for taking photographs was death. However, a number of press photographers were able to evade the military authorities and take pictures, and a large number of officers and soldiers who had been enthusiastic photographers in peacetime took their cameras to war and kept a valuable record. From these two sources, newspapers and magazines were able to use a limited

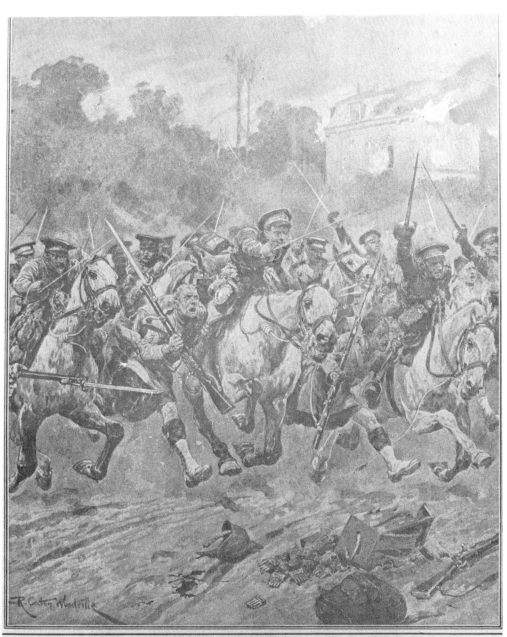

THE "STIRRUP-CHARGE" OF THE SCOTS GREYS AND HIGHLANDERS AT ST. QUENTIN.

The British Army, covering itself with new glory in the storied battlefields of Flanders, reviving memories of gallant deeds done in old Elizabethan days, performed a series of exploits at St. Quentin which recalled vividly to the public imagination the never-dying magnificent charge of the Scots Greys and Highlanders at Waterloo—a deed commemorated in Lady Butler's famous painting "Scotland for Ever!" On August 30th, 1914, the Scots Greys and the Highlanders together took part, not in one charge, but in a series of charges "as at Waterloo," bursting into the thick of the enemy, the Highlanders holding on to the stirrup-leathers of the Greys as the horsemen galloped, and attacking hand to hand. The Germans had the surprise of their lives, and broke and fled before the sudden and unexpected onslaught, suffering severe losses alike from the swords of the cavalry and the bayonets of the Highland infantrymen.

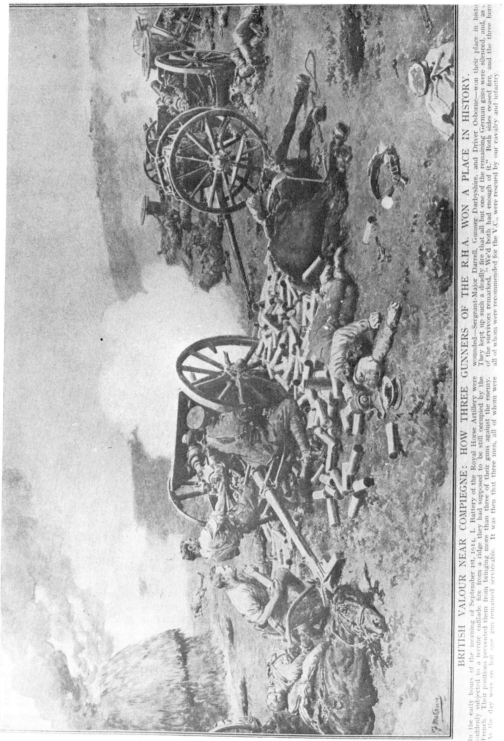

BRITISH VALOUR NEAR COMPIEGNE: HOW THREE GUNNERS OF THE R.H.A. WON A PLACE IN HISTORY.

In the early hours of the morning of September 1st, 1914, L. Battery of the Royal Horse Artillery were suddenly subjected to a terrific enfilade fire from a ridge they had supposed to be still occupied by the French. Their positions prevented them from bringing more than three of their guns against the enemy. As the day wore on but one gun remained serviceable. It was then that three men, all of whom were wounded—Sergeant-Major Darrell, Gunner Darbyshire, and Driver Osborne—won their place in history. They kept up such a deadly fire that all but one of the remaining German guns were silenced, and, as one of the survivors remarked, "We'd both had enough of it." Both sides ceased fire, and the three heroes, all of whom were recommended for the V.C., were rescued by our cavalry and infantry.

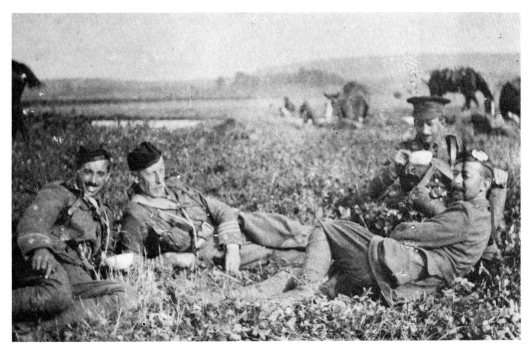

172. Lieutenant Money seated on the left and other officers of the Scottish Rifles during the retreat from Mons on 28 August 1914.

number of photographs to illustrate the ebb and flow of battle during the first five months of the war.

Because there were effectively no official war photographers on the Western Front working for the British Army until 1916, the photographic record of the first year of the war consists of the surviving photographs taken by press photographers and individual soldiers. These photographs are scattered through various museums and press agencies, and some still remain in private hands. By far the greatest number are held by the Department of Photographs at the Imperial War Museum, London. Some of the photographs come from the stock of an old press agency, Sport and General, who must have had one or two press photographers in Belgium and France in 1914. The majority of these photographs are without captions and only careful research and sometimes an educated guess provide any firm identification. The greater proportion of the photographs come from the private collections of individual officers and soldiers who have donated them to the museum. Certain regiments and units are very well represented because the officer or soldier who recorded them on film stayed on the strength for a considerable period of time.

From the photograph albums at the Imperial War Museum it is possible to identify several individuals whose photographs are very important for the early months of the war. There is a comprehensive collection of photographs relating to the Cameronians, the Second Scottish Rifles, from August 1914 to May 1915. These photographs were taken by one of the young regimental officers, Lieutenant R. C. Money, who had been an

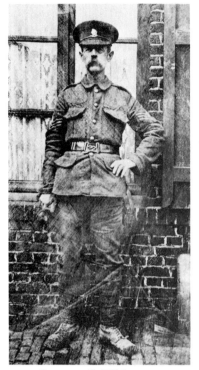

173. Sergeant C. Pilkington, Artists' Rifles, who accompanied the Scots Guards to France in 1914 and photographed them for posterity.

174. Paul Maze, Interpreter, French Mission, 2nd Cavalry Division, October 1914.

enthusiastic photographer before the war. Lieutenant Money took with him to France a small folding Kodak camera which only weighed a few ounces and could be carried on his belt. Although the military authorities forbade cameras to be carried on active service, Lieutenant Money had never heard of the order. Thanks to his enthusiasm, we have a very good photographic record of the Scottish Rifles from its arrival in France, through the retreat from Mons, the advance to the Marne and the Aisne and the autumn fighting in Flanders. Lieutenant Money sent his films back to a Glasgow firm to be developed, and they forwarded many of his photographs to various newspapers who used them under such headings as 'Taken by one of our officers at the Front.'

Another major collection of photographs in the Imperial War Museum was taken by Sergeant C. Pilkington of the Artists Rifles. This rather eccentric part-time soldier accompanied the 2nd Battalion Scots Guards from London to Zeebrugge in October 1914 and recorded their movements in Flanders including the fighting around Ypres. Other individuals whose photographs are deposited in the Imperial War Museum include Paul Maze, the distinguished artist, who acted as an interpreter for a British cavalry regiment in 1914, and Edward Spears, a young British liaison officer attached to the French Fifth

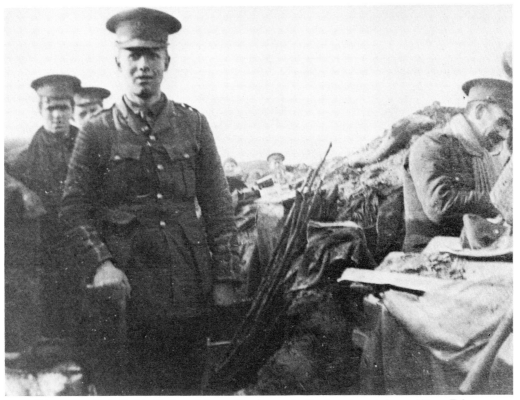

175. Lieutenant J. A. Reid, York and Lancs Regiment, in the trenches at Armentières, February 1915.

Army, later Major-General Edward Spears, author of *Liaison 1914*. Several regimental museums hold collections of photographs which include pictures of the BEF in 1914. One important collection was taken by Lieutenant Reid of the York and Lancaster Regiment and includes pictures of the Christmas truce of 1914.

The important point about all these private collections of photographs is that very few of them were posed or specially set up for propaganda purposes. The majority were meant to be nothing more than a record, an extension of the family snapshot, and in that respect many of them may appear dull and commonplace. But they faithfully recorded many aspects of the BEF in 1914 that a war artist would fail to see.

The photographic record of the 'Old Contemptibles' depends upon a number of chance circumstances. Whether a unit happened to have someone who was an amateur photographer; whether he had the time and the interest to record both the exciting and the commonplace; and whether his photographs survived the turmoil of war and the indifference of peace. Certain units of the BEF and particular incidents have received a disproportionately high photographic representation in relation to their historic importance. There are very few genuine front-line battle scenes recorded for this period of the war because under such conditions officers and soldiers had more important things to

do than to take snapshots, and even if they had the time few would have had the inclination to take pictures when under direct fire or attack.

There is a photograph purporting to show the King's Liverpool Regiment at the second battle of Ypres in May 1915 preparing to meet a German attack from some shallow trenches with fixed bayonets. If the photograph accurately depicts a real incident then the photographer had very steady nerves. In fact, the photograph shows an incident which was more common during the first battle of Ypres in October and November 1914, than what was to take place during the following year. Even when captions have been provided for the original photographs, it is frequently very difficult to date and locate a particular photograph. Sometimes it is tempting to use photographs taken later in the war to illustrate an incident in 1914 for which there is no photographic record.

176. 'Fix Bayonets!' – soldiers of the King's Liverpool Regiment at Ypres in May 1915 crouch in their shallow trenches and prepare to meet a German attack from across the field to the left.

Notes

1. E. J. Needham, *The First Three Months*: The Impressions of an Amateur Infantry Subaltern (Gale & Polden, 1936), p. 14.
2. *ibid*, p. 15.
3. C.S.M. Boreham quoted in *The War the Infantry Knew 1914–1919*: A Chronicle of Service in France and Belgium with The Second Battalion His Majesty's Twenty-Third Foot, The Royal Welch Fusiliers (P. S. King, 1938), p. 4.
4. F. A. Bolwell, *With a Reservist in France* (George Routledge, n.d.), p. 3.
5. John F. Lucy, *There's a Devil in the Drum* (Faber & Faber, 1938), p. 73.
6. John Terraine, ed., *General Jack's Diary 1914–1918* (Eyre & Spottiswoode, 1964), p. 22.
7. Major Lord Gordon-Lennox quoted in J. M. Craster, ed., *'Fifteen Rounds a Minute'*: The Grenadiers at War August to December 1914. Edited from the Diaries and Letters of Major 'Ma' Jeffreys and Others (Macmillan, 1976), p. 22.
8. *ibid*, p. 23.
9. *ibid*, p. 24.
10. Frank Richards, *Old Soldiers Never Die* (Faber & Faber, 1933), p. 11.
11. *ibid*, p. 13.
12. Needham, *The First Three Months*, p. 22.
13. Lucy, *There's a Devil in the Drum*, p. 85.
14. Lieutenant-Colonel H. R. Davies quoted in Lieutenant-Colonel A. F. Mockler-Ferryman, ed., *The Oxfordshire and Buckinghamshire Light Infantry Chronicle 1914–1915* (Eyre & Spottiswoode, n.d.), p. 125.
15. Major Jeffreys quoted in *'Fifteen Rounds a Minute'*, p. 30.
16. Lucy, *There's a Devil in the Drum*, p. 97.
17. Quoted by Brigadier-General Sir James Edmonds in the foreword of Walter Bloem, *The Advance from Mons* (Peter Davies, 1930), p. viii.
18. Bloem, *The Advance from Mons*, p. 53.
19. C.S.M. Boreham quoted in *The War the Infantry Knew*, p. 18.
20. Lucy, *There's a Devil in the Drum*, p. 112.
21. *ibid*, p. 114.
22. Bloem, *The Advance from Mons*, p. 56.
23. Lucy, *There's a Devil in the Drum*, p. 119.
24. Captain von Brandis quoted in Brigadier-General Sir James Edmonds, *Official History of the Great War Military Operations France and Belgium 1914 Vol I* (Macmillan, 1933), p. 115.
25. Bloem, *The Advance from Mons*, p. 75.
26. *ibid*, p. 98.
27. Arthur Osburn, *Unwilling Passenger* (Faber & Faber, 1932), p. 60.
28. Quoted by Edmonds in Bloem, *The Advance from Mons*, p. viii.
29. Captain Geiger quoted in *The War the Infantry Knew*, p. 24.
30. *General Jack's Diary*, p. 34.
31. *ibid*, p. 37.
32. Corporal Denore quoted in C. B. Purdom, ed., *Everyman at War*: Sixty Personal Narratives of the War (J. M. Dent, 1930), p. 8.
33. Needham, *The First Three Months*, p. 36.
34. Bolwell, *With a Reservist in France*, p. 25.
35. Needham, *The First Three Months*, p. 39.
36. Captain Geiger quoted in *The War the Infantry Knew*, p. 31.
37. *General Jack's Diary*, p. 32.
38. Brigadier-General John Charteris, *At GHQ* (Cassell, 1931), p. 38.
39. Lucy, *There's a Devil in the Drum*, p. 147.
40. Captain Geiger quoted in *The War the Infantry Knew*, p. 46.
41. Corporal Denore quoted in *Everyman at War*, p. 8.
42. Captain Geiger quoted in *The War the Infantry Knew*, p. 59.
43. Richards, *Old Soldiers Never Die*, p. 27.
44. Major Lord Gordon-Lennox quoted in *'Fifteen Rounds a Minute'*, p. 76.
45. Major-General C. E. Callwell, *Field Marshal Sir Henry Wilson*: His Life and Diaries, Vol I (Cassell, 1927), p. 177.
46. Needham, *The First Three Months*, p. 58.
47. Lucy, *There's a Devil in the Drum*, p. 172.
48. Lieutenant-Colonel Smith quoted in *'Fifteen Rounds a Minute'*, p. 96.
49. Needham, *The First Three Months*, p. 59.
50. Lucy, *There's a Devil in the Drum*, p. 184.
51. Lieutenant-Colonel Davies quoted in *The Ox. & Bucks. Chronicle*, p. 172.
52. Captain Stockwell quoted in *The War the Infantry Knew*, p. 75.
53. Major Jeffreys quoted in *'Fifteen Rounds a Minute'*, p. 108.

54. Captain Dillon quoted in *The Ox. & Bucks. Chronicle*, p. 186.
55. Rudolf Binding, *A Fatalist at War* (George Allen & Unwin, 1929), p. 19.
56. Richards, *Old Soldiers Never Die*, p. 37.
57. Major Jeffreys quoted in *'Fifteen Rounds a Minute'*, p. 124.
58. Charteris, *At GHQ*, p. 52.
59. Lucy, *There's a Devil in the Drum*, p. 263.
60. Charteris, *At GHQ*, p. 60.
61. Major Jeffreys quoted in *'Fifteen Rounds a Minute'*, p. 125.
62. Lucy, *There's a Devil in the Drum*, p. 281.
63. Richards, *Old Soldiers Never Die*, p. 35.
64. Major Lord Gordon-Lennox quoted in *'Fifteen Rounds a Minute'*, p. 118.
65. Richards, *Old Soldiers Never Die*, p. 44.
66. Major Jeffreys quoted in *'Fifteen Rounds a Minute'*, p. 141.
67. C.Q.M.S. Powell quoted in *The War the Infantry Knew*, p. 84.
68. Charteris, *At GHQ*, p. 58.
69. Captain The Hon. Julian Grenfell quoted in Laurence Housman, ed., *War Letters of Fallen Englishmen* (Victor Gollancz, 1930), p. 118.
70. Captain Pike quoted in *'Fifteen Rounds a Minute'*, p. 133.
71. Major Jeffreys quoted in *'Fifteen Rounds a Minute'*, p. 166.
72. Lucy, *There's a Devil in the Drum*, p. 267.
73. Charteris, *At GHQ*, p. 63.
74. Lieutenant-Colonel Davies quoted in *The Ox. & Bucks. Chronicle*, p. 208.
75. Captain Sir Edward Hulse quoted in *War Letters*, p. 144.
76. Quoted in *The War the Infantry Knew*, p. 185.

Bibliography

Barnes, Major R. Money, *The British Army of 1914* (Seeley Service, 1968).

Baynes, John, *Morale: A Study of Men and Courage* (Cassell, 1967).

Binding, Rudolf, *A Fatalist at War* (George Allen & Unwin, 1929).

Bloem, Walter, *The Advance from Mons* (Peter Davies, 1930).

Bolwell, F. A., *With a Reservist in France* (George Routledge, n.d.).

Bond, Brian, *The Victorian Army and the Staff College 1854–1914* (Eyre Methuen, 1972).

Callwell, Major-General C. E., *Field Marshal Sir Henry Wilson: His Life and Diaries*, Vol. I (Cassell, 1927).

Charteris, Brigadier-General John, *At GHQ* (Cassell, 1931).

Craster, J. M., ed., *'Fifteen Rounds a Minute':* The Grenadiers at War August to December 1914. Edited from the Diaries and Letters of Major 'Ma' Jeffreys and Others. (Macmillan, 1976).

Edmonds, Brigadier-General Sir James, *Official History of the Great War Military Operations France and Belgium 1914*, Vol. I (Macmillan, 3rd edn., 1933).

Edmonds, Brigadier-General Sir James, *Official History of the Great War Military Operations France and Belgium 1914*, Vol. II (Macmillan, 1925).

Farrar-Hockley, Anthony, *Death of an Army* (Arthur Barker, 1967).

Field Service Pocket Book 1914 (HMSO, 1914).

Housman, Laurence, ed., *War Letters of Fallen Englishmen* (Victor Gollancz, 1930).

Johnson, Peter, *Front Line Artists* (Cassell, 1978).

Knightly, Phillip, *The First Casualty* (André Deutsch, 1975).

Lewinski, Jorge, *The Camera at War* (W. H. Allen, 1978).

Liddell Hart, B. H., *History of the First World War* (Cassell, 1970).

Lucy, John F., *There's a Devil in the Drum* (Faber & Faber, 1938).

Macdonald, Gus, *Camera* (Batsford, 1979).

Mockler-Ferryman, Lieutenant-Colonel A. F., ed., *The Oxfordshire and Buckinghamshire Light Infantry Chronicle 1914–1915* (Eyre & Spottiswoode, n.d.).

Mollo, Andrew, and Turner, Pierre, *Army Uniforms of World War I* (Blandford Press, 1977).

Needham, E. J., *The First Three Months*: The Impressions of an Amateur Infantry Subaltern (Gale & Polden, 1936).

Osburn, Arthur, *Unwilling Passenger* (Faber & Faber, 1933).

Purdom, C. B., ed., *Everyman at War*: Sixty Personal Narratives of the War (J. M. Dent, 1930).

Richards, Frank, *Old Soldiers Never Die* (Faber & Faber, 1933).

Terraine, John, *Mons* (Batsford, 1960).

Terraine, John, ed., *General Jack's Diary 1914–1918* (Eyre & Spottiswoode, 1964).

The War the Infantry Knew 1914–1919: A Chronicle of Service in France and Belgium with The Second Battalion His Majesty's Twenty-Third Foot, The Royal Welch Fusiliers (P. S. King, 1938).

Woodward, David, *Armies of the World 1854–1914* (Sidgwick & Jackson, 1978).

Index

Aisne, River 60, 67; advance to 1, 63, 134; crossing of 64, 66; position held 71; deployment from 75, 83, 89, 91, 97; attritional warfare 87
Albert, King of the Belgians 21
Aldershot 15, 25
Alsace 19
Antwerp: plan to send BEF to 4; fortified 21; retreat of Belgian Army to 35; fate in balance 71; bombardment 73; position desperate 75; evacuated 76; capitulation 83
Armentières 83, 89, 91
Army Council 7, 22, 32
Army Ordnance 33, 118
Army Service Corps 23, 33
Arras 13, 81
Artillery: British Army – organisation and tactics 24-5, 29, 31; at Le Cateau 50-1; casualties 57; at the Aisne 67; at Ypres 104.
 German Army – tactics 19; at Mons 43, 45; at Le Cateau 53; at the Aisne 63, 66; at La Bassée 91; at Gheluvelt 97
Austria-Hungary 4, 16
Avonmouth 9

Balkans 16, 19, 29
Bayonets 25, 28, 31, 71
Belfast 9
Belgian Army: on peace footing 4; resists German advance 13; organisation 21; retreat to Antwerp 35; fate in balance 71, 73, 76, 83
 Divisions 21
 Garde Civique 21
Belin, Gen. (Chief of Staff, French Army) 19
Binding, Lt. R. (German Army) quoted 96
Bloem, Capt. W. (12th Brandenburg Grenadiers, German Army) quoted 40, 43, 45
Bolwell, Private F. A. (1st Bn. Loyal North Lancashire Regiment) quoted 6, 51-2
Boreham, CSM A. (2nd Bn. Royal Welch Fusiliers) quoted 6, 42
Boulogne 10
Brandis, Capt. von (12th Brandenburg Grenadiers, German Army) quoted 44
British Army (BEF) 22-9, 31-4
 GHQ 15, 25, 54-5, 64, 67, 71, 124
 Cavalry Division (later Cavalry Corps) 4, 24-5
 Cavalry Corps 75, 83, 89, 91, 97, 112
 3 Cavalry Division 73, 76
 I Corps 5, 38, 45, 49, 55, 64, 75, 83, 91, 112
 1 Division 4, 24, 97
 2 Division 4, 24, 97
 II Corps 5, 38, 40, 42, 44-5, 47, 49-50, 64, 75, 83, 89, 91, 112

 3 Division 4, 24, 40, 42
 5 Division 4, 24, 40, 42
 III Corps 58, 64, 75, 83, 89, 91, 112
 4 Division 4, 15, 24, 49, 58
 6 Division 4, 24, 58
 IV Corps 83, 89, 112
 7 Division 73, 75, 76, 94, 96-7, 106, 108
Bruges 75
Brussels 21, 35

Calais 73, 81, 91
Capper, Maj.Gen. T. (GOC 7 Division) 75, 106
Casualties 50, 57, 64, 87, 104, 106, 108, 111
Cavalry: British Army – organisation 24, 29; role 31-2; British cavalry enters Mons 38; retreat from Mons 44, 47; at Le Cateau 50-1; at Ypres 99, 101, 104
 French Army – covering role 83
 German Army 89; at La Bassée 91
 See also British Army (BEF) – Cavalry Division, etc.
Charleroi 13, 44
Charteris, Capt. J. (ADC to Haig, later GSO2 HQ I Corps) quoted 55, 99-100, 106, 122
Christmas truce, 1914 124, 127, 135
Churchill, W. S. (Secretary of State for the Navy) 71, 73
Colonial forces 22, 23, 26
Communications 27, 31, 53
Conscripts 127, 129
Cork 9
Courtrai 91

Davies, Lt.Col. H. R. (2nd Bn. Oxfordshire and Buckinghamshire Light Infantry) quoted 15, 75, 122
Denore, Cpl. B. J. (1st Bn. Royal Berkshire Regiment) quoted 50, 58
Dillon, Capt. H. M. (2nd Bn. Oxfordshire and Buckinghamshire Light Infantry) quoted 94, 96
Dominion forces 22, 26
Dublin 9

Egyptian Army 33
Engineers British Army – organisation 24-5; retreat from Mons 49; at the Marne 62; at the Aisne 64; at Ypres 103
'Entente Cordiale' 21

Falkenhayn, Lt.Gen. von (Chief of the German General Staff) 73, 75, 91
Field Service Regulations 27
Fismes 75

FitzClarence, Brig.Gen. (GOC 1st Guards Brigade) 106

Flanders: operations in 71, 83, 87, 101; Royal Naval Division sent to 73; description of terrain 81; BEF push 89; German 6th Army formed in 91; distribution of forces 112; photographic record 134

Foch, Gen. F. (GOC French 9th Army) 22, 58, 75, 89, 108

Franco–Prussian War 19, 21

Franco–Russian Alliance 16

Franz Ferdinand, Archduke of Austria 3

Fraternising 124, 127

French Army: organisation and deployment 18–19, 21–2; views compared with British 29, 53; support of Belgian Army 73; deployment 75
 2nd Army 37
 3rd Army 47
 4th Army 19, 47
 5th Army 18–19, 37, 44–5, 56, 64, 134–5
 6th Army 56, 58, 64
 9th Army 58
 Cavalry Corps 37, 45

French, FM Sir J. D. P. (C-in-C, BEF) 1, 4–5, 9, 12, 40, 44, 49, 54–6, 66, 71, 73, 75, 89, 108

French War Plan XVII 19, 37

Galliéni, Gen. (Military Governor of Paris) 56

Garde Civique (Belgian) 21

Geiger, Capt. G. J. P. (2nd Bn. Royal Welch Fusiliers) quoted 49, 54, 57, 62

General Staff 21–2

German Army: organisation and deployment 18–19, 33; views compared with British 29; British ignorance of its methods 32; deployment 37–8, 40
 1st Army 1, 37–8, 40, 47, 56, 60
 2nd Army 37–8, 60
 4th Army 91, 94
 6th Army 91

Gheluvelt 81, 97, 99, 101, 111

Ghent 21, 76

Givenchy 112

Gordon-Lennox, Maj. Lord B. (2nd Bn. Grenadier Guards) quoted 9–11, 63–4, 103

Grand Morin, River 60

Grenades 29, 118

Grenfell, Capt. the Hon. J. (1st Royal Dragoons) quoted 106

Grierson, Lt.Gen. Sir J. M. (GOC II Corps) 5, 21

Grougis 15

Haig, Lt.Gen. Sir D. (GOC I Corps) 5, 22, 32, 99; operations of I Corps 38, 49, 55, 91

Haking, Lt.Gen. 128

Haldane, Rt. Hon. R. Viscount (Secretary of State for War) 21–5, 27

Howitzers 25, 27, 64, 67

Hulse, Capt. Sir E. (1st Bn. Scots Guards) quoted 124, 127

Imperial War Museum, Department of Photographs 133–4

Indian Army 1, 4, 26, 33–4

Indian Corps 87, 112

Indian Staff College, Quetta 22

Ireland, danger of civil war 3–4

Jack, Capt. J. (1st Bn. Cameronians (Scottish Rifles), later Staff Capt. 19th Brigade) quoted 7, 49–50, 55

Jeffreys, Maj. G. D. (2nd Bn. Grenadier Guards) quoted 15, 89, 97, 101, 104, 112

Joffre, Gen. (C-in-C, French Army) 12, 19, 37, 47, 56, 75

King's African Rifles 33

Kitchener, FM H. Earl (Secretary of State for War) 4, 10–11, 56, 71, 87, 130

Kluck, Col.Gen. von (GOC German 1st Army) 1, 56

La Bassée Canal 81, 83, 89, 91, 111–12

Lances 32, 87

Landrecies 63

Lanrezac, Gen. (GOC French 5th Army) 12–13, 37, 44–5

Le Cateau 13, 22; battle 1, 49, 50, 54

Lee Enfield Rifle 25, 127

Le Havre 9–10

Liège 21, 35

Lille 81

Liverpool 10

Lomax, Maj.Gen. S. H. (GOC 1 Division) 106

Lorraine 19, 73

Lucy, Cpl. J. (2nd Bn. Royal Irish Rifles) quoted 6, 15, 38, 42–4, 57, 69, 71, 99, 101, 118

Machine guns 19, 25, 29, 31, 43, 50, 63, 69

Marines 71, 91

Marne, River: advance to 1; German Army position 56; BEF crosses 60; battle of the Marne 56, 60, 62, 73; photographic record 134

Maubeuge 13, 22

Maunoury, Gen. (GOC French 6th Army) 56

Maze, Paul (interpreter) 134

Medical services 24–5, 49

Messines 83, 89, 91, 101

Metz 37

Meuse, River 19, 21

Militia 22–3, 25, 118

Mobilisation: British Army 4–6, 9, 15, 24, 26–7; French Army 16, 19; Russian Army 16, 19; German Army 18; Belgian Army 21

Moltke, Col.Gen. von (Chief of the German General Staff) 18, 37, 73

Money, Lt. R. C. (Cameronians (Scottish Rifles)) 133–4

Mons: Belgian 5th Division at 21; British cavalry enter 38; Germans encounter British 40; description 81; battle and retreat from 1, 15, 42–5, 49, 54, 57; photographic record 134

Mons–Condé Canal 38
'Mons' (1914) Star 1, 129
Mormal, Forest of 45
Mortars 29
Murray, Lt.Gen. Sir A. (Chief of Staff, BEF) 4

Namur 21, 35
Needham, Capt. E. J. (1st Bn. Northamptonshire
 Regiment) quoted 5–6, 13, 50–3, 67, 71
Newhaven 10
Non-Commissioned Officers 32–4, 50–1 122

'Old Contemptibles' origin of name 1–2, 37; Asso-
 ciation 129; photographic record 130, 135
Osburn, Capt. A. (RAMC) quoted 47
Ostend 71, 91
Other ranks 2, 25, 33–4, 122, 124
Oulchy-le-Chateau 63
Ourcq, River 60

Paris 18, 53, 56
Passchendaele 1, 81
Petit Morin, River 60
Photography, War 2, 130, 133–6
Pike, Capt. E. J. L. (2nd Bn. Grenadier Guards)
 quoted 108
Pilkington, Sgt. C. (Artists Rifles) 134
Pistols 25
Powell, CQMS F. (2nd Bn. Royal Welch Fusiliers)
 quoted 104
Prior Melton (war artist) 130

Rawlinson, Lt.Gen. Sir H. S. (GOC IV Corps) 22, 73,
 76, 83
Reconnaissance 31
Regimental systems 23–4, 33–4, 51
Reid, Lt. J. A. (2nd Bn. York and Lancaster Regiment)
 135
Reservists 1; mobilisation 5–6; organisation 22–4, 27;
 Special Reserve 25, 118; Regular Army Reserve
 34; tactics and training 44; at Le Cateau 50; form
 part of Royal Naval Division 73; reinforce
 Regulars 87; German Reserve Corps 91; compared
 with volunteers 129
Richards, Private F. (2nd Bn. Royal Welch Fusiliers)
 quoted 12, 62, 96, 103
Robertson, Maj.Gen. Sir W. R. (QMG, BEF) 4–5,
 22, 53
Ronarc'h, Admiral 91
Roubaix 81
Rouen 10, 57
Royal Flying Corps 24, 26, 56
Royal Military Academy, Woolwich 33
Royal Military College, Sandhurst 33
Royal Naval Division 73, 76
Royal Navy 10, 34
Royal Welch Fusiliers 128
Russia 4, 16, 18, 19, 21
Russo-Japanese War 19, 29

Sabres 87, 99
St Quentin 50
Sambre 37
Sarajevo 3
Schlieffen, FM A. Graf (Chief of the German General
 Staff) 16, 18
Schlieffen Plan 16, 18–19, 56
School of Musketry, Hythe 31
Signals 24–5
Smith, Lt.Col. W. R. A. (2nd Bn. Grenadier Guards)
 quoted 71
Smith-Dorrien, Gen. Sir H. L. (GOC II Corps) 5, 38,
 49; quoted 40
Soissons 64
Somme, River 19; battle 1
Sordet, Gen. (GOC French Cavalry Corps) 37, 45
South African War 4, 5, 7, 19, 21–3, 25–7, 29, 31, 33,
 130
Southampton 9
Spears, Lt. E. (British Liaison Officer, French Army,
 later Maj.Gen.) 134–5
Staff College, Camberley 7, 22, 32–3
Stockwell, Capt. C. I. (2nd Bn. Royal Welch Fusiliers)
 quoted 83, 87
Sudan 130
Supply services 24–5, 27, 53, 118
Swords 25, 32, 71

Tactics: French tactical doctrine 21; British tactical
 training and doctrine 27–9, 31, 44
Territorial Force 1; mobilisation 4; organisation 25–7,
 33–4; reinforces Regulars 87, 112; compared with
 Regulars 129
Tourçoing 81
Training: British tactical training and doctrine 27–9,
 31, 44
Transport: BEF transported to France 9; organisa-
 tion 24, 27, 118; 4 Division's lack of transport 49;
 retreat from Mons 53, 57
Trench warfare 2, 29; entrenchment along the Aisne
 66–7, 69; at La Bassée 91; at Ypres 103–4; after
 Ypres 108, 111–12, 115, 118, 124
Tupigny 15

Uniforms 25–6

Verly 15
Vesle, River 60, 63
Villiers, Frederic (war artist) 60, 63
Volunteers 1, 9, 22–3, 25, 34, 127, 129; form part of
 Royal Naval Division 73; German volunteers 91

War artists 2, 130, 135
War correspondents 130
War Office 7, 9, 21
Weapons: British Army divisional establishment 25;
 weapons training 28; shortage of 29, 67, 104, 127;
 role 31; cavalry weapons 32; trench warfare 118
 See also individual weapons, e. g. howitzers, swords.

Wilhelm II, Kaiser 1, 18
Wilson, Maj.Gen. H. H. (Sub-Chief of Staff, BEF) 4, 22; quoted 64
Woodville, R. C. (artist) 130
Wytschaete 81, 124

Yeomanry 22, 25

Ypres: BEF concentrates at 76, 83, 89; German advance towards 91; battle 1–2, 91, 94, 96–7, 99–101, 103–4, 106; BEF moves south of 108, 112; casualties 111; aftermath 127, 129; photographic record 134, 136
Yser, River 91

Zeebrugge 73, 75, 134

ACKNOWLEDGMENTS

PICTURE CREDITS
The publisher would like to thank the following
individuals and organizations for their kind
permission to reproduce the images in this book.
Every effort has been made to acknowledge the
pictures, however we apologize if there are any
unintentional omissions.

Alamy/Biju: 34; Imagebroker: 38; Doug Steley C.: 52.
Corbis/Reuters/Munish Sharma: 46.
iStockphoto/Karim Hesham: 70.

Miki, Nakayama 132
monasticism 100, 102
Moon, Sun Myung 142
Mormonism 106–7
Muhammad, the Prophet
66, 68, 71
al-Muntazar, Muhammad
68

N
Nanak 44, 47
Native American Church
18, 20–1
Neo-Paganism 120–1
New Religion *see*
Shinshukyo
New Testament 87, 110
nirvana 31, 36, 40

O
Old Testament 65, 87
Olodumare 14
Orthodox Christianity
see Eastern Orthodoxy

P
Pali Canon 38–9
pedobaptism 100, 110
Pentecostalism 104–5
Peter, Saint 82, 124
Prabhupada, Swami A.C.
Bhaktivedanta 128

Q
qigong 137, 140
Quakers *see* Society of
Friends
Qur'an, The 66, 70–1

R
Rapture 100, 108
Rastafarian movement
148–9
Rave, John 20
Reformation, Protestant
81, 88
reincarnation 137, 144
Roman Catholicism
82–3, 144
Russell, Charles Taze 108

S
Sabbath 101, 112
Scientology 146–7
Selassie, Haile 148
Seventh-day Adventist
Church 112–13
shari'a 59, 66
Shenism 24–5
Shinshukyo 150–1
Shinto 54–5, 132, 150
Sikhism 44–7
Singh, Gobind 44, 47
Smith, Joseph 106
Society of Friends 96–7

Southern Baptist
Convention (SBC) 110
speaking in tongues 101,
104
Spiritualism 122–3
spiritual warfare 101, 104
Sufism 72–3
sunna 58, 66
sutras 39, 40

T
Taoism 24, 48–9, 53,
130, 140, 144
folk 48
religious 48
Ten Commandments
65, 90
Tenrikyo 132–3
Torah, The 59, 60, 64–5

U
Unification Church 142–3

V
Voodoo 124–5

W
Wesley, John 94
whirling dervishes 72
White, Ellen G. 112
Wilson, John 20

Y
yin and yang 48, 53
Yoruba 14–15

Z
Zarathushtra 26
zombies 119, 124
Zoroastrianism 26–7

INDEX

A

Aboriginal dreaming 16–17
Ahmad, Mirza Ghulam 74
Ahmadiyya 74–5
Ali 68
Allah, Baha' 76, 119, 137
Anglicanism 92–3
Animism 18–19, 54

B

Baha'i Faith 76–7, 119
Baptist Christianity 110–11
Baptist World Alliance (BWA) 110
Bhagavad Gita 34–5, 118, 128
Bible, The 65, 86–7
Buddha, The 36, 144
Buddhism 36–41, 42, 132, 140, 144, 150
 Mahayana 39, 40–1, 48
 mainstream 24, 36–7
 Vajrayan (tantric) 39

C

Calvin, John 90
Calvinism 90–1
Candomblé 126–7
Cao Dai 144–5
Catholicism see Eastern Orthodoxy and Roman Catholicism
Cheondoism 130–1
Ch'oe Che'u 130
Christian Science 114–15
Chuang Tzu 48
Confucianism 24, 50–1, 53, 142, 144
Confucius 50
Coptic Christianity 102–3
credobaptism 100, 110

D

dharma 30, 32

E

Eastern Orthodoxy 72, 84–5, 118
Eddy, Mary Baker 114
Episcopalianism see Anglicanism
Eucharist 80, 82

F

Falun Gong 140–1
First Great Awakening 80, 94
Fox, George 96
Frum, John 138

G

Gandhi, Mohandas 42
al-Ghazali 72
Great Schism 81, 84
Guru Granth Sahib 46–7
 Adi Granth 44, 47

H

hadith 58, 66
Halacha 58, 60
Hare Krishna movement 128–9
Henry VIII, King of England 92
Hinduism 32–3, 44, 118, 128
Hubbard, L. Ron 146

I

I Ching 52–3
International Society for Krishna Consciousness (ISKCON) 128
Islam 66–71
 Shi'a 68–9
 Sunni 66–7
Izo, Iburi 132

J

Jainsim 42–3
Jehovah's Witnesses 108–9
Jesus Christ 82, 84, 88, 102, 106, 144
Jesus Christ of Latter-day Saints, Church of 106
John Frum movement 138–9
Judaism 60–3
 Hasidic Jews 58, 60
 Orthodox 60–1
 Reform 62–3
 Ultraorthodox Jews 60

K

karma 30, 32, 42, 128, 140
Krishna 35, 118, 128

L

Lao Tzu 48
Le Van Trung 144
Li Hongzhi 140
Luther, Martin 88, 90, 92
Lutheranism 88–9

M

Mahavira 42
Mary, mother of Jesus 82, 88
Mesoamerican religion 22–3
Methodism 94–5

Alexander Studholme is Lecturer in Indian Religions at the School of Theology and Religious Studies at Bangor University in Wales. His interests include mantras, Jungian approaches to Buddhism and the Wisdom Christianity of Bede Griffiths. He is a member of the Dzogchen Community of the Tibetan lama, Namkhai Norbu Rinpoche. He is the author of *The Origins of Om Manipadme Hum, A Study of the Karandavyuha Sutra.*

NOTES ON CONTRIBUTORS

Richard Bartholomew has a Ph.D. from the School of Oriental and African Studies, University of London, UK and he has published articles on the subject of religion and media. He runs a blog on religion and current affairs, which can be found here: http://barthsnotes.wordpress.com/. He also compiles indexes for academic books on religion.

Mathew Guest is senior lecturer in the department of Theology and Religion at Durham University, UK. He teaches classes in the study of religion, religion in contemporary Britain and religious innovations in the modern world, and his research focuses on the sociology of contemporary evangelical Christianity. He is the author and editor of five books, including *Bishops, Wives and Children: Spiritual Capital Across the Generations* (with Douglas Davies), *Congregational Studies in the UK: Christianity in a Post-Christian Context* (edited with Karin Tusting and Linda Woodhead), *Religion and Knowledge: Sociological Perspectives* (edited with Elisabeth Arweck) and *Evangelical Identity and Contemporary Culture: A Congregational Study in Innovation*.

Graham Harvey is Reader in Religious Studies at The Open University, UK, where he co-chairs the M.A. in Religious Studies. His research is mostly concerned with contemporary indigenous people, especially in North America and Oceania, but also in diaspora. He has also published about Paganism. Much of his teaching-related work engages with Judaism, pilgrimage and the performance of religion.

Russell Re Manning is an Affiliated Lecturer at the Faculty of Divinity and a Fellow of St Edmund's College at the University of Cambridge, UK. His interests include philosophy of religion, theology and the arts, and the science-religion dialogue. His books include *The Oxford Handbook of Natural Theology* and *The Cambridge Companion to Paul Tillich*.

Religions in the Modern World
Linda Woodhead, Hiroko Kawanami
and Christopher Partridge (eds)
(Routledge, 2009)

*Western Muslims and the
Future of Islam*
Tariq Ramadan
(Oxford University Press, 2005)

A World Religions Reader
Ian Markham and Christy Lohr (eds)
(Wiley-Blackwell, 2009)

MAGAZINES/JOURNALS

*International Journal for the Study
of New Religions*
http://www.equinoxjournals.com/IJSNR

*The Journal of the American
Academy of Religion*
http://jaar.oxfordjournals.org/

Journal of Contemporary Religion
http://www.tandf.co.uk/journals/cjcr

The Journal of Religion
http://www.journals.uchicago.edu

The Journal of Religion and Society
http://moses.creighton.edu/JRS/

Reviews in Religion and Theology
http://www.blackwellpublishing.com/
journal.asp

WEBSITES

ABC Online Religion and Ethics Portal
http://www.abc.net.au/religion/
Collection of articles, commentaries and
interviews on religious and ethical subjects
hosted by Australian broadcaster ABC.

BBC Religion
http://www.bbc.co.uk/religion/
Portal to articles and links about religions
and religious subjects, hosted by British
broadcaster BBC.

CESNUR: Center for Studies on New Religions
http://www.cesnur.org/
An international network of associations of
scholars working in the field of new religious
movements.

*INFORM: Information Network Focus on
Religious Movements*
http://www.inform.ac/
An independent charity providing balanced,
up-to-date information about new and
alternative religions or spiritual movements.

Religion Online
http://www.religion-online.org
Collection of scholarly articles, mainly from a
Christian perspective.

The Religion Hub
http://www.thereligionhub.com/
Interactive social network for people
interested in religion.

RESOURCES

BOOKS

Animism: Respecting the Living World
Graham Harvey
(C. Hurst & Co., 2005)

A Brief Introduction to Hinduism
A.L. Herman
(Westview Press, 1991)

Buddhist Religions: A Historical Introduction
Richard H. Robinson, Willard L. Johnson and Thanissaro Bhikkhu
(Wadsworth, 2003)

Christian Theology. An Introduction
Alister E. McGrath
(Wiley-Blackwell, 2010)

Encountering Religion: An Introduction to the Religions of the World
Ian Markham and Tinu Ruparell (eds)
(Wiley-Blackwell, 2000)

Historical Dictionary of Shamanism
Graham Harvey and Robert J. Wallis
(The Scarecrow Press Inc., 2007)

Judaism
Nicholas de Lange
(Oxford University Press, 2003)

Listening People, Speaking Earth: Contemporary Paganism
Graham Harvey
(C. Hurst & Co., 1997)

Magic and the Millennium: A Sociological Study of Religious Movements of Protest among Tribal and Third-World Peoples
Bryan R. Wilson
(HarperCollins, 1975)

The New Believers: A Survey of Sects, Cults and Alternative Religions
David V. Barrett
(Cassell, 2001)

A New Dictionary of Religions
John R. Hinnells (ed)
(Wiley-Blackwell, 1995)

New Religions: A Guide – New Religious Movements, Sects and Alternative Spiritualities
Christopher Partridge and J. Gordon Melton
(Oxford University Press, 2004)

The Oxford Handbook of New Religious Movements
James R. Lewis
(Oxford University Press, 2008)

Religion in China
Richard C. Bush
(Argus, 1978)

Religion in Contemporary Japan
Ian Reader
(University of Hawaii Press, 1991)

Religions in Focus: New Approaches to Tradition and Contemporary Practices
Graham Harvey (ed)
(Equinox Publishing, 2009)

APPENDICES

SHINSHUKYO

the 30-second religion

Japanese religion is characterized by syncretism and decentralization: typically, a birth is marked by a Shinto ceremony and Buddhism provides funeral services. 'Shinshukyo' refers to 'Newly Rising Religions', although in fact many groups so described draw on various aspects of this diverse and ancient religious heritage as interpreted by a particular individual. These founders and religious leaders, for adherents, make religion relevant for today, and the organizations that promote their teachings have replaced older patterns of religious affiliation. Some leaders, following the shamanistic aspects of Japanese religion, are believed to be channelling messages directly from a god and to have supernatural powers, such as healing. Others are venerated as teachers of exceptional insight; a New Religion may have a founder of the first type who is succeeded by a leader of the second type. Japanese New Religions tend to focus on concerns in this world, particularly health and personal success. The most successful Japanese New Religion is Soka Gakkai; this group emphasizes the traditional Buddhist practice of chanting the sacred text of the *Lotus Sutra*, but it teaches that this will have concrete material, as well as spiritual, benefits. Some New Religions also assimilate ideas from Christianity or from popular culture.

3-SECOND SERMON
Religion in Japan is renewed and made relevant through the revelations and insights of founders and teachers.

3-MINUTE THEOLOGY
New Religions often face suspicion or ridicule from wider society, and media reports on Japanese New Religions have often focused on particularly eccentric groups with leaders who, to outside observers, appear to be dishonest or deluded. There has been less tolerance for New Religions in Japan since the Tokyo terrorist attack of 1995, when Aum Shinrikyo unleashed poison gas on the public as a result of its beliefs about the end of the world.

RELATED RELIGIONS
See also
MAHAYANA BUDDHISM
Page 40
SHINTO
Page 54
TENRIKYO
Page 132

3-SECOND BIOGRAPHIES
NAKAYAMA MIKI
1798–1887

KAWATE BUNJIRO
1814–1883

DEGUCHI NAO
1836–1918

DAISAKU IKEDA
1928–

SHOKO ASAHARA
1955–

30-SECOND TEXT
Richard Bartholomew

The New Religions of Japan are grounded in Buddhism and Shinto, but reinterpreted for a modern Japan by influential leaders.

RASTAFARIAN MOVEMENT

the 30-second religion

The Rastafarian movement

began in Jamaica, when the coronation of Ras Tafari as Emperor Haile Selassie of Ethiopia in 1930 was interpreted as a prophetic event by some black Jamaicans. While the Caribbean and most of Africa were under white colonial domination, Ethiopia remained a proud and independent black African nation, and Haile Selassie, as God, would restore black supremacy and bring blacks back to Africa. The Bible, complemented by other texts, was interpreted in the light of the situation of blacks: just as the ancient empire of Babylon had oppressed the Jews, so whites were 'Babylon' oppressing the black chosen people, considered reincarnated Israelites, and Ethiopia was Zion. Believers express their identity through the 'livity', a way of life that emphasizes naturalness. Hair is worn as dreadlocks, diet is vegetarian and herbal medicine is favoured; in particular, ganja (marijuana) is regarded as a sacrament that brings spiritual healing when smoked. Language is adapted to convey Rastafarian experience: human dignity and subjectivity are expressed by using 'I' instead of the Creole *mi* (me), and the divine essence inside each person is called 'I and I'.

3-SECOND SERMON
God redeems black people from white oppression, and he came to the earth as Haile Selassie, the Emperor of Ethiopia.

3-MINUTE THEOLOGY
The figure of Haile Selassie (who died in 1975) is no longer central for many Rastafarians, and the idea of a return to Africa is often understood symbolically in terms of self-expression within white-majority societies. Personal liberation not black supremacy is stressed, and there are now also white Rastafarians. However, despite the emphasis on liberation, the religion remains patriarchal, and Rasta women have complained about their subordinate position within the religion.

3-SECOND BIOGRAPHIES
HAILE SELASSIE
1892–1975

JOSEPH HIBBERT
1894–date unknown

MARCUS GARVEY
1887–1940

LEONARD PERCIVAL HOWELL
1898–1981

ARCHIBALD DUNKLEY
fl. 1930s

BOB MARLEY
1945–1981

30-SECOND TEXT
Richard Bartholomew

God, manifest as the Emperor Haile Selassie, arrived on the earth to help raise black consciousness.

SCIENTOLOGY
the 30-second religion

According to L. Ron Hubbard's

book *Dianetics* (1950), humans are limited by 'engrams', bad experiences stored in the unconscious mind that affect behaviour. These experiences may be from earlier in one's life, from the womb or from past lives. Engrams can be removed through a process called 'auditing' – this involves answering questions, either using the book or in a professional environment while attached to a device invented by Hubbard called the E-Meter. Psychiatry, by contrast, is rejected as harmful, particularly in its use of drugs. Those who have completed the process are called 'Clears'. Hubbard's subsequent teaching states that a 'Clear' can further develop the inner self, called a 'Thetan'. A Scientologist seeks to become an Operating Thetan (OT), and then to pass through various levels. At OT III, a Scientologist learns about how the Thetans were brought to the earth by Xenu, a galactic dictator, in traumatic circumstances 75 million years ago. However, this knowledge is believed to be dangerous to the unprepared, and it will be meaningful only if revealed in a ritual context. Hubbard discovered this through scientific investigation, not through revelation, although some Scientologists regard the story as allegorical. Hubbard is venerated as the greatest author, inventor and explorer.

3-SECOND SERMON
Human functioning and awareness can be dramatically improved, and with progress comes personal development from secret knowledge about the history of the universe.

3-MINUTE THEOLOGY
Hubbard is reported to have said in the 1940s that he would like to start a religion to make money, and sceptics allege that Scientology is not a real religion. The Church is known for having an aggressive attitude to critics, and in the 1970s it was beset with allegations of criminality in more than one country in pursuit of its interests. Recently, masked anti-Scientologist activists calling themselves 'Anonymous' have picketed Scientologist establishments.

3-SECOND BIOGRAPHIES
L. RON HUBBARD
1911–1986

MARY SUE HUBBARD
1932–2002

MICHAEL MISCAVAGE
1960–

30-SECOND TEXT
Richard Bartholomew

Having divested yourself of bad engrams, as a 'Clear' you can embark on a series of stages that will reveal the true history of the universe.

CAO DAI

the 30-second religion

Cao Dai was established in southern Vietnam in 1926. It teaches that the religious founders and other great figures of the past represent two earlier eras of divine communication with the world. The Third Era was revealed to a Vietnamese civil servant named Ngo Minh Chieu, when he was contacted by a spirit named Cao Dai during a séance; the name means 'Roofless Tower', and refers to the 'Supreme Being'. Believers also adhere to further teachings delivered through mediums, both directly from Cao Dai and through various disembodied spirits of the dead. One such spirit is that of the French author Victor Hugo, who is thought to have been the Supreme Being's messenger to the West. Clergy are divided into three subgroups representing Buddhism, Confucianism and Taoism, and organized along a structure borrowed from Roman Catholicism (although there is no Pope at present, and women are allowed to fill some positions). The Supreme Being is symbolized as a left eye, called the Celestial Eye, and significant figures such as The Buddha and Jesus are among a group of deities at levels below Cao Dai. Adherents believe in karma, and seek merit through religious practice and service to society to escape the cycle of reincarnation.

RELATED RELIGIONS
See also
MAINSTREAM BUDDHISM
Page 36
TAOISM
Page 48
CONFUCIANISM
Page 50
SPIRITUALISM
Page 122

3-SECOND BIOGRAPHIES
LE VAN TRUNG
1875–1934

NGO MINH CHIEU
1878–1932

PHAM CONG TAC
1890–1959

30-SECOND TEXT
Richard Bartholomew

3-SECOND SERMON
This is the Third Era of Salvation; religions are united in the worship of the Supreme Being, and there is communication with the spirit world.

3-MINUTE THEOLOGY
Cao Dai represents a modernizing synthesis that began by appealing to educated Vietnamese living under colonial rule; this modern perspective includes the emphasis on spirit contact, since Western spiritualist phenomena have been regarded in some circles as scientific. Cao Dai is also associated with anticolonialism, and festivals and exhibitions organized by the religion have celebrated progress and spiritual evolution by showing members in modern professions.

Utilizing elements of Buddhism, Cao Dai, through the teachings of the eponymous Supreme Being, will lead followers to break the cycle of reincarnation.

UNIFICATION CHURCH

the 30-second religion

Unificationists believe that God's plan is for his love to be made manifest through a perfect trinity of God, man and woman, expressed through the 'ideal family'. However, the bond between humans and God was broken when Eve, the first woman, had intercourse with the angel Lucifer, and then with the first man. Jesus came to restore the trinity by having a family, but he was crucified before he could complete his work. Sun Myung Moon (born in Korea in 1920) claims to be the Messiah come again as the 'True Father', while his wife is the 'True Mother'. Adherents believe that their bond with God is restored through taking part in a mass wedding ceremony performed by Moon, with a partner chosen by the Church.
As a sign that humanity is one family, many Unificationist couples are international or interracial and Moon teaches that their children will be without the Original Sin inherited from Adam and Eve. Moon warns that the human sexual organs are precious and must be used properly; 'free love' and homosexuality should disappear. Such teachings are called the 'Divine Principle'. Moon does not believe he is God and believers object to being called 'Moonies'.

RELATED RELIGIONS
See also
CONFUCIANISM
Page 50
CALVINISM
Page 90

3-SECOND BIOGRAPHIES
SUN MYUNG MOON
'True Father'
1920–

HAK JA HAN MOON
'True Mother'
1943–

HYO JIN MOON
1962–2008

HYUN JIN (PRESTON) MOON
1969–

30-SECOND TEXT
Richard Bartholomew

3-SECOND SERMON
The perfect marriage of the Messiah restores humanity's bond with God; Rev. Moon is the 'True Father' who completes the work of Jesus.

3-MINUTE THEOLOGY
Although the theology of the Unification Church diverges from traditional Christianity, Moon was raised as a Presbyterian and he regards his theology as Christian. Organizations founded by the church promote interfaith activities and Moon's emphasis on marriage has attracted some African Catholic clerics whose own church demands that priests be celibate. Moon's parents had formerly been Confucians before they became Christians, and the scholar Ninian Smart described Moon's teachings as 'Evangelical Confucianism'.

Mass wedding ceremonies symbolize the reunification between God, man and woman – the perfect trinity.

FALUN GONG

the 30-second religion

Falun Gong is based on the

teachings of Li Hongzhi, a former musician who is regarded by followers as a master of qigong, a form of Chinese meditation and exercise used for healing and for increasing human potential. Li draws on popular Buddhism and Taoism, and he relates health to karma, in which actions in one's past lives affect one's current life. Karma is a black substance inside the body, which, through suffering or practice alongside moral living, can be made white. Followers should read Li's writings, get rid of 'attachments', and follow the exercises that he prescribes; practitioners may develop paranormal powers, and Li claims to have a greater understanding of the universe than can be known by science. This includes the knowledge that aliens exist, and that the world has been destroyed and recreated a number of times and is about to undergo this process again. A sign that this is about to occur is the repression that followers have experienced in China since 1999; Li says that those who suffer or die for their belief will receive instant enlightenment. Members have held silent protests in Beijing and outside Chinese embassies abroad.

RELATED RELIGIONS
See also
MAINSTREAM BUDDHISM
Page 36
TAOISM
Page 48

3-SECOND BIOGRAPHY
LI HONGZHI
1952–

30-SECOND TEXT
Richard Bartholomew

3-SECOND SERMON
Certain exercises will transform the body and reveal a person's place in the universe; a new world cycle of destruction and renewal is imminent.

3-MINUTE THEOLOGY
In the People's Republic of China, Falun Gong is regarded as a 'heretical cult' that exploits members, causes deaths and is a threat to society. Practitioners have been detained and sent to labour camps, although claims of organ harvesting reported in Falun Gong media, such as the *Epoch Times*, are unsubstantiated. In 2001, Li was awarded a prize by Freedom House, a prominent American human rights organization, as a 'defender of religious rights'.

Adherents of Falun Gong seek enlightenment through the practice of qigong and the teachings of Li Hongzhi.

JOHN FRUM MOVEMENT

the 30-second religion

Believers regard John Frum as

God; he is thought to divide his time between America and Yasur, a volcano on the island of Tanna in Vanuatu in the South Pacific. He first made himself known to local inhabitants in the 1930s through a vision, urging the rejection of Christianity and colonial currency, and a return to *kastom* – traditional culture. These were the customs and traditions that missionaries had forbidden, such as drinking an intoxicant called *kava*. Followers believe that subsequent events vindicated their faith: the Second World War brought sailors dressed in white to the island, along with technological marvels. Although these Americans left after the war, John Frum will one day return with a bounty of cargo from the United States. Believers offer prayers to Frum, and each year celebrate John Frum Day; ceremonies include raising US flags and marching in mock US uniforms, and replica chainsaws are swung symbolically to prepare space for the building of factories. Members of the movement have also constructed an airstrip with bamboo control towers to facilitate the arrival of the cargo.

3-SECOND SERMON
John Frum is King of America, and he will make the island of Tanna into a utopia by restoring traditional customs and bringing cargo.

3-MINUTE THEOLOGY
The John Frum Movement is categorized as a 'cargo cult'. However, followers are not just motivated by a desire for material goods: the movement began as a protest against colonial domination. The movement's relationship with authorities in Vanuatu is tense. Paradoxically, it defends *kastom* by appropriating symbols of technology and of the United States, and it rejects Christianity while adapting millenarian Christian beliefs about a coming New World.

3-SECOND BIOGRAPHIES
NAMBAS
fl. 1950s

NAKOMAHA
fl. 1950s

ISAAK WAN
Current

FRED NESSE
Current

30-SECOND TEXT
Richard Bartholomew

Followers believe that John Frum, king of America, will return, bringing wealth and the re-establishment of traditional customs.

Messiah The saviour of the Jews, whose arrival is anticipated in the Old Testament. For Christians, Jesus of Nazareth fulfilled the prophecies and became their Messiah. More generally, the term is used to refer to any saviour figure. From the Hebrew word *masiah*, meaning 'anointed one'.

Operating Thetan According to Scientology, the spiritual rank above 'Clear'. Once humans have been audited, they reach a state of 'Clear'. After that, further study will enable them to become Operating Thetans. There are many stages thereafter, with OTI-VII being preliminary stages before becoming a fully fledged OT at OTVIII, when the full truth is revealed.

qigong A Chinese martial art that combines meditation and movement. The full technique includes 460 movements, which involve visualizations and breathing exercises. Originating in China in 1122 BC, the aim is to harmonize mind and body. From the Chinese *qi* or *chi* (energy) and *gong* (cultivation).

reincarnation Similar to the Buddhist concept of rebirth, except it is applied to a specific individual soul, instead of the more general concept of an 'evolving consciousness'. This idea is central to most Eastern religions, including Hinduism, Jainism and Sikhism.

Supreme Being God, in the Cao Dai religion. The term is used to avoid any gender, race or religious associations, although it is explicitly the same god worshipped by all other religions. The aim of the Cao Dai is to unite all believers in a supreme being.

syncretism The merging of different faiths, usually implying a successful new fusion. Christian Spiritualism is one example. The Baha'i Faith, which accepts Muhammad, Jesus, Moses, Buddha, Zoroaster and Abraham as prophets, is considered another, although it has its own prophet, Bahá'u'lláh, and its own holy scriptures.

Thetan According to Scientology, the essence of life, similar to the soul in other religions. Thetans were self-willed into existence trillions of years ago and created the physical world for their own amusement. However, in time they forgot their true nature and became locked in their physical bodies. The aim of Scientology is to return them to their original state of 'self-determinism'.

Zion Originally a hill in Jerusalem conquered by David, but also a general term for a promised land. For Rastafarians, Zion is located in Ethiopia.

Babylon The most important city in ancient Mesopotamia, located on the Euphrates River, 80 km (50 miles) south of Baghdad. It was the capital of the Babylonian Empire from 612 BC. To Rastafarians, Babylon is a symbol of the oppression of blacks by whites, just as the Jews were oppressed during the Persian rule of Babylon in 538–332 BC.

black supremacy The belief that black people are superior to other races. At its most extreme, it is a racist ideology that encourages hatred towards anyone not of African ancestry, especially whites and Jews. However, some historians suggest that black supremacy is simply a reaction to white racism. Key organizations in the promotion of black supremacy are the Nation of Islam, formed in 1930, and the Black Panther Party, formed in 1966.

divine eye The symbol of the Cao Dai religion; a left-hand eye inside a circle or triangle. The eye is supposed to remind followers that the Supreme Being is 'all seeing' and 'all knowing' and that their every action is being watched. The left eye is shown because left represents yang, or the holy spirit, which watches over humankind.

dreadlocks Hair that is grown long, is twisted, and then becomes matted into long coils that look like rope. Although also practised by other religions, dreadlocks are particularly associated with Rastafarians, who wear 'dreads' as an expression of religious belief and to assert their black identity. Several passages from the Bible are quoted to support the practice, including Leviticus 21:5 and Numbers 6:5.

livity The Rastafarian way of life. This includes rejecting Babylon, or the modern way of life, by not paying taxes, only eating additive-free food, avoiding alcohol and coffee, smoking cannabis, eating a mainly vegetarian diet – or at very least not eating pork and shellfish – and growing hair into dreadlocks. The Rastafarian ethos has been criticized for its negative attitude to women and homosexuals.

Lucifer The word 'Lucifer' is derived from the Latin *lux* (light) and *ferre* (to bear), meaning the light bearer, and original referred to the morning star. The term was used in the New Testament to refer to a Babylonian king who fell from power (Isaiah 14:3–20) and only later was the name applied to the devil. Nowadays, the word is used almost interchangeably with Satan, the devil and Beelzebub.

NEW RELIGIONS

天理市

TENRIKYO

the 30-second religion

Followers of Tenrikyo believe

that from 1838 God the Parent (Tenri-O-no-mikoto) began to reveal himself through Nakayama Miki, a farmer's wife who was declared to be the Shrine of God and 'Oyasama', meaning 'Parent'. God the Parent conveyed through Oyasama the promise that, following rebirths, humans will eventually experience an age in which everyone will enjoy the 'joyous life'; suffering is due to causation (*innen*, or karmic fate). The path to the 'joyous life' is to express gratitude for the life loaned to us by God, to understand that all people are brothers and sisters, and to detach ourselves from negative 'dusts', such as envy or hate that settle in our minds and cause selfishness. Oyasama embodied the path by giving away her family's wealth and impoverishing herself. God the Parent later revealed that a location within the historical heartland of Japan is the centre of the universe; this place, now within the city of Tenri in Nara, is where God the Parent resides, and it was here that humanity was created. Today, it is a place of pilgrimage, and it is venerated with sacred dance. Oyasama's male descendants now lead the religion.

RELATED RELIGIONS
See also
MAHAYANA BUDDHISM
Page 40
SHINTO
Page 54
SHINSHUKYO
Page 150

3-SECOND BIOGRAPHIES
NAKAYAMA MIKI
1798–1887

IBURI IZO
1833–1907

30-SECOND TEXT
Richard Bartholomew

3-SECOND SERMON
God the Parent wants all humans to partake of the 'joyous life' through moral cultivation.

3-MINUTE THEOLOGY
Tenrikyo draws on folk shamanism and Buddhism, and despite the emphasis on Japan as the centre of the universe, the religion regards itself as having a message for the whole world. However, it also shares elements with Shinto, and from 1908 to 1970 it was formally assimilated by the state into a form of Shinto. During her lifetime, Oyasama's message of equality and her female leadership were regarded with suspicion as well as hostility by the Japanese authorities.

Echoing the Buddhist belief in reincarnation, Tenrikyo teaches that attainment of the 'joyous life' is achieved by denying negative tendencies.

CHEONDOISM

the 30-second religion

Adherents believe that the Ruler of Heaven, Sangje, revealed himself to a young Korean scholar named Ch'oe Che'u in 1860. Sangje gave Ch'oe Che'u a cryptic phrase, which, when written on paper and swallowed, will cure disease and impart long life. Repeating the phrase in worship is believed to help humans to bring their thoughts and actions into harmony with heaven. In addition, humans should work to build a paradise on earth, and this has been understood to mean support for Korean nationalism. The teaching is characterized as 'Eastern Learning' (*Tonghak*, the original name of the religion), in conscious opposition to 'Western Learning' (*Sohak*), which was identified with Roman Catholicism. However, although the name 'Sangje' comes from Chinese Taoism, the religion has a central prayer which uses the Roman Catholic term for God, 'Chonju', and worship style and architecture suggest influence from Protestantism. The current name of the religion, adopted in 1905, means 'Religion of the Heavenly Way'.

3-SECOND SERMON
Humans and heaven are one, and humans can realize this truth by reverencing the Ruler of Heaven and repeating a sacred phrase.

3-MINUTE THEOLOGY
Cheondoism blends Chinese religion with Korean shamanism in the context of a nationalistic Korean identity. Ch'oe Che'u was executed for treason in 1864, and leaders of the group led insurrections against corrupt rulers in the 1890s. A later leader, Son Pyong-hui, helped to write the Korean Declaration of Independence, and in the 1960s members were prominent in patriotic pro-government rallies in South Korea.

RELATED RELIGIONS
See also
ANIMISM
Page 18

MAINSTREAM BUDDHISM
Page 36

TAOISM
Page 48

3-SECOND BIOGRAPHIES
CH'OE CHE'U
1824–1864

CH'OE SIHYONG
1827–1898

SON PYONG-HUI
1861–1922

30-SECOND TEXT
Richard Bartholomew

The repetition of a sacred phrase provided by the Ruler of Heaven will bring about harmony between heaven and earth.

HARE KRISHNA MOVEMENT

the 30-second religion

RELATED RELIGION
See also
HINDUISM
Page 32

3-SECOND BIOGRAPHIES
A.C. BHAKTIVEDANTA
SWAMI PRABHUPADA
1896–1977

GEORGE HARRISON
1943–2001

RAVINDRA SVARUPA DASA
William H. Deadwyler
c. 1946

3-SECOND SERMON
Sincere devotion to Krishna expressed through chanting, service and right living will lead to God consciousness.

3-MINUTE THEOLOGY
Despite its conservative moral strictures and patriarchy, ISKCON's first appeal was to members of the 1960s counterculture, most famously George Harrison. However, following the death of Prabhupada, the organization experienced scandals involving gurus who were expelled for engaging in illicit sex and using drugs. While Prabhupada regarded the religion in universal terms, ISKCON today places greater stress on its Hindu background, and non-ISKCON Hindus are known to attend ISKCON temples for worship.

The International Society for Krishna Consciousness (ISKCON) believes that the Hindu deity Krishna represents the supreme manifestation of God, and that he has been incarnated at various times in history, including as Rama and The Buddha. Most recently, he came as Chaitanya Mahaprabhu (1486–1533), who taught salvation through devotion (*bhakti*). ISKCON members express their love for Krishna by worship practices that include public dancing and preaching, and by repeating a sixteen-word mantra taken from the Hindu *Upanishads*, and which begins 'Hare Krishna' ('Hare' refers to the energy of God). Through such activities the law of karma and the cycle of reincarnation will be overcome, although the ordinary devotee must remain under the guidance of a recognized guru within the movement, and moral precepts must be followed. The words of Krishna are believed to be recorded in the Bhagavad Gita, and adherents consider that the purest translation into English and most authoritative commentary was made by A.C. Bhaktivedanta Swami Prabhupada, who founded ISKCON in the United States in 1966. ISKCON is noted for providing free meals, both as a charitable act for the needy and to promote the virtues of vegetarianism, and for its mass distribution of literature.

30-SECOND TEXT
Richard Bartholomew

Adherents of the Hare Krishna movement worship Krishna as the Supreme Lord and aim to promote spirituality, peace and unity.

CANDOMBLÉ
the 30-second religion

Followers of Candomblé venerate
African deities, drawing on traditions from several parts of Africa (but primarily Yoruba) that were brought to Brazil by slaves. The deities are known as *orixás*, although there is some variation of nomenclature; there is a distant high God named Olorun, his son Oxalá, who created the world, and a small pantheon of other deities representing aspects of human experience and the natural order, such as war and agriculture (Ogum) and luxury and fertility (Oxum). Each person is the 'child' of a particular *orixá*, and a follower of the religion (either a woman or a man) may choose to become an *iaô*, an initiate of a deity. Following the initiation process, the *iaô* represents the deity to the people, entering trance possessions and dancing, and after seven years the *iaô* may become a *mãe* or *pie de santo* (mother or father of saints). The gods are offered animal sacrifices, and they are consulted about problems through divination methods, such as throwing down cowry shells and interpreting the resulting pattern. Health and harmony depend on achieving a balance between the various forces represented by the different *orixás*.

RELATED RELIGIONS
See also
YORUBA
Page 14
VOODOO
Page 124

3-SECOND BIOGRAPHIES
IYA NASSO
fl. 1830s

MÃE ANINHA
Eugênia Anna Santos
1879–1938

MÃE MENININHA
Maria Escolástica
da Conceição Nazaré
1894–1986

MÃE STELLA DE OXOSSI
Maria Stella
de Azevedo Santos
1925–

30-SECOND TEXT
Richard Bartholomew

3-SECOND SERMON
The gods give us life, protection and advice, so we should reciprocate with food offerings, celebrations and, in some cases, initiations.

3-MINUTE THEOLOGY
Candomblé has traditionally contained elements taken from Roman Catholicism, with the *orixás* identified with Jesus and the saints. Followers of Candomblé also typically describe themselves as Roman Catholics. However, since the 1980s there has been a movement to reject Catholic influence as a 'syncretistic' imposition; those who take this view seek 're-Africanization' and advise the removal of Catholic images. However, some scholars believe that this quest for purity belies the historical complexities in the development of Candomblé.

With strong African associations, Candomblé followers look to the gods for security in return for offerings and veneration.

VOODOO

the 30-second religion

According to the beliefs of

Voodoo, there are thousands of spirits (*lwa*) that interact with humanity. These *lwa* were once human, and they are classified into 'nations' that reflect the ancestral homelands of African slaves. Some spirits are generous *rada* spirits, while others are more aggressive *petro* spirits, although these can be seen as alternative manifestations of the same *lwa*. Certain spirits are particularly associated with the dead; these are the *gede*, headed by Baron Samdi and are known for their trickery and raucous behaviour. The spirits were all created by the Supreme God, Bondye, who considers petitions from humans conveyed by the *lwa* but who is otherwise uninvolved with humanity. The *lwa* are served by Voodoo priests (*oungan*) and priestesses (*manbo*), and contact with the *lwa* can occur through dreams, possession trances or divination. Rituals include drumming and dancing, because these attract the spirits and induce possession, while animal sacrifice provides the spirits with sustenance. There are also malign lesser spirits, *baka*, who can be manipulated for selfish purposes by sorcerers, called *boko*. *Boko* are also thought to have the power to create zombies; these are bodies controlled by the *boko* by capture of the owner's soul.

RELATED RELIGIONS
See also
YORUBA
Page 14
CANDOMBLÉ
Page 126

3-SECOND BIOGRAPHIES
BOUKMAN DUTTY
d. c. 1791

MARIE LAVEAU
1794–1881

MAYA DEREN
1917–1961

30-SECOND TEXT
Richard Bartholomew

3-SECOND SERMON
Many spirits make themselves known through dreams, trances and communication with priests; Voodoo rituals provide healing, assistance and protection from evil forces.

3-MINUTE THEOLOGY
Many followers of Voodoo consider themselves to be Roman Catholics, despite the Church's antagonistic attitude towards the religion. Many of the *lwa* are identified with Roman Catholic saints – such is the gatekeeper *lwa* Legba; he is often associated with Saint Peter, who in Catholic tradition holds the keys to heaven. Some Voodoo practitioners complain about the lurid way in which the religion is depicted in popular culture as a form of 'black magic'.

Intoxicating rituals open contact with the spirit world, allowing Voodoo priests and priestesses to seek assistance and healing.

SPIRITUALISM
the 30-second religion

Spiritualists believe that mediums can convey messages from the spirit world. Communications may be religious teachings from a spirit guide, or personal messages from deceased loved ones. A spirit may communicate in various ways: the medium may go into a trance and either speak the spirit's words or write them down – if the medium is consulted during a séance, in which a small group of people sit around a table, the spirit may answer by rapping on the table or by tipping it. Alternatively, the medium may stand before a larger audience and claim to receive personal information from a variety of spirits about particular people present. Some mediums advertise themselves as able to provide messages for people who contact them by telephone or text message; in the past, some claimed that during their trance their bodies would exude ectoplasm, a substance that would form into the image of the spirit and which could be photographed. Despite the Biblical taboo against contacting the dead, there are Christian Spiritualists, some of whom emphasize teachings received from a disciple of Jesus called Zodiac. The spirit world is thought to consist of various levels or 'spheres'; spiritual progression continues after death.

3-SECOND SERMON
The dead can communicate from the spirit world with the living via mediums, providing information and other manifestations that scientifically prove life after death.

3-MINUTE THEOLOGY
Spiritualism claims to offer scientific evidence for the afterlife, in the form of information that the medium could not have known without communication with spirits. As such, it has attracted considerable interest from investigators of paranormal phenomena, some of whom have become convinced that mediumship is genuine. Others, however, believe that, due to wishful thinking, those who consult mediums overlook incorrect information and the medium's ability to coax or discern information naturally.

3-SECOND BIOGRAPHIES
EMANUEL SWEDENBORG
1688–1772

MARGARET FOX
1833–1893

LEONORA PIPER
1857–1950

ARTHUR CONAN DOYLE
1859–1930

DORIS STOKES
1920–1987

30-SECOND TEXT
Richard Bartholomew

Spiritualists believe that the spirit survives death. Messages from the spirit world are relayed to the living via mediums.

NEO-PAGANISM

the 30-second religion

Neo-Pagans are inspired by the ancient pre-Christian religions of Europe (and, to a lesser extent, the Middle East), and there is a diversity of beliefs and emphases. Hellenic Neo-Pagans, for example, worship Greek deities, such as Zeus, while others look to Norse gods, such as Odin. The best-known strand, however, is known as Wicca, which stresses the notion of a Goddess of fertility and rebirth, and her male consort, the Horned God of the forests. Nature is to be respected and celebrated – both in the rhythm of the year and the life cycle – and humans in harmony with nature can become adepts of 'the Craft', the use of magic. However, such self-described 'witches' are cautioned to use magic for healing and for personal development instead of for outward manipulation. Some Neo-Pagans regard the deities as real beings, others as symbolic representations of natural forces and aspects of human characteristics. Much of the scholarship on 'the Goddess' that Wicca draws on is today regarded as historically problematic, but members are often aware of this and are willing to regard such texts as 'founding myths'.

RELATED RELIGION
See also
ANIMISM
Page 18

3-SECOND BIOGRAPHIES
GERALD GARDNER
1884–1964

ALEX SANDERS
1926–1988

MAXINE SANDERS
1946–

STARHAWK
1951–

30-SECOND TEXT
Richard Bartholomew

3-SECOND SERMON
Humans should live in harmony with nature by venerating ancient gods and goddesses, while magical rituals can bring healing and spiritual growth.

3-MINUTE THEOLOGY
With its stress on a female divinity and its empowering reclamation of the label 'witch', Wicca in particular has attracted some feminist support. However, because the Goddess is often portrayed as a stereotypically alluring, slim young woman, the movement has been criticized for entrenching gender essentialism. Neo-Pagan practices – particularly those that involve nudity – are regarded with hostility by many Christians, and Wiccans have often complained of being accused of Satanism by churches and the media.

Neo-Paganism is an essentially polytheistic, religion, recognizing a divine Goddess, and celebrating nature as a divinity in its own right.

Satanists Those who worship Satan. The term is sometimes used by Christian fundamentalists to describe all non-Christians. The real Church of Satan, however, has well-defined principles, such as fulfilling desires and not turning the other cheek, but also being kind to those who deserve it and not harming children.

séance A meeting of people, usually around a table, to contact the spirits of the dead. A medium is usually used as an intermediary, and messages are relayed in the form of speech, writing, cards or Ouija boards. From the French meaning 'to be seated', originally it referred to any meeting but especially meetings of the legislature.

shamanism The belief that the world is filled with spirits, which can be influenced by a holy man. The shaman is thought to be able to heal people and resolve problems within communities by connecting with the spirit world and restoring balance. The religion is prevalent in Asia and Siberia and among Native American tribes.

spirit The non-physical, metaphysical part of a person; their essential life force. Many religions consider that it is the spirit that gives the body life, and that the spirit survives after the body has died.

syncretism The merging of different faiths, usually implying a successful new fusion. Christian Spiritualism is one example. The Baha'i faith, which accepts Muhammad, Jesus, Moses, Buddha, Zoroaster and Abraham as prophets, is considered another, although it has its own prophet, Bahá'u'lláh, and its own holy scriptures.

Wicca A pagan or nature-based religion that is said to have its roots in pre-Christian witchcraft. Covens of Wiccans use magic rituals to celebrate seasonal festivals based around a Mother Goddess. Some claim sexual acts are involved.

zombie A dead body brought to life by supernatural forces. In Voodoo religions, the term can also refer to a spell cast to bring a corpse back to life and control it. The concept originates in West Africa but has been popularized in Western popular culture through novels and films.

animal sacrifice The ritual killing of an animal to appease or petition deities. It is sometimes interpreted as the killing of humankind's baser, 'animal' instincts, or simply as sacrificing something precious to prove devotion. Many religions practise animal sacrifice, including Hinduism, and there are numerous descriptions of it in the Old Testament.

Bhagavad Gita A section of the Mahabharata, composed in c. 250 BC, in which Krishna reveals himself to Arjuna and embarks on a long theological discussion about human nature and the meaning of life. Many of the central tenets of Hinduism are discussed, including the dissolution of ego and following the natural path.

black magic The channelling of malevolent spirits and other paranormal phenomena to create spells and bring about evil deeds, or the belief that this is possible.

Christian spiritualists People who combine their Christian faith with spiritualist beliefs. The main attraction for such people is the alleged ability to contact the dead and communicate with their loved ones. Orthodox Christian religions maintain that the Bible expressly forbids contacts with the dead, quoting passages from Deuteronomy (18:11) and Luke (16:19–31).

ectoplasm A substance said to exude from various orifices, or possibly the pores, of mediums while they are in a trance. Starting as a smoke or vapour, it is said to react to light and turn into a cloth-like substance.

medium A person who is said to contact the spirits of the dead and other paranormal forces and to act as an intermediary with the living. Contact is usually made when the medium falls into a trance and allows the spirit to use his or her body to communicate either verbally or through writing or other signs. The practice is prevalent in certain religions, such as Spiritualism and Voodooism.

Odin In Norse mythology, the supreme God, who created heaven, earth and the first human beings, Ask and Embla. He was also venerated as the god of poetry, wisdom, knowledge, magic, prophecy, war, hunting, victory and death.

pantheon A temple devoted to the gods, such as the building of that name in Rome, or a collective name for a group of gods or deities.

paranormal Something that cannot be explained by normal experience or currently accepted scientific laws. Typical examples are telepathy, divination, astrology, channelling, ghosts and UFOs.

FUSION RELIGIONS

CHRISTIAN SCIENCE

the 30-second religion

In 1875, Mary Baker Eddy

published a book entitled *Science and Health with Key to the Scriptures*. Eddy, who had been experiencing persistent health problems for many years, tells of how in 1866 she had recovered unexpectedly from a bad fall and had founded the new religion of Christian Science. In 1879, the First Church of Christ, Scientist was founded in Boston, Massachusetts. Central to Christian Science is the belief that prayer can lead to healing and, in most cases, should be preferred to conventional medical treatment. This is not, however, because God is thought to intervene miraculously in the world. Instead, Christian Scientists believe the material world to be a distorted version of the true world – a world of spiritual ideas. Prayer enables an undistorted vision of the spiritual reality. Illness is understood to be the result of a mistaken conviction in the reality of a material problem; hence, healing is the removal of this error by the recognition that the problem is only really an illusion. Christian Scientists regard Jesus Christ as the 'Wayshower' and consider his healing 'miracles' as exemplars of his spiritual understanding: an understanding that is available to all humanity.

3-SECOND SERMON
The real world is an immortal reality of spiritual ideas; recognize this and healing follows.

3-MINUTE THEOLOGY
For Christian Scientists, the relation between Christian belief and the natural sciences is simple. The natural sciences describe the unreal world of the material and as such are illusory; instead Christian Science leads to an understanding of the real immortal world of spiritual ideas. There is no real conflict: the natural scientific accounts of biological evolution are as mistaken as 'Creationist' accounts: both come from the belief in the reality of the material world.

RELATED RELIGIONS
See also
EUROPEAN CHRISTIANITIES
Pages 78–97
WORLD CHRISTIANITIES
Pages 98–115

3-SECOND BIOGRAPHIES
JESUS
C. 5 BC–C. AD 30

MARY BAKER EDDY
1821–1910

30-SECOND TEXT
Russell Re Manning

God encompasses the spiritual reality, which is truth and good. According to Christian Scientists, the material world, including evil, is unreal and false.

SEVENTH-DAY ADVENTIST CHURCH

the 30-second religion

3-SECOND SERMON
A Christian community
that observes the Sabbath
on Saturday and which is
preparing for the imminent
return of Jesus Christ.

3-MINUTE THEOLOGY
Seventh-day Adventists
believe in so-called
'investigative judgment'.
This is generally meant as
an interpretation of Daniel
7:10 and Revelation 20:12,
which talk of the opening
of the 'book of life', in
which all the deeds of
humanity are written.
According to these visions,
Satan accuses believers of
transgression and unbelief
and Jesus acts as advocate,
whose atoning sacrifice
helps to blot out believers'
sins. Those whose names
remain are punished by
permanent destruction.

Formally established in 1863, the
Seventh-day Adventist Church is the largest
and most significant Christian Church to have
emerged from the Adventist movement of the
1840s, when the imminent 'Second Advent' of
Jesus Christ was predicted. When this did not
happen (known as 'the Great Disappointment'),
the predictions were reinterpreted to suggest
that Christ had entered 'the Most Holy Place'
of the heavenly sanctuary and that the process
of divine judgment had begun. Seventh-day
Adventists also believe that the Bible commands
Christians to observe the 'Sabbath' – that is to
keep Saturday (not Sunday) as a day of rest and
worship. No secular work may be performed;
instead, the day consists of worship, charitable
work and family orientated activities, such as
nature walks. Even secular recreational activities,
such as competitive sports, are generally avoided.
Influenced by the writings of Ellen G. White,
Seventh-day Adventists place considerable
emphasis on Christian deportment, ranging from
sexual ethics of abstinence and strict dietary
observance to conservative attitudes towards
dress and leisure activities. Although it may not
appeal to some, the sober Adventist lifestyle
seems to be good for the health: a recent study
claims that male Adventist Californians live 7.3
years longer than their non-Adventist neighbours!

RELATED RELIGIONS
See also
EUROPEAN CHRISTIANITIES
Pages 78–97
WORLD CHRISTIANITIES
Pages 98–115

3-SECOND BIOGRAPHIES
JESUS
C. 5 BC–C. AD 30

WILLIAM MILLER
1782–1849

ELLEN G. WHITE
1827–1915

JOHN HARVEY KELLOGG
1852–1943

30-SECOND TEXT
Russell Re Manning

*A healthy body
and a healthy
soul – Adventists
emphasize health
through abstinence
from alcohol, tobacco
and often meat.*

BAPTIST CHRISTIANITY

the 30-second religion

RELATED RELIGIONS
See also
ORTHODOX JUDAISM
Page 60
EUROPEAN CHRISTIANITIES
Pages 78–97
WORLD CHRISTIANITIES
Pages 98–115

3-SECOND SERMON
Baptism of adult believers is an outward sign of repentance of sins and confession of faith in Jesus Christ as the Son of God.

3-MINUTE THEOLOGY
Baptists believe that religious faith is a matter of a personal relation between God and the believer. This support for 'religious freedom' entails that individuals may practise any religion, or none. Historically, they have been ardent supporters of the principle of the separation of Church and State, particularly in the United States. Of course, Baptists have the evangelical hope that individuals will confess a Christian faith, but insist that this must be a free decision.

A diverse group of Christian denominations, Baptists take their name from their practice of adult baptism. Unlike most Christians, who baptize infants or young children into the fellowship of the community of Christians (known as 'infant baptism', or 'pedobaptism'), Baptists insist that individual believers freely and publically commit themselves to their Christian faith in a ceremony of adult baptism (known as 'believers' baptism', or 'credobaptism'). Often these baptisms are full immersions, in which the believer is lowered completely beneath the surface of the water, emerging in the eyes of the Church as 'born again' in Christ. Baptist churches emerged in the early seventeenth century within various Protestant denominations, and while today there is still no central Baptist authority, two prominent confederations are the Baptist World Alliance (BWA) and the Southern Baptist Convention (SBC). In 2004, the SBC, the largest Protestant denomination in the United States with over sixteen million members, voted to leave the BWA over fears of a drift towards theological liberalism. Generally evangelical, Baptists require that the New Testament be the explicit authority for their beliefs and practices. While not always taking the Bible literally, Baptists insist that Christian beliefs and practices are commanded or commended by example within the Bible.

3-SECOND BIOGRAPHIES
JESUS
C. 5 BC–C. AD 30
JOHN SMYTH
C. 1570–C. 1612
THOMAS HELWYS
C. 1575–C. 1616
ROGER WILLIAMS
C. 1603–1683

30-SECOND TEXT
Russell Re Manning

For Baptists, only adults can profess to a true faith in Jesus Christ and repent of their sins.

JEHOVAH'S WITNESSES

the 30-second religion

The Jehovah's Witnesses is the largest and best known of a group of millenarian restorationist Christian denominations that emerged out of the Bible Student Movement of the late nineteenth century, founded by Charles Taze Russell. Through continuous preaching and the journal *Zion's Watch Tower and Herald of Christ's Presence*, Russell critiqued many of the established Christian doctrines and taught the urgent message that the second coming of Christ was at hand. Through a mixture of literal and symbolic interpretations of the Bible, Jehovah's Witnesses believe in Russell's predications of the imminent apocalypse – including a cosmic battle between the forces of heaven and the forces of Satan – and the Rapture (assumption into heaven) of all true believers. Jehovah's Witnesses interpret political events, as well as the evidence of global climate change, as proof that the world is coming to an end. Unlike many Christians, Jehovah's Witnesses do not believe in the Holy Trinity, believing God (or 'Jehovah' after God's original Biblical name, the Tetragrammaton JHVH, or YHWH) to be Universal Sovereign, Jesus to be God's only direct creation and the Holy Spirit to be God's power in the world. Jehovah's Witnesses also believe Satan to be a fallen angel, who, along with his demons, misleads people and causes evil and human suffering.

3-SECOND SERMON
The last days began in 1914, leading to the imminent destruction of the world by God's intervention and the deliverance of those who worship Jehovah.

3-MINUTE THEOLOGY
Evangelism is central to Jehovah's Witnesses, in particular, the practice of spreading their beliefs by visiting people's homes. The *Watchtower* commentaries and other teaching material are widely available, with some texts translated into over 500 different languages. Jehovah's Witnesses use and distribute a new translation of the Bible, the *New World Translation of the Holy Scriptures*, of which over 165 million copies have been published in over eighty languages.

RELATED RELIGIONS
See also
ORTHODOX JUDAISM
Page 60
EUROPEAN CHRISTIANITIES
Pages 78–97
WORLD CHRISTIANITIES
Pages 98–115

3-SECOND BIOGRAPHIES
JESUS
C. 5 BC–C. AD 30

CHARLES TAZE RUSSELL
1852–1916

30-SECOND TEXT
Russell Re Manning

Jehovah's Witnesses believe Russell's prediction that Armageddon will cleanse the earth, and God will create a paradise that will be ruled over by Jesus Christ and 144,000 of the anointed.

MORMONISM

the 30-second religion

The Church of Jesus Christ of

Latter-day Saints was founded by Joseph Smith in 1830 in Fayette, New York. Mormons believe that Smith received a series of religious visions in which he was given specific instructions and authority to restore the Christian Church. Central to these was the unearthing and translation of a holy book written on plates of gold and containing the story of God's dealings with the ancient people of the Americas, as compiled by the ancient American prophet Mormon. Mormons use this book alongside the Christian Bible (in the Authorized King James Version) in religious teaching and study. Mormons believe in the continuation of prophecy: living prophets are chosen by God to act as means through which revelations can be communicated. For Mormons, all people can receive inspiration from God, but in practice God uses senior Church officials. For Mormons, Jesus is the first-born son of God and the only perfect human being and they believe that by following his example, they might achieve salvation, or the gift of an eternal life with God. Unlike many Christians, Mormons do not believe in original sin, but assert that each individual sins by choosing to do wrong. Hence salvation, while enabled by God's grace, requires the performance of good actions in imitation of Jesus.

3-SECOND SERMON
The Church of Jesus Christ of Latter-day Saints that aims to restore Christianity with new revelations of God's acts and nature.

3-MINUTE THEOLOGY
In contrast to many Christians, Mormons do not believe that God created the universe out of nothing (ex nihilo), but that God – the all-powerful and all-knowing supreme being – created it out of pre-existing material, which he ordered into its proper forms. For Mormons, God has a physical body (albeit exalted in heaven), Jesus is the perfect first-born son of God, and the Trinity consists of three distinct beings united in a common purpose.

RELATED RELIGIONS
See also
ORTHODOX JUDAISM
Page 60
EUROPEAN CHRISTIANITIES
Pages 78–97
WORLD CHRISTIANITIES
Pages 98–115

3-SECOND BIOGRAPHIES
BRIGHAM YOUNG
1801–1877

JOSEPH SMITH
1805–1844

30-SECOND TEXT
Russell Re Manning

The Book of Mormon, *as translated by Joseph Smith from golden plates, forms the basis of Mormon doctrine and is considered the most 'correct text'.*

PENTECOSTALISM

the 30-second religion

3-SECOND SERMON
A branch of Christianity
centred on a belief in
the present-day reality of
spiritual gifts bestowed
by the Holy Spirit.

3-MINUTE THEOLOGY
Some Pentecostals believe
in 'spiritual warfare',
which refers to the
struggle Christians are
called to in battling evil
powers with the power
of God. This is expressed in
praying over those thought
to be possessed by demons,
calling upon God to heal
the sick. This reflects a
'restorationist' dimension;
Pentecostals see
themselves as restoring
the Church to its original
form, when Christians
drove out demons and
healed the sick, following
Jesus' example.

Pentecostalism takes its name
from the Christian festival of Pentecost, which
commemorates the episode after Jesus' death
and Resurrection when his disciples were
filled with the Holy Spirit of God and spoke
in tongues (strange utterances interpreted as
unknown or divine language). This phenomenon
was recognized in the early Church as a sign of
God's presence, although later the Church came
to view these episodes as ceasing with the
death of the first disciples (the 'cessationist'
perspective). Things changed at the turn of
the twentieth century, when groups of North
American Christians began to experience what
they viewed as the Holy Spirit, and again spoke
in tongues as an expression of this. Most
influential was the Azusa St. Revival in Los
Angeles in 1906, led by African-American
preacher William Joseph Seymour, notable for
spanning the racial divide. Devotees united in
their experience of the Spirit, which initially
overruled any notion of hierarchy, priesthood
or privilege. Pentecostals continue to speak
in tongues and some see this as a sign of
their salvation as Christians. Others view it
as 'second blessing', a confirmation of being
one of God's people following the initiation of
baptism. Pentecostalism is the fastest-growing
branch of Christianity, making up well over a
quarter of all Christians.

RELATED RELIGIONS
See also
LUTHERANISM
Page 88
BAPTIST CHRISTIANITY
Page 110

3-SECOND BIOGRAPHY
WILLIAM J. SEYMOUR
1870–1922

30-SECOND TEXT
Mathew Guest

*Pentecostals firmly
believe in the presence
of the Holy Spirit of
God, who bestows
the gift of 'speaking
in tongues' on
the blessed.*

COPTIC CHRISTIANITY

the 30-second religion

3-SECOND SERMON
Ancient Christian Church based in Egypt, born out of a Christological schism and the cradle of Christian monasticism.

3-MINUTE THEOLOGY
While monasticism is widespread in religious traditions, Christian monastic practices are widely held to originate with the communities and individuals who isolated themselves from worldly life in the Egyptian deserts and inspired the ascetic spirituality of the Coptic Church. Following in the footsteps of Saint Anthony, Coptic monastic traditions emphasize practices of withdrawal and abstention – sometimes to complete isolation and silence – to enable believers to devote themselves fully to a life of prayer and contemplation.

In AD 451, Anatolius, the Patriarch of Constantinople, convened the Council of Chalcedon in an attempt to settle theological controversy about the nature of Jesus Christ. The Council affirmed Jesus as 'fully human and fully divine': two natures united in one person. Not all agreed, with the 'oriental orthodox' bishops believing instead that Jesus is of one nature: one nature consisting of humanity and divinity. The difference may seem slight, but it was enough to trigger the first major schism within Christianity and the result was the Coptic Orthodox Church of Alexandria. Even before Chalcedon, Christianity in Egypt had taken a distinctive form, using the local language of Coptic (instead of Greek or Latin) and adopting practices of desert monasticism. The writings of the Desert Fathers, especially their sermons, are highly influential for Coptic Christian spirituality, in particular, the tradition of *hesychasm* (from the Greek for 'stillness'), which promotes the practice of 'interior silence and continual prayer'. Copts use a liturgical calendar, based on ancient Egyptian traditions, consisting of thirteen months and three seasons: inundation, sowing and harvest. The head of the Coptic Church is the Pope of Alexandria (presently Shenouda III), believed to be a successor to the Apostle Mark, who founded the first church in Egypt.

RELATED RELIGIONS
See also
ORTHODOX JUDAISM
Page 60
EUROPEAN CHRISTIANITIES
Pages 78–97
WORLD CHRISTIANITIES
Pages 98–115

3-SECOND BIOGRAPHIES
JESUS
C. 5 BC–C. AD 30

SHENOUDA III
1923–

30-SECOND TEXT
Russell Re Manning

Coptic Christianity's practice of desert asceticism is regarded as the precursor of Christian monasticism.

repentance The regret of past misdeeds and commitment to change one's behaviour in the future. In a religious context, this usually means showing contrition for not obeying the rules of the faith and reaffirming belief in that faith.

Resurrection The return to life of a dead body. According to Christian belief, Christ came back to life three days after his body was placed in a tomb. The Resurrection is one of the central tenets of the Christian faith, because it symbolizes the possibility of redemption for all believers after they die. Indeed, a passage from the Bible says: 'If Christ be not risen, then is our preaching vain' (1 Corinthians 15:14).

Sabbath A day of rest and worship in Judaeo-Christian religions. According to Genesis, God created the world in six days and rested on the seventh. However, not everyone agrees which day it was, with most Jews observing the Sabbath on Saturday, while most Christians observe it on Sunday.

speaking in tongues Uttering noises that sound like language but have no known meaning. The speaker usually makes the sounds while in a trance and, according to certain religious groups, is possessed by a supernatural force. Also known as 'glossolalia'.

spiritual warfare The belief that the will of God is constantly under attack from the forces of evil. This can take many forms, from the thwarting of religious works through to people being possessed by the devil. Several evangelical churches promote this idea and practise different ways of casting out demons from those thought to be affected.

Trinity The idea that God exists in three persons, the Father, the Son and the Holy Spirit, who are essentially one. This is a central tenet of the Christian faith, although its exact formulation is disputed and was one of the reasons the Orthodox Greek Church split from the Roman Catholic Church in 1054.

WORLD CHRISTIANITIES
GLOSSARY

baptism A Christian ceremony during which a person is immersed in or sprinkled with water as part of their initiation into the faith. The act is intended to symbolize the cleansing of the soul. Most Christian churches insist on the baptism of children, but not necessarily of adults.

credobaptism The baptism of someone who has affirmed their belief in the Christian faith. This contrasts with the baptism of children (known as pedobaptism), during which an affirmation of belief is not required. Some Christian churches believe that only the baptism of consenting adults is valid; full immersion in water is often required as part of the ceremony.

millenarianism The belief that a major catastrophe or apocalypse is imminent. This is often linked to the belief that the world is being ruled by corrupt or evil forces, which must be overthrown in order for the true faith to prevail. Millenarianists include Christians who believe in the second coming of Christ.

monasticism The religious practice of abandoning mainstream society and devoting one's life to spiritual development and prayer. Derived from the Greek *monos*, meaning 'only one, alone'. Many faiths have strong monastic traditions, including Christianity, Buddhism and Hinduism.

pedobaptism The baptism of children, where an affirmation of belief is not required, as opposed to credobaptism (the baptism of adults), where it is.

Pentecost A Christian festival that celebrates the descent of the Holy Spirit among Christ's disciples fifty days after his death (hence Pentecost, from the Greek for 'fifty days'). According to the Bible, after the Holy Spirit had descended, the disciples started to 'speak in tongues' and were understood by those present, each in their own language. This led to the creation of the Christian Church.

Rapture The idea that Jesus will reappear in the sky and that all true believers will rise up to meet him. There is some disagreement about when this will happen, however, with some believing it has already happened, during the destruction of Jerusalem in AD 70, as described in Matthew 24.

WORLD CHRISTIANITIES

SOCIETY OF FRIENDS (QUAKERS)

the 30-second religion

In 1650, the Christian dissenter George Fox, on trial for blasphemy, exhorted the judge to 'tremble at the word of the Lord'. The judge found Fox guilty, sent him to prison, and mocked him as a 'quaker' – a name that was soon adopted by groups of nonconformist Christian revivalists – otherwise known as 'Children of the Light', 'Friends of Truth' or the 'Society of Friends'. Quakers believe that a direct experience of God through Christ is available to all people – without the intervention of clergy – and that through 'the inner light' God is always present to all people, without the mediation of religious sacraments. As a result, although most Quakers hold regular services of worship, they are known as meetings and are often 'unprogrammed', with no designated leader or predetermined structure. Sometimes worshippers take turns to speak when they feel led by the Holy Spirit, but frequently the entire meeting takes place in silence because believers gather simply to wait 'expectantly' in the presence of God and their fellows. It is important for most Quakers to bear witness or 'testify' to their faith in their everyday actions, which aim to embody the values of peace, equality, simplicity and truth.

3-SECOND SERMON
A Christian dissenting movement that rejects religious hierarchy and institutions in favour of an unmediated experience of God.

3-MINUTE THEOLOGY
Quakers are committed to promoting peace and are strongly opposed to all forms of violence and armed conflict. They derive their pacifism from Jesus' command 'to love your enemies' and their belief in the inner light of God. Quakers 'conscientiously' object to conscription to armed forces and many refuse to pay that portion of their taxes that is to be spent on weapons. In 1947, the Society of Friends was awarded the Nobel Peace Prize.

RELATED RELIGIONS
See also
ORTHODOX JUDAISM
Page 60
EUROPEAN CHRISTIANITIES
Pages 78–97
WORLD CHRISTIANITIES
Pages 98–115

3-SECOND BIOGRAPHIES
JESUS
C. 5 BC–C. AD 30

GEORGE FOX
1624–1691

30-SECOND TEXT
Russell Re Manning

Quakers believe that the inner light of God exists in every man and every woman; as such, everyone shall be considered equal.

METHODISM

the 30-second religion

Methodists were so-named on account of the highly methodological habits of a group of students who met in Oxford, England, in the 1730s for the purposes of mutual improvement. Among their disciplines were regular communion and fasting, abstinence from amusement and luxuries, as well as frequent missions to the poor. Developed from the teachings of the Anglican priest John Wesley and his younger brother Charles, Methodism is characterized by its emphasis on the importance of the spiritual transformation of the individual through close study of the Christian Scriptures, and through practical action to promote social welfare and justice. Methodists were prominent antislavery campaigners, were frequently active promoters of the temperance movement, and strove to spread their message overseas through extensive missionary activity. The Methodist interest in social matters is reflected in their practice of preaching outside churches, taking the Gospel to the 'unchurched' in market places and prisons. Methodist churches often have an annual Covenant Service on the first Sunday of the year, in which believers reaffirm their total reliance on God and their willingness to devote themselves to His service.

3-SECOND SERMON
Revivalist movement originating within Anglicanism that stresses the need for personal piety and individual good works in response to God's grace.

3-MINUTE THEOLOGY
Methodists were central figures in the so-called First Great Awakening in America in the 1730s and 1740s. This religious revivalist movement had a profound effect on the future of religious belief in the Americas, encouraging a scepticism towards ritual and established religious traditions and emphasizing instead the importance of personal faith and individual good works. The most famous itinerant Methodist preacher was George Whitefield, whose enthusiastic sermons attracted large crowds and resulted in mass conversions.

RELATED RELIGIONS
See also
ORTHODOX JUDAISM
Page 60
EUROPEAN CHRISTIANITIES
Pages 78–97
WORLD CHRISTIANITIES
Pages 98–115

3-SECOND BIOGRAPHIES
JESUS
C. 5 BC–C. AD 30

JOHN WESLEY
1703–1791

CHARLES WESLEY
1707–1788

30-SECOND TEXT
Russell Re Manning

Morality and social welfare are central to Methodist practice. Methodism founder John Wesley was an active campaigner against slavery and discouraged the drinking of alcohol.

ANGLICANISM (EPISCOPALIANISM)

the 30-second religion

In 1521, King Henry VIII of England was granted the title 'Defender of the Faith' (*fidei defensor*) by Pope Leo X for his pamphlet accusing Martin Luther of heresy. Thirteen years later, an Act of Parliament declared an excommunicated Henry 'the only supreme head on earth of the Church in England'. The unusual historical origins of the Church of England – part religious renewal, part royal love story, part realpolitik – define the characteristics of Anglicanism as a Protestant Christian tradition. The wider Anglican Communion is made up of forty-four provinces, including the Episcopal Church of the United States, united by the Archbishop of Canterbury – known as the *primus inter pares*, or first among equals. Within the Anglican Communion there is a very wide range of beliefs and practices. For 'evangelical' Anglicans, the reformed emphasis on the Bible is central; for 'Anglo-Catholics', the focus is rather on religious liturgy and the continuity of the Anglican Church with its pre-Reformation origins. Richard Hooker's account of the so-called 'three-legged stool' of Anglican beliefs – derived primarily from the scriptures, informed by reason and supported by tradition – has been an influential statement of the nature of Anglican authority.

RELATED RELIGIONS
See also
ORTHODOX JUDAISM
Page 80
EUROPEAN CHRISTIANITIES
Pages 78–97
WORLD CHRISTIANITIES
Pages 98–115

3-SECOND BIOGRAPHIES
JESUS
C. 5 BC–C. AD 30

HENRY VIII
1491–1547

RICHARD HOOKER
1554–1600

ROWAN WILLIAMS
1950–

30-SECOND TEXT
Russell Re Manning

3-SECOND SERMON
The religious beliefs of a global collection of churches, the history of which can be traced back to the post-Reformation Church of England.

3-MINUTE THEOLOGY
As with many Christian Churches, the status of women in the Anglican Communion is controversial. Most Anglican provinces ordain women as priests and some permit the ordination of women as bishops. For many, the issue is one of equality under God; for others, the ambiguity of the Biblical view is crucial, for example, Galatians 3:24 asserts that gender is surpassed in Christianity, while the epistle 1 Timothy subordinates women to men and requires that women stay silent in worship.

The forty-four regional and national member churches of the Anglican Communion affirm their beliefs through the Anglican Communion Covenant.

CALVINISM

the 30-second religion

3-SECOND SERMON
The 'Five Points' of Calvinism affirm belief in total depravity, unconditional election, limited atonement, irresistible grace and preservation of the saints.

3-MINUTE THEOLOGY
Predestination is the Calvinist belief in God's free choice to save some people, leaving the remainder to suffer (deservedly) eternal damnation for their sins. Some Calvinists believe that God ordained who would be saved before the event of the Fall ('supralapsarianism'), others that God's election occurred after the Fall ('intralapsarianism') because salvation logically requires something to be saved from. 'Double predestination' is the view that God elects both whom to save and whom to damn.

John Calvin was a Protestant

thinker who developed the 'reform' of Christianity begun by Martin Luther. Today, over 75 million 'Reformed' Christians share the principles of his theological system. Calvinism teaches the absolute sovereignty of God and the total depravity (original sin) of humanity. As a consequence of the Fall (Adam and Eve's disobedience of God's command not to eat from the 'Tree of Knowledge'), all people are in every respect enslaved to sin and, hence, incapable of being moral without external agency. For Calvinists, God, who would be justified in condemning all humanity, instead voluntarily decides to be merciful to some. Calvinists believe that these elect are saved because of God's free irresistible grace, not because of any virtue or quality they possess. Only the elect are saved and preserved forever in communion with God through his grace alone; all others are condemned. Calvinism holds that only practices that are instituted in the New Testament should have a place in Christian worship ('the regulative principle'), leading to the widespread rejection of all visual images in churches and their replacement with texts, such as the Ten Commandments, although recently hymns and 'worship songs' have become more common.

RELATED RELIGIONS
See also
ABRAHAMIC TRADITIONS
Pages 56–77
EUROPEAN CHRISTIANITIES
Pages 78–97
WORLD CHRISTIANITIES
Pages 98–115

3-SECOND BIOGRAPHIES
JESUS
C. 5 BC–C. AD 30

JOHN CALVIN
1509–1564

30-SECOND TEXT
Russell Re Manning

For Calvinists, God's rule is absolute, and only through his grace and mercy will the elect be saved.

LUTHERANISM

the 30-second religion

3-SECOND SERMON
A branch of Protestant
Christianity inspired by the
teachings of the reformer
Martin Luther, based on
the idea of justification by
grace through faith alone.

3-MINUTE THEOLOGY
Luther reacted to what
he saw as the 'cult' of
the saints in Roman
Catholicism, affirming
instead that Christians
should have no other
mediator than Christ
himself. As a result,
Lutherans do not venerate
the saints as intercessors
but honour them as
examples of pure faith
and divine mercy. Similarly,
many Lutherans pray to
the Virgin Mary for God
to do what they ask
through her, but insist that
the work is God's alone.

In 1517, Martin Luther, a priest
and theologian in Wittenberg, Germany,
protested against the Catholic Church's practice
of selling 'indulgences', which promised believers
remission of sin in exchange for financial
donations. Luther affirmed that only God could
grant forgiveness from sin. In the context of
widespread dissatisfaction with the established
Church and aided by the recently invented
printing press, Luther's ideas spread rapidly,
leading to the religious and political upheavals
of the Protestant Reformation. Luther's concept
of justification by grace through faith alone
rejects all human attempts to gain God's favour,
and hence grace, as the idolatrous works of sin;
instead Lutherans rely on God's initiative in Jesus
Christ as the only means to salvation. Luther
derived this doctrine from a close study of
the Bible, which he translated from Latin into
vernacular German and which Lutherans hold
as normative for all subsequent religious
thought and practice. Lutherans stress the
importance of the individual believer's personal
faith, with some followers, known as 'pietists'
(from the word 'piety'), emphasizing the
emotional and subjective elements of belief.
While Lutheran worship retains the centrality
of the Eucharist, a significant role is given to
the Scriptures and to inclusive participation,
especially communal singing.

RELATED RELIGIONS
See also
ABRAHAMIC TRADITIONS
Pages 56–77
EUROPEAN CHRISTIANITIES
Pages 78–97
WORLD CHRISTIANITIES
Pages 98–115

3-SECOND BIOGRAPHIES
JESUS
C. 5 BC–C. AD 30

MARTIN LUTHER
1483–1546

30-SECOND TEXT
Russell Re Manning

*Luther's posting of the
Ninety-Five Theses on a
church in Wittenberg,
questioning the validity
of indulgences, is
widely seen as the start
of the Reformation.*

THE BIBLE

The 'best-selling book of all time', the Bible is estimated to have sold between 2.5 and 6 billion copies, depending on your source. Yet the Christian holy book is an unlikely mix of texts written by forty authors in three languages over the space of 1500 years. And what's more, there are many different versions available.

In terms of structure, the Bible is made up of two parts. The first part, the Old Testament, written between 1200 and 165 BC, consists of thirty-nine books and covers the history of the world from its creation (Genesis) up until shortly before the birth of Jesus Christ. This is by far the longer of the two parts. The New Testament, written in the first century AD, consists of twenty-seven books describing the life of Jesus and the origins of Christianity. There are the gospels of Matthew, Mark, Luke and John, followed by an account of the first thirty years of Christianity (Acts) written by Luke, followed in turn by twenty-one pastoral letters (or epistles) written by Paul and others, and finally the apocalyptic vision of Revelation.

Although written by different people and for different audiences, the four gospels (from the Old English *godspel*, meaning 'good news') broadly agree on the main events in Jesus' life. Matthew and John are both said to have known Jesus personally, while Mark and Luke were closely connected to the apostles, and all the accounts were written within seventy years of Christ's Crucifixion. The letters, on the other hand, were written by Church leaders to their disciples and, with the exception of Romans and Hebrews, were not intended to officially represent Christian doctrine. As such, they are more conversational and sometimes sound like one side of a dialogue, or as answers to questions submitted by disciples.

Favourite sections (such as John 3:16) have been translated into 3000 languages, while the Bible itself is available in 400. Despite such a diverse literal provenance, to devout Christians the book is 'divinely inspired', and, therefore, the work of just one author: God.

The Bible is the sacred book of Christianity, comprising the Old and New Testaments.

C. 450 BC
Hebrew Bible (*Tanakh*) created

C. 250 BC
Hebrew Bible translated into Greek

C. AD 200
New Testament translated into Latin

1456
Gutenberg Bible, first printed edition

1534
Luther Bible, first full translation into German

1535
Coverdale Bible, first full translation into English

1558
Geneva version introduces verse numbers

1611
Authorized King James version